DAVID
SMITH

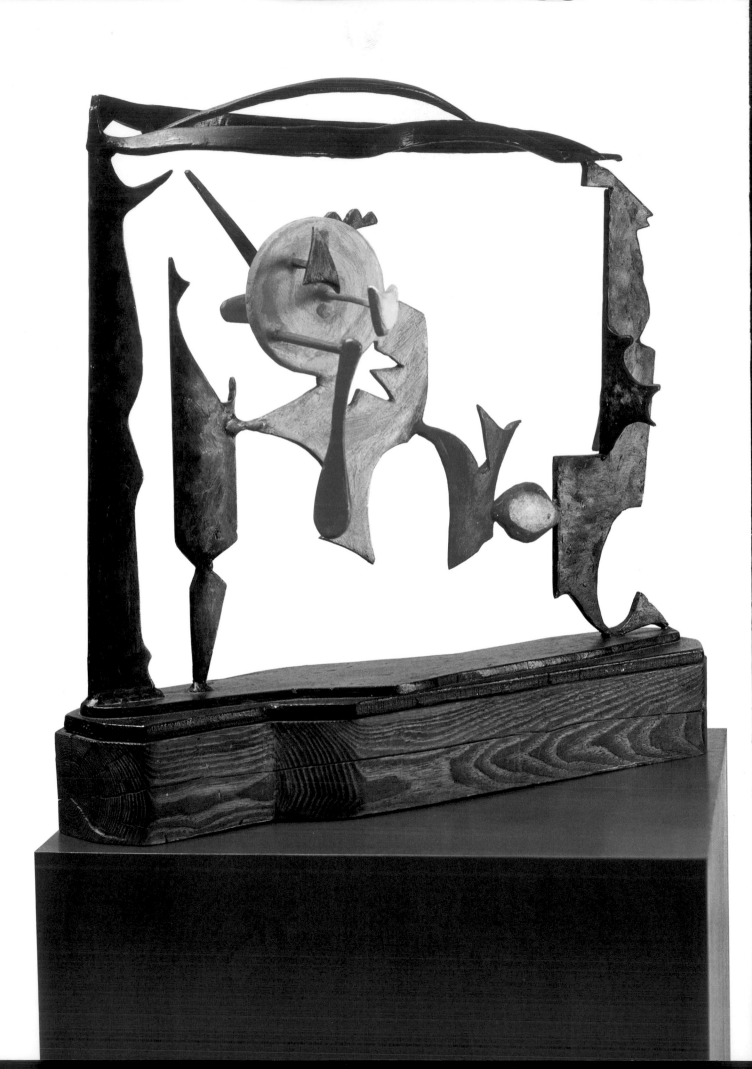

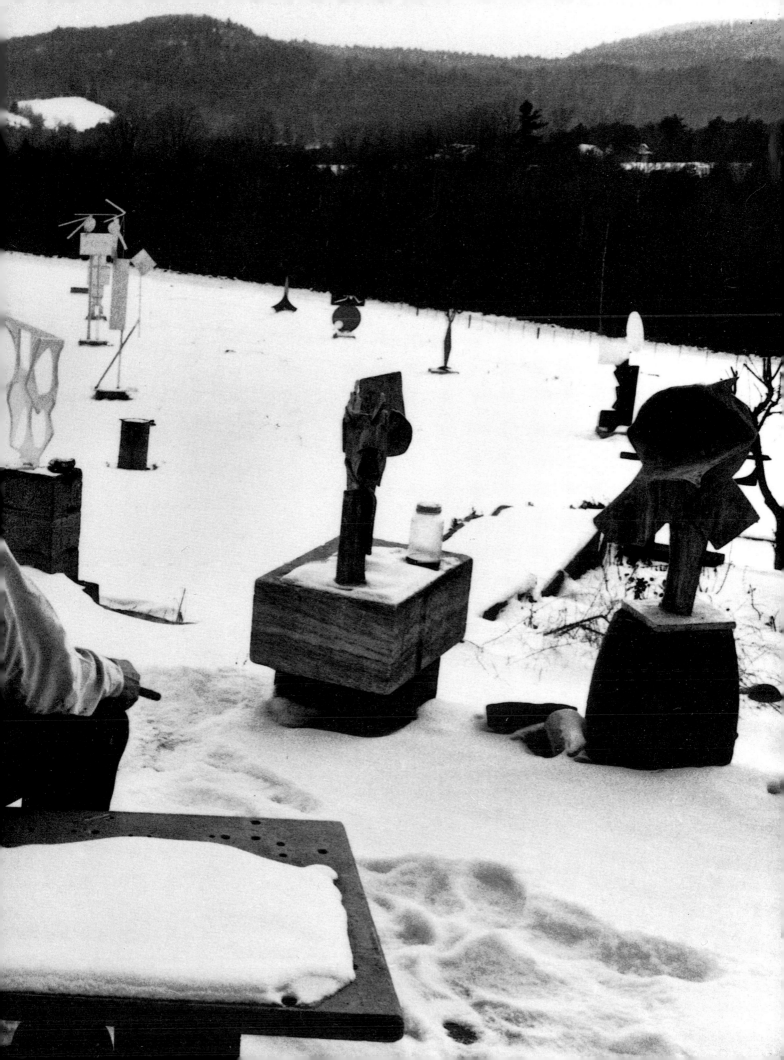

MODERN MASTERS

DAVID SMITH

KAREN WILKIN

Hillsborough Community
College LRC

Abbeville Press Publishers
New York London

David Smith is volume six in the Modern Masters series.

ACKNOWLEDGMENTS: This book would not have been possible without the sympathetic cooperation of Rebecca and Candida Smith and Peter Stevens. My thanks go to Dorothy Dehner, Esther Gottlieb, James Wolfe, E. A. Carmean, Jr., Miranda McClintic, and Garnett McCoy and the Archives of American Art, Smithsonian Institution, for their assistance, and to the Edmonton Art Gallery and Trent University for supporting portions of the research for this book.

FRONT COVER: *Royal Incubator,* 1949. See plate 47.
BACK COVER: *Pillar of Sunday,* 1945. See plate 41.
FRONT ENDPAPERS: David Smith studying sculpture in the south field, Bolton Landing, 1962 or 1963. Photograph by Dan Budnik.
BACK ENDPAPER, left: David Smith at work on the Voltri-Bolton series, Bolton Landing, 1962. Photograph by Dan Budnik.
BACK ENDPAPER, right: David Smith in his Bolton Landing studio workshop with *Detroit Queen.*
FRONTISPIECE: *Helmholtzian Landscape,* 1946. Steel painted blue, red, yellow, and green, 15½ x 17⅝ x 7⅛ in. Mr. and Mrs. David Lloyd Kreeger.

Series design by Howard Morris
Editor: Nancy Grubb
Designer: Gerald Pryor
Picture Editor: Amelia Jones
Production Manager: Dana Cole
Chronology, Exhibitions, Public Collections, and Selected Bibliography compiled by Anna Brooke

Marginal numbers in the text refer to works illustrated in this volume.

Library of Congress Cataloging-in-Publication Data

Wilkin, Karen.
 David Smith.

 (Modern master series, ISSN 0738-0429; v. 6)
 Bibliography: p.
 Includes index.
 1. Smith, David, 1906–1965. I. Title. II. Series.
N6537.S616W5 1984 709'.2'4 83-21516
ISBN 0-89659-429-7
ISBN 1-55859-256-3 (pbk.)

First edition, 15 14 13 12 11 10 9 8 7 6

For bulk and premium sales and for text adoption procedures, write to Customer Servive Manager, Abbeville Press, 137 Varick Street, New York, NY 10013 or call 1-800-ARTBOOK.

Contents

Introduction

Every year David Smith's reputation grows a little. Every new showing of his work makes him loom larger, yet he remains an elusive artist. The *idea* of Smith is more present than the fact of his work. The full range of his achievement is still not widely known; his most familiar sculptures are not always his finest. Since about 1978, exhibitions ranging from drawings and paintings to little-known works have helped expand knowledge of Smith's art, but in spite of them, and in spite of a considerable body of writing on Smith, the myth of the larger-than-life American artist-hero seems to have been assimilated more fully than the work itself.

And yet, it is not altogether a myth. So much about Smith does seem larger than life: his genius, his protean energy, his gargantuan appetite for work, his ambition, his sheer physical size, even his premature death at a critical time in his career. Impressive, too, is the intensity of his sculpture, its undercurrents of violence and disguised sensuality. And the image of the fields surrounding his home at Bolton Landing, filled with rows of his challenging, potent sculpture, is unforgettable.

Smith himself could encourage misleading notions of his work and life, but many apparent contradictions are real. He earned his place in the history of contemporary art as a sculptor in metal, yet he insisted that he "belonged with painters" and liked to point out that much of the best modern sculpture had been made by painters, citing Picasso, Matisse, and Degas. Smith's own formal training was as a painter; as a sculptor, he was virtually self-taught. Even after he had determined that he was primarily a sculptor, Smith never abandoned painting. His desire to fuse the two disciplines in colored structures that would, in his words, "beat either one," is well known, but perhaps more significantly, he drew and painted prodigiously throughout his working life. He concentrated on sculpture, and no one would deny that his most inventive and powerful efforts were in three dimensions, but there is also an enormous body of two-dimensional work in an impressive range of media. The same sort of omnivorous ambition led Smith to explore, at various times, the possibilities of cast bronze and aluminum, forged iron, ceramics, and, briefly, carved stone.

1. David Smith, 1957

He saw himself as a universal artist who transformed whatever he turned his hand to by the force of his individuality, yet he is generally thought to have been exclusively a sculptor in welded metal.

Generally, too, Smith is viewed as an anguished, lonely figure working in self-imposed exile, away from colleagues and contemporaries, in upstate New York. The anguish and the loneliness were undoubtedly intense; they pervade Smith's writings and his friends' recollections of him, but so does an exuberant gregariousness. It is true that after 1940 Smith chose to live and work on a remote farm near Lake George, but he was hardly isolated. Friends and colleagues visited; he went to New York often. His work clearly demonstrates his awareness of current aesthetic concerns (just as it helped formulate what we now perceive as those concerns). It takes nothing away from Smith's originality to say that his sculpture obviously responds to and disputes with notions being promulgated at the time of its making. It is informed, sophisticated art, alert to its place in the history of sculpture, which gives the lie to the image of its maker as a reclusive autodidact.

Much of the writing on Smith emphasizes his size and strength, the factory methods he used to make art, the sculpture's macho, heroic qualities. It's all true, of course, even if Smith was sometimes guilty of overemphasizing this side of his work. His own
·2 photographs of his sculptures, for example, make them look enormous and monumental, and exaggerate their flatness and thinness. To encounter sculptures that we have previously seen only in Smith's own images is often startling. The works are as notable for their delicacy and intimacy as for their power and size. The industrial antecedents of their methods and materials seem less important than the evidence of their maker's hand. Rather than the huge, declarative, flat sculpture that Smith's photographs have led us to expect, we are confronted by works of human scale, great subtlety, and remarkable spatial complexity.

If our ideas about Smith seem haunted by confusion, it is not always the fault of our perceptions. The work is astonishingly difficult. It is uningratiating and contradictory, resisting precise definitions. The best pieces are often at once radically abstract and uncannily anthropomorphic, aggressively robust and surprisingly sensitive. They seem to both exemplify and reinvent the vocabulary of Abstract Expressionism, to point back to Cubism and to anticipate concerns of the 1970s and '80s. Like their maker, they cannot easily be categorized.

Time and two generations of heirs to Smith's new tradition of sculpture have not lessened the impact of his work. It remains modern and challenging, even disturbing. Its evolution recapitulates the development of freestanding open construction from Cubist painting and collage, but two decades after Smith's death, his art still stakes out new territory for sculpture. Paradoxically, it seems to combine a tough-minded formal detachment with an overwhelming desire to achieve expressiveness, as though Smith worked with two contradictory attitudes. On the one hand, he appears to

* Marginal numbers refer to works illustrated in this volume.

2

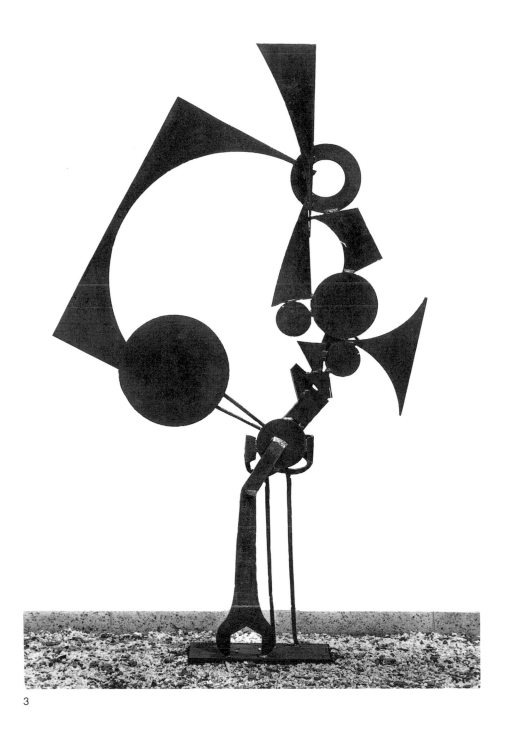

3

2. *Widow's Lament*, 1942
Steel and bronze, 14½ x 20 x 6⅝ in.
Photograph by David Smith
Private collection

3. *Volton XVIII*, 1963
Steel, 110⅞ x 67⅛ x 15⅛ in.
State of New York: Governor Nelson A.
Rockefeller
Empire State Plaza, Albany

have been dispassionately alert to the possibilities that arose in the course of working, and on the other, intensely concerned with the invention—or discovery—of personal metaphorical images.

Smith could be uncritical of his own production, not in the sense of being easily satisfied, but in insisting on the significance of everything he made as the declaration of a particular, special individual. In any case, he disliked critical distinctions: "The works you see are segments of my work life. If you prefer one work over another, it is your privilege, but it does not interest me. The work is a statement of identity, it comes from a stream, it is related to my past works, the three or four works in process and the work yet to come."[1]

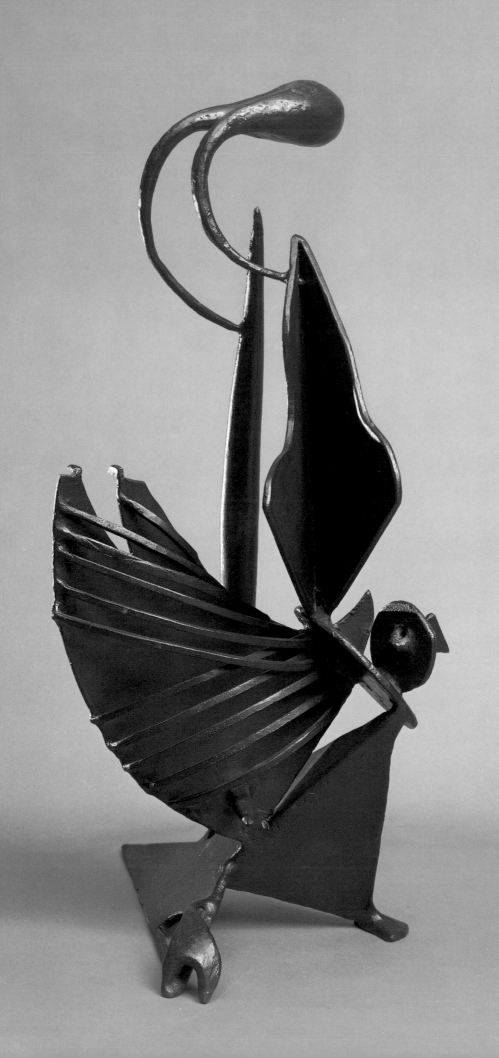

Early Life and Work

David Roland Smith was born in 1906, in Decatur, Indiana. He grew up at a time when the machine was making its first impact on small-town America, but it was also a time not too removed from the frontier generation. Family tradition named Smith's great-great-grandfather, a blacksmith, as a founder of Decatur. Smith seems to have identified quite strongly with his Indian-fighting, pioneer ancestors,[2] but his later statements equally stress the presence of twentieth-century technology in his childhood and adolescence. His recollections were bound up with railroads, automobiles, empty factories. His father was the manager of an independent telephone company and as Smith recalled "invented things."[3] "When I was a kid, everyone in town was an inventor. There must have been fifteen different makes of automobile in Decatur, Indiana; two blocks from where I lived there were guys building automobiles in an old barn. Invention was the fertile thing then. . . ."[4]

When Smith was fifteen, his family moved to Paulding, Ohio. Like Jackson Pollock and Clyfford Still, he seems to have been one of those curious beings who grow up more or less isolated from serious painting or sculpture, but who know they want to make art. Pollock, at least, had the advantage of an art-loving mother, a sympathetic art teacher in high school, and the example of older brothers studying at Columbia University and the Art Students League. Smith's early experience was more limited. He had memories of making a mud lion as a very small boy, and of having it admired, but art was not something encouraged by his severe Methodist family. Smith's mother, a teacher, appears to have been a powerful advocate of piety, propriety, and hard work. (Two of Smith's most savage sculptures of the 1940s—*Widow's Lament*, with its tightly contained "secret" passages, and *Spectre of Mother*, with its spurs and fierce, insect-weapon imagery—are among his most overt statements on the subject.) His grandmother, however, unwittingly influenced Smith's formation as an artist by giving him an illustrated bible. When he went to Europe in the mid-1930s, the Egyptian and Sumerian art that he saw in museums there reawakened vague memories of the bible's pictures of similar pieces; they in turn became sources of Smith's imagery. (The bible itself remained in Smith's studio.)

2

32

4. *Leda*, 1938
Steel, painted brown, 28⅝ x 13½ x 15½ in.
Museum of Fine Arts, Houston
Gift of Mr. and Mrs. W. D. Hawkins

11

Art, Smith later recalled, was something far removed from Paulding, Ohio. It existed chiefly as reproductions of remote, European masterpieces. Yet Smith's facility as a cartoonist won him praise in high school and he was ambitious enough about his drawing to subscribe to a correspondence course. (Paulding High offered only mechanical drawing.) At Ohio University, in 1924, he gave most of his attention to art courses, although he later was bitter about the instruction he had received. Not only, he complained, was it designed to produce teachers rather than artists, but it was immediately foreign and ultimately useless to him. "I was required to use a little brush, a little pencil, to work on a little area, which put me into a position of knitting—not exactly my forte. . . . I think the first thing that I should have been taught was to work on great big paper, big sizes to utilize my natural movements. . . ."5

Contemporary modernism had no place in this program. Possibly because of these deficiencies, Smith transferred to Notre Dame in the fall of 1925, but left after two weeks when he found that no art instruction was offered. Neither lack of teaching nor of direct experience of art inhibited Smith's ambition: "I don't think I had seen a museum out in Indiana or Ohio other than some very, very dark picture with sheep in it in the public library. I didn't know anything about art until I came to New York. [But] I wanted to be a painter when I came."6

During the summer of 1925, between his brief bouts of higher education, Smith worked as a welder and riveter at the Studebaker plant in South Bend, Indiana. He later described the job as something he had done "strictly for money,"7 the most he had ever earned. But this factory stint, at the age of nineteen, played a significant role in his life as a sculptor: "Before knowing what art was or before going to art school, as a factory worker I was acquainted with steel and the machines used in forging it. During my second year in art school [in New York] I learned about Cubism, Picasso and González through *Cahiers d'art*. From them I learned that art was being made with steel—the materials and machines that previously meant only labor and earning power."8

Although Smith later liked to trace his identification with the working man and his skill as a metal worker to his early days at Studebaker, he quickly shifted from a blue collar to a white collar position, when he returned to the company after dropping out of Notre Dame. He joined the finance department, not the assembly line. A related job, with a cooperative banking plan, took him to Washington, D.C., and one summer semester of studying poetry at George Washington University, which had no satisfactory art program. In 1926 the company sent Smith to New York. He asked his landlady for advice about art schools and she referred him to another tenant, a young woman named Dorothy Dehner. She was away, visiting her family in California, but she recalls that as soon as she returned, a very tall young man introduced himself brusquely and demanded information. She recommended the Art Students League, where she was studying.

The League was, at the time, probably the most progressive and stimulating art school in New York. Smith remained there for five

years, part-time and full-time, studying with John Sloan, Richard Lahey, Kimon Nicolaides, and Jan Matulka. Matulka, a Czech Cubist who had studied with Hans Hofmann, was one of the most influential teachers at the League, and the one to whom Smith always gave most credit. Matulka attracted a remarkable group of young artists to his painting classes, including, along with Smith and Dehner, I. Rice Pereira, Burgoyne Diller, and George McNeil. Some, like Smith and Dehner, studied with him privately when he left the League.

Important as Matulka's teaching was to Smith's sudden and enthusiastic assimilation of modernist notions, Dorothy Dehner's influence was perhaps even more crucial. Her intelligence and sophistication, her unorthodox background (and striking good looks) could well have stood for everything that Smith's own experience had failed to provide. Orphaned as a child, Dehner had been raised by a trio of unconventional aunts in Pasadena. She had been trained as a modern dancer and had traveled a great deal. When she and David Smith met, Dehner was familiar with some of the most advanced music, dance, art, and literature of the time. The combination was irresistible. They married in December 1927 and stayed together nearly twenty-five years. (Dehner has had a significant career as a painter and sculptor in her own right.) Smith was aware of his debt to her; writing to her in June 1944, he said, "I owe my direction to you."[9]

The League generated many of the Smiths' friendships. Thomas Furlong and his wife, the League's secretary, were among their

5

5. David Smith and Dorothy Dehner, 1927

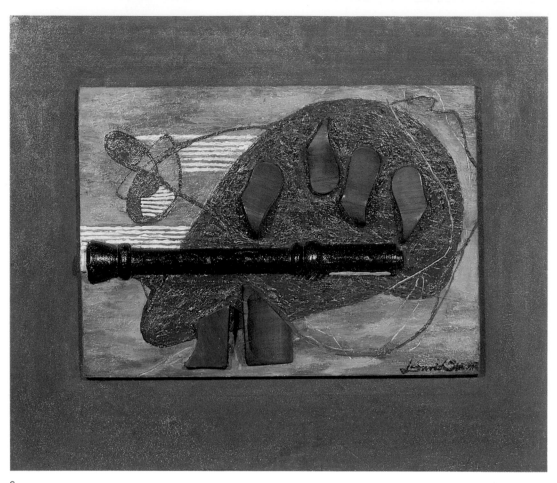

6

earliest acquaintances. The Furlongs' familiarity with new European art helped encourage Smith's interest in abstraction, even before he became a student of Matulka's. The couple had a summer house at Bolton Landing, near Lake George, where the Smiths vacationed as paying guests. After one of these visits, in the summer of 1929, the Smiths bought a former fox farm nearby.

It was the Furlongs, too, who introduced the Smiths to John Graham, the Russian emigré painter. Graham was a considerable presence in New York's underground art world of the late 1920s and '30s, and was soon a considerable presence in the Smiths' lives. They quickly became part of the informal circle of young artists for whom the older Graham served as a link with the distant excitement of Paris. Graham was well qualified for the role. A member of the minor Russian nobility, he had lived in Paris after 1917, and as a painter and a kind of private dealer, he had come to know an impressive cross section of the European avant-garde. He knew Picasso, Julio González, and the Surrealists, and his annual trips to Paris provided his artist friends in New York with first-hand information about the latest adventurous art. He was also a connoisseur of primitive art and advised collectors of African sculpture.

It was Graham who, around 1930, gave Smith copies of French art magazines, including issues of *Cahiers d'art* with illustrations of welded metal sculpture by Picasso and González. In 1930 Graham bought three works by González, almost certainly the first to be

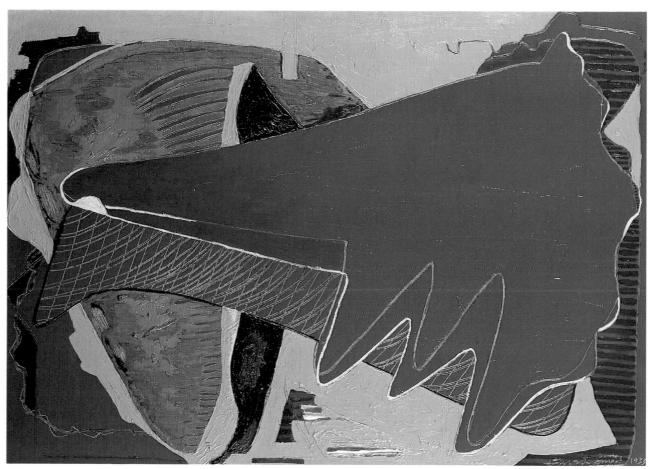

7

6. *Untitled (Virgin Islands Relief)*, 1932
Oil on wood with wooden pieces, 18 x 22 in.
Collection of Candida and Rebecca Smith

7. *Virgin Islands Shell and Map Landscape*,
1933
Oil on canvas, 26 x 36 in.
Metropolitan Museum of Art, New York

brought to the United States and among the few examples of
modernist sculpture that Smith saw at the time, aside from re-
productions. (Graham gave Smith a González mask in 1934.)
Dehner recalls, too, that Graham's collection of African sculpture
was their introduction to that art as something other than an
ethnic curiosity. In 1933 Graham had Smith hired to make bases
for a collection of fine African carvings Graham had selected;
Smith lived with the sculptures for months, storing them in his
apartment while he worked on the bases.

Graham's tastes were wide ranging. His 1937 book, *System and
Dialectics of Art*, which seems an accurate reflection of his con-
versation, distills then current ideas about creativity, Marx, Freud,
psychoanalysis, primitivism, and abstraction—and even such recher-
ché problems as the relationship between art and crime, genius
and suicide. The Jungian notion of the collective unconscious and
a firm belief in its role as the source of creativity are central to
Graham's text. Obviously he was not the only source of these
ideas. The theories of Freud and Jung, the potency of myth and
symbol, the relation between creativity and neurosis, were all
absorbing topics among the intellectually curious of New York, as
elsewhere. In the same way, the leftist beliefs that the Smiths
espoused were also common coin, a reaction to the social and
economic upheavals of the period.

In addition to the stimulus provided by Graham and by Smith's
teachers at the League, there were opportunities to see a small

amount of provocative new art in New York, although the city at the time was far from being a center where innovative painting and sculpture were readily accessible. When Smith first arrived, in 1926, recent modernist works were exhibited at only a handful of galleries and a few rather shaky institutions dedicated to "new movements in the arts." Until the founding of the Museum of Modern Art in 1929, the Art Center (which had exhibited the remarkable John Quinn collection) and the Museum of Living Art, at New York University (which showed works from the Gallatin collection) were among the few places where advanced art was regularly on view.[10]

By the 1930s, though, a wider range of first-hand experience was available. The best information still came from European magazines (although even the conservative *American Magazine of Art* had started to reproduce work by advanced Europeans), but exhibitions at the Museum of Modern Art and a growing number of commercial galleries committed to the modern movement provided New Yorkers with more direct access to radical ideas. Dorothy Dehner recalls the eagerness with which young artists visited these shows: "We looked at everything we could see. We were hungry."[11]

It is often fairly easy to identify the art that Smith was looking at, especially during the early years when he was still clarifying his direction. His close acquaintance with African sculpture provoked a series of angular carved wood pieces, and some of his first metal sculptures of the early 1930s demonstrate his familiarity with John Graham's works by González. The suspended forms and ringed trachealike structures of a group of reclining figures of about 1935 point to Giacometti's *Woman with Her Throat Cut*, while the splayed flipper hands of other figures of the same period suggest Picasso's bathers.

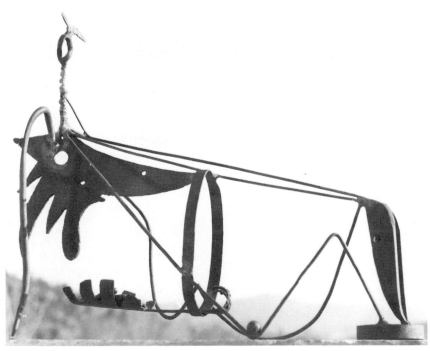

8. *Suspended Figure*, 1935
Iron, 21¾ x 27½ x 10¼ in.
Private collection

8

Since the illustrated magazine was Smith's chief source of information about the European artists he admired, the few modernist works that he was able to see firsthand made particularly strong impressions. The presence of widely spaced, rounded, organic forms in Smith's early work (as in that of so many of his New York colleagues) probably owes something to Miró, while his debt to Picasso's "rod and ball" drawings and the formal violence of *Guernica* is plainly legible. This comes as no surprise when we remember that Picasso's and Miró's paintings were exhibited regularly in New York in the 1930s and '40s, and that *Guernica* and the studies relating to it were shown at the Valentine Gallery for the benefit of the Spanish Refugee Relief Committee.

Modernist sculpture, even by Picasso, was shown far less often. Even the Museum of Modern Art's 1939 retrospective, *Picasso: Forty Years of His Work*, focused almost exclusively on painting. An exhibition of work by González's pupil, Pablo Gargallo, at the Brummer Gallery in 1934 gave Smith an early opportunity to examine sculpture that he had probably seen in *Cahiers d'art*, and several uncharacteristically fussy Smiths of the late 1930s show fairly direct influence. Smith thought highly enough of Gargallo to illustrate his work (along with his own) in an article on modern sculpture published some years later in *Architectural Record*. Gargallo's figures, which occupy an uneasy territory between origami and Cubist construction, were poor substitutes for those by Picasso or González, but in the absence of more challenging work, they served as examples of Cubist notions. Ironically, because he was in Europe, Smith missed the Museum of Modern Art's 1936 exhibition, *Cubism and Abstract Art*, which included one of the most comprehensive cross sections of advanced European sculpture ever to have been shown in New York.

By the 1930s the Smiths were part of a small group of forward-looking younger artists. Some, like the Adolph Gottliebs and Edgar Levy and his wife, the illustrator Lucille Corcos, were the Smiths' close friends and neighbors in Brooklyn. Levy, whom Dehner describes as a "real intellectual," was evidently a thoughtful and well-read man who rarely showed his quite radical paintings. Like Graham, he acted as a conduit of information and current ideas. Through Graham, the Smiths met other adventurous artists, including Stuart Davis, Jean Xceron, Arshile Gorky, and Willem de Kooning. Xceron, who went frequently to Paris, had a special role because of his fresh news of European art. Xceron was also particularly esteemed by Smith because of an early and perceptive article he had written about González while reviewing art for the *Paris Herald Tribune*. Smith credited Xceron with having convinced him to focus his energies on sculpture: "Remember May, 1935, when we walked down 57th Street after your show . . . how you influenced me to concentrate on sculpture. I'm of course forever glad that you did, it's more my energy, though I make two hundred color drawings a year and sometimes painting . . . but I paint and draw as a sculptor. I have no split identity as I did in 1935."[12]

Smith, Graham, de Kooning, Gorky, and Levy even formed a short-lived group in 1935. Their only collective action, Smith

recalled, "was to notify the Whitney that we were a group and would only exhibit in the 1935 abstract show if all were asked. Some of us were, some exhibited, some didn't and that ended our group."[13] Stronger bonds were formed, about the same time, when Smith, like many of his artist friends, was assigned to a variety of New Deal art projects. Smith recalled enjoying the group association with the WPA. ". . .For the first time, collectively we belonged somewhere. . . . It gave us unity, it gave us friendship, and it gave us a collective defensiveness."[14]

The Smiths and their friends shared a common enthusiasm for modernism. At the time, of course, this meant innovative European art. There were no American models comparable to the inventors of Cubism or Surrealism. There was a handful of American painters—such as Max Weber, Marsden Hartley, and Alfred Maurer—who had been in Europe before World War I and had participated directly in the rethinking of what art could be, but they had returned, retreated, or become invisible. Only a few older American modernists—such as John Marin, Georgia O'Keeffe, and Joseph Stella—exhibited regularly in New York, but in the eyes of Smith's generation, their work didn't come close to embodying the modern spirit, as that of Picasso and his colleagues did. "Official" American art was neither modernist nor looked to Europe: there was the self-conscious regionalism of the Thomas Hart Benton-Grant Wood variety (which Smith called "the new satin realism" and Adolph Gottlieb described as "The Corn Belt Academy") and an engagé social realism that was its urban equivalent. More importantly for Smith, advanced sculpture was even less visible than advanced painting. He knew the few Americans who were attempting to make challenging sculpture, such as Alexander Calder and Ibram Lassaw, and in later interviews he always spoke admiringly of them, but once again, their work did not have the authority for him that that of the Europeans did.

Smith's recollections of the 1930s were rather bleak: "One did not feel disowned—only ignored and much alone, with a vague pressure from authority that art couldn't be made here."[15]

Smith's own development reflects the variety of influences that surrounded him during his early years in New York. In Matulka's class, he produced paintings whose discrete interlocking shapes and flattened, compressed space demonstrate his assimilation of a Cubist vocabulary. Matulka's teaching encouraged the use of strongly differentiated textures to separate forms, and Smith's first experiments with affixing objects to his canvases, made while he was Matulka's student, were an outgrowth of this notion. These exaggerated collages became reliefs of a kind and, eventually, autonomous three-dimensional objects. From visual differentiation of forms by means of variations in texture, Smith arrived at literal differentiation of forms by means of physical separation. As he described the process: "The painting developed into raised levels from the canvas. Gradually, the canvas became the base and the painting was a sculpture."[16]

Smith made his first completely freestanding sculptures when he and Dehner "escaped" to the Virgin Islands for an eight-month stay in 1931 and '32. The fragile assemblages of coral and wire he

9

9. *Construction*, 1932
Wood, wire, nails, and coral, painted red,
blue, and yellow, 37⅛ x 16¼ x 7¼ in.
Collection of Candida and Rebecca Smith

made at this time seem to have more to do with recognizing human-
oid qualities in lumps of coral than with construction, but they
could be said to prefigure his later use of found objects and his
uncanny ability to animate even the most unprepossessing of those
objects.

When he returned to New York, Smith brought back a collec-
tion of coral and beach debris, and later that year he incorporated
this into a series of figurelike polychrome constructions. They 9
combine wood, wire, stone, and coral in a manner that at once
suggests Matulka's interest in textural differentiation and Smith's
own later fascination with the amalgamation of disparate parts.
Like his paintings of the period, the constructions testify to Smith's
interest in contemporary French modernism, particularly the work

of Picasso and Henri Laurens (which he saw reproduced in the magazines given him by Graham). Their relation to Smith's own later work is perhaps more interesting: in these constructions, the solid forms, differentiated from one another by varying materials and colors, are both supported and connected by cursive linear elements, like three-dimensional drawing. Smith used similar compositions of shapes and lines in his paintings of the time, but in the constructions, the way each solid element is angled in space is a clear indication that he was already thinking in plastic, sculptural terms, not translating from two dimensions.

Smith continued to make collagelike constructions the following year and, in addition, the carved pieces prompted by his work with the African sculpture collection. He was becoming increasingly dedicated to sculpture, but the critical influence seems to have been seeing González's metal sculptures reproduced in *Cahiers d'art*. Since he knew no French, Smith was unable to read the text, but the images and their materials impressed him greatly. At Bolton Landing, during the summer of 1933, he began to work at a forge and, according to his memoirs, to weld. He continued to work in metal when he returned to the Brooklyn Heights apartment. Dehner recalls following him around with a sprinkling can to quench the welding sparks, which threatened to set fire to the drawings tacked to the walls of the small living room that served as a studio. Shortly afterward, at Dehner's prompting, Smith moved into Terminal Iron Works, a commercial welding shop that made fire escapes for New York public schools, located at the foot of Atlantic Avenue, near his home. The welders allowed Smith to work there, helped him to improve his welding technique, and sometimes even gave him material to work with. It was a happy association and Smith remained there until 1940. He often spoke of his affection for the men at Terminal Iron Works, and their uncritical acceptance of his work. He described *Blackburn: Song of an Irish Blacksmith* (1949–50) as an homage to one of the welders and said he intended to do another, dedicated to Blackburn's colleague, Buckhorn. When the company moved from the Atlantic Avenue site to do war work, Smith stayed on, keeping the name Terminal Iron Works. He later gave his Bolton Landing property the name, partly out of sentiment and partly because its professional associations allowed him to establish credit and purchase materials more easily.

The concept of the factory as studio (and vice versa) had a lasting effect on Smith. It was not just that he liked the idea of making art with materials and methods associated with industry. When Smith first began to make forged and welded metal sculpture, the use of nonart materials was an act of faith, a declaration of being modern, as well as a way of arriving at new kinds of sculptural forms. Smith was sensitive to both aspects: "The material called iron or steel I hold in high respect. . . . What it can do in arriving at a form economically, no other material can do. The metal itself possesses little art history. What associations it possesses are those of this century: power, structure, movement, progress, suspension, brutality."[17] But the factory itself was ingrained in Smith's approach to sculpture making. His studios at Bolton Landing were built and outfitted with the functional economy of the mechanized

46

10

10. Smith at Terminal Iron Works

11. David Smith and Dorothy Dehner embarking for Europe, 1935

workshop, and his working habits throughout his life seemed to conform to the schedules of industrial production. The brief time he spent on the Studebaker assembly line, after his first year at college, set an early precedent; he even claimed that his aesthetics had been at least partly influenced by the experience: "In fact, my beginning before I knew about art had already been conditioned to the machine—the part of the whole, by addition. . . ."[18] The assembly line, which added part to part, had prepared Smith for the notion of collaged, constructed sculpture, structures made by accumulation of separate elements rather than by cutting away from a preexisting whole.

Working in metal allowed Smith a new kind of formal freedom and released a new kind of ambition in him. His metal sculptures of the fall of 1933 were his most audacious to date, their use of welding and of found objects a way of challenging Picasso and González on their own terms, not simply a reaction to their example. Smith's 1933 series of iron and steel heads may be the first of their kind made in the United States. While works such as *Agricola Head* and *Saw Head* may initially seem fairly straightforward descendants of Cubism, they also explore ideas that, in retrospect, seem particularly Smith's own.

12, 13

Smith transformed his found objects in a way that completely subverts their role in the work of his predecessors. The ball fringe and absinthe spoon of Picasso's constructions, like the wallpaper patterns and newspapers of his collages, were meant to declare themselves frankly as what they were. By calling attention to the everyday world, these inclusions were intended to make the painted or constructed planes that surrounded them seem more extraordinary and, at the same time, more convincing as a self-sufficient world with its own rules. The tension between the real and the made is a great part of the pleasure of these constructions. It is no accident that Picasso always adhered to the proper size of the images he built: the guitars, the *Glass of Absinthe*, and the still-life constructions are all life-size, while the oval of *Still Life with Chair Caning* of 1912 approximates the size and shape of a chair seat. In contrast, the shears and saw blade of Smith's *Saw Head* do not allude to any other reality. They disappear into their new context, subservient to the masklike head they evoke. In later works, such as the Agricolas, Smith made even greater efforts to transform his collaged objects, so that visually they simply became neutral components of the completed sculpture. (The farm machinery fragments contained within the Agricolas probably had some additional meaning for Smith, but their formal relationships dominate.)

Smith continued to employ both welding and forging techniques during 1933 and '34, in small-scale, usually horizontal sculptures that are closely related to his paintings of the period. They are less resolved and often less successful than the series of heads, appearing to be fairly literal, if diagrammatic, three-dimensional translations of the paintings and drawings, but they suggest that Smith was exploring what he could do, pictorially, with his new medium. He already knew what its structural capabilities were. There are not many pieces from these first years of Smith's production in iron and steel. Some have been lost, but Smith made relatively few pieces in

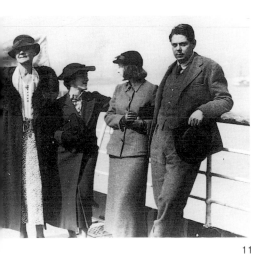

11

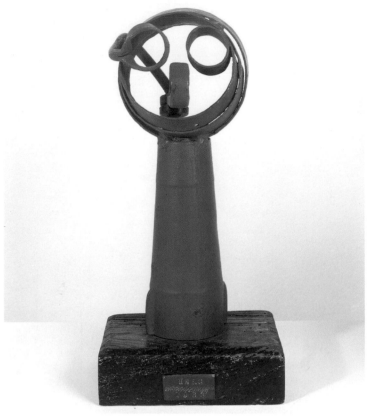

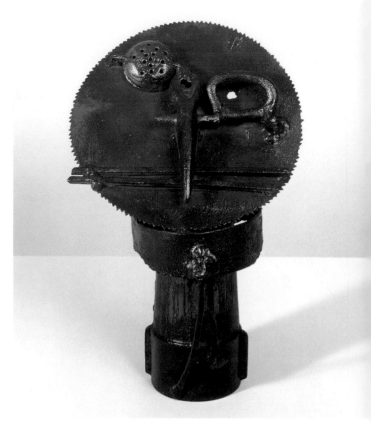

12 13

1933 and '34, and in 1935, he and Dehner left for Europe, where
they remained for almost a year.

It was Smith's first European trip, and the descriptions he wrote
in his notebooks bear witness to his having looked at and absorbed
a remarkable amount. John Graham met the couple in Paris and
served as a guide to the world of European modernism, even offer-
ing an introduction to Picasso. Smith refused because he didn't
speak French and because he had heard that he would have to
address Picasso as "maître," something he was unwilling to do.
The Smiths then traveled to Greece, where they stayed for several
months. In addition to his exhaustive study of museum collections
and gallery exhibitions, Smith drew and painted throughout the
trip. He also was able to make a bronze sculpture in Greece, which
he destroyed almost immediately because he was dissatisfied with
the casting.

The trip included a visit to the Soviet Union, whose politics and
brief official support of modernist art seemed to offer a provoca-
tive example to American artists living through the Depression. In
a sense, the Smiths were too late—a proclamation issued at the
first All Union Writers Conference in 1934 had already announced
the official jettisoning of the avant-garde—but they were at least
able to see the extraordinary collection of early twentieth-century
art at the Museum of Modern Western Art in Moscow.

The Smiths returned from Europe on July 4, 1936. For the next
four years, they divided their time between Brooklyn Heights and

12. *Agricola Head*, 1933
Iron and steel, painted red, 18⅜ x 10⅛ x
7¾ in.
Collection of Candida and Rebecca Smith

13. *Saw Head*, 1933
Iron, painted orange, and bronze, 18¼ x 12 x
8¼ in.
Collection of Candida and Rebecca Smith

14. *Structure of Arches*, 1939
Steel with copper and cadmium plating,
39½ x 49 x 30½ in.
Addison Gallery of American Art, Phillips
Academy, Andover, Massachusetts
Gift of Mr. and Mrs. R. Crosby Kemper, Jr.

Bolton Landing. Smith's works from this period are remarkable individually for their astonishing inventiveness and collectively for their restless investigation of a great variety of approaches and media. The span is from attenuated linear steel sculptures derived from such disparate themes as reclining nudes and studio interiors, to volumetric, often naturalistic forms in cast aluminum or forged iron. They encompass spatially complex works, such as *Structure of Arches*, that declare their independence from observed appearances, as well as the figurative bronze reliefs of the Medals for Dishonor.

14

Smith not only used different materials for different kinds of sculpture, but he also combined different materials in the same sculpture. Each material was used for its particular characteristics:

14

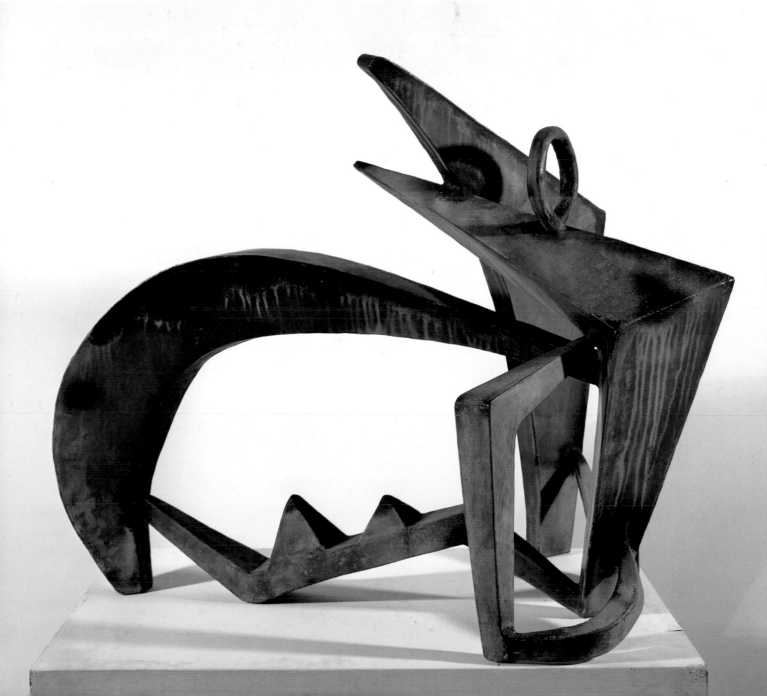

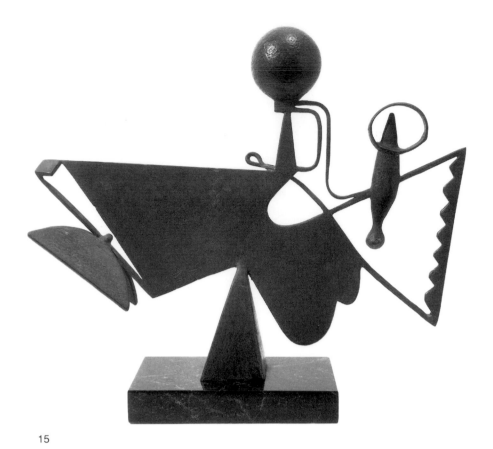

15

linear bars of steel, solid biomorphic forms cast from bronze, flat
planes of sheet metal, and so on. We have already seen this kind of
multiplicity in Smith's first wood, wire, and coral constructions. As
he continued to work in metal, he found ways of exaggerating the
subtle differences of color and surface inherent in his various
materials, by means of paint and patination. In the 1940s, for
example, he contrasted shiny bronze with black painted steel in
35 *Reliquary House* (1945) and green bronze with red rubbed steel in
47 *Royal Incubator* (1949) to emphasize the differences between parts
of the sculpture. The next step, of course, is Smith's problematic
use of polychromy. Throughout his career, he was fascinated with
the possibility of combining painting and sculpture, and alternated,
with varying degrees of success, among surface treatments that
unified, accentuated, or opposed three-dimensional structure. Smith
frankly admitted to the failure of most of his efforts at painted
sculpture, but was proud of the ones he felt were successful and
remained faithful to the idea.[19]

Smith's painting was not limited to coloring his sculpture. In his
early years, he continued to work extensively in many different
media, although by the late 1930s his emphasis was increasingly
17 on sculpture. The drawings from this period are typical sculptor's
drawings, inhabited by clearly defined, self-contained, *buildable*
forms. (Smith's drawings, not surprisingly, never wholly lost this
quality, but they did become more concerned with line and stroke,
less with the illusion of objects, in the 1950s.) Despite his growing
concentration on sculpture in the 1930s, however, Smith was cited
by John Graham, in *System and Dialectics of Art*, as one of the few
"young outstanding American painters" (along with Milton Avery,

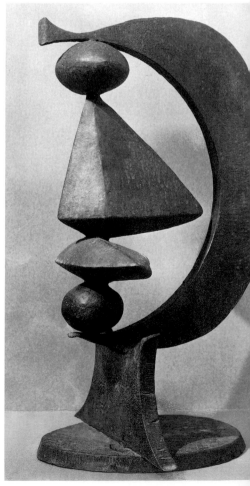

16

Willem de Kooning, and Edgar Levy).[20] The continuing duality of Smith's concerns is illustrated by the fact that his first one-man show, at Marian Willard's East River Gallery in 1938, consisted of both sculpture and drawings.

That Smith was increasingly finding his own voice becomes clear when we compare his sculptures of the late 1930s with work by the European modernists he admired. Giacometti's *The Palace* 19 *at 4 a.m.* was a major work that Smith certainly knew well, both from magazine reproductions and from its exhibition at the Museum of Modern Art.[21] It had a powerful effect on Smith, yet while works such as *Interior* (1937), *Interior for Exterior* (1939), and even *The* 108, 18 *Cathedral* (1950), have clear connections with the Giacometti piece, 130 they are equally remarkable for their evidence of Smith's individuality. Their differences are revealing. Smith largely ignored the surrealizing, symbolic aspect of the Giacometti and took its formal structure as his point of departure. *The Palace at 4 a.m.* is a logically constructed skeletal building made of wood, wire, glass, and string, populated by forms utterly different from their surroundings. Part of the work's mystery is due to its fragile materials and

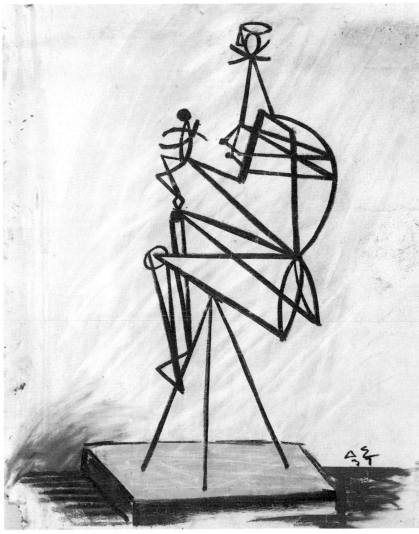

15. *Construction on a Fulcrum*, 1936
Bronze and iron, 14 x 17 x 3 in.
Willard Gallery, New York

16. *Head*, 1938
Cast iron and steel, 19¾ x 9⅝ x 11½ in.
The Museum of Modern Art, New York
Gift of Charles E. Merrill

17. *Untitled*, 1937
Pastel, 22 x 17 in.
Collection of Candida and Rebecca Smith

17

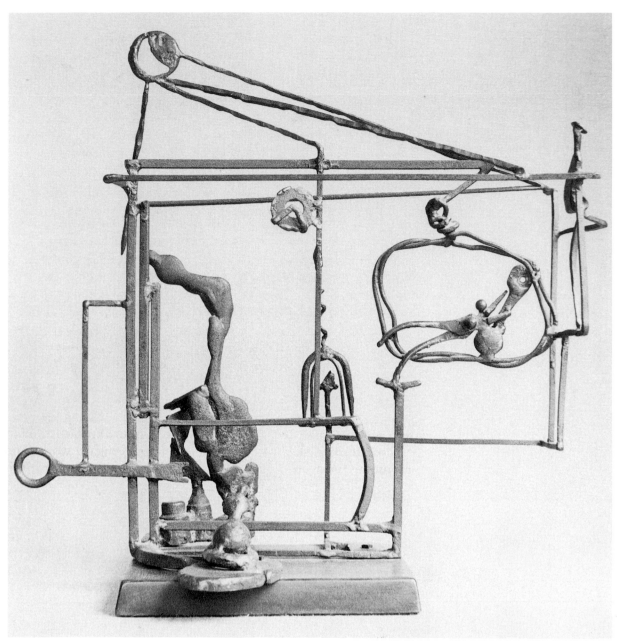

18

precarious construction, which suggest impermanence and imminent collapse. Smith appropriated Giacometti's imagery and linearity, but translated them into his own robust vocabulary, replacing European refinement with ad hoc transformations of unexpected materials. *Interior for Exterior*, for example, contains something very like a corkscrew—perhaps in lieu of the meticulously assembled "spine" of the Giacometti—while a flying pliers parodies *The Palace*'s prehistoric bird.

Both Smith's and Giacometti's sculptures are linear and drawing-like, but *The Palace* is that way because Giacometti chose to reduce architecture to a schematic framework; the thin elements of the piece are justified by the fact that buildings have slender supporting members. In Smith's sculptures, however, line functions inde-

18. *Interior for Exterior*, 1939
Steel and bronze, 18 x 22 x 23¼ in.
Mr. and Mrs. Orin Raphael

19. Alberto Giacometti
The Palace at 4 a.m., 1932–33
Construction in wood, glass, wire, and string,
25 x 28¼ x 15¾ in.
The Museum of Modern Art, New York
Purchase

pendently of rational descriptive needs. The central maze of *Interior*, for example, is not a logical diagram of a room and its contents, but a suggestive drawing tenuously related to the *idea* of a room and its contents. Smith's responses to Giacometti's example are less elegant and more pictorial than the work that provoked them. Since Smith saw the Giacometti sculpture, we cannot explain the pictorialism of *Interior* or *Interior for Exterior* by a supposed dependence on a two-dimensional reproduction; instead we must acknowledge it as evidence of Smith's making a deliberate choice.

While there is nothing surprising in Smith's fascination with the notion of a building or room as subject matter for sculpture, his close attention to the formal properties of a work by a Surrealist artist is rather unusual. More typically, Smith, like so many of his New York contemporaries at the time, seems to have been attracted to Cubist ideas of structure and indifferent to the look of orthodox Surrealism. Nevertheless, he was drawn to Surrealist ideas of content and to the intellectual justification of the movement. Again like so many of his New York colleagues, Smith adhered to the Surrealist view of the subconscious as the source of creativity, "that region of the mind from which the artist derives his inspiration."[22] While their formal language owes a debt to Cubism, works such as *Leda* (1938), with its mythological and sexual allusions, or the bronze Medals for Dishonor, with their nightmarish, symbolic images, explore conceptual territory different from Smith's more detached and objective figure constructions.

The fifteen Medals are Smith's most overtly engagé works and among the most unequivocal images of his career. Antiwar, antifascist, and anticapitalist, they offer, on one level, an immediate response to the advent of World War II; on another, they are an angry denunciation of all political and social violence. In them, Smith explicitly states themes that recur throughout his working life. We will meet repeatedly, albeit often in disguised, abstracted forms, the cannons, birds, composite monsters, eviscerated figures, even the fragmented architecture of the Medals.

Images of brutality and aggression are common enough in Smith's notebooks and sculpture, sometimes with a naked force approaching the Medals: a group of small bronzes of the early 1940s explores the cannon-rape theme, while the Spectres of the mid-40s savagely dissect heroic attitudes toward war. More generally, a phallic cannon and a related phallic cannon-bird are frequently repeated motifs. In some sculptures, these composite images become more recognizably phallus or cannon or bird, but even when they are not specifically legible, they inform later works. The looming, elevated birdlike sculptures of the 1950s, for example, seem more closely related to the threatening Spectres than to idealized images of flight, and the Zigs of the early 1960s evoke associations with fortresses and antiaircraft guns.

The Medals for Dishonor preoccupied Smith, off and on, for almost four years after his return from Europe.[23] A great many detailed preparatory drawings survive. Their insectlike figures and stylized landscape settings were derived, Smith later said, from Sumerian cylinder seals and a group of satirical war medals seen in the British Museum. It seems likely that the Sumerian objects were

19

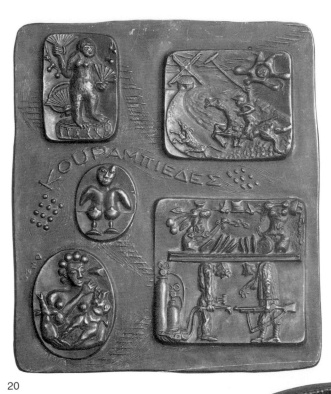

20

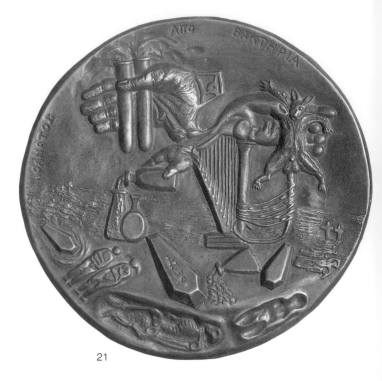

21

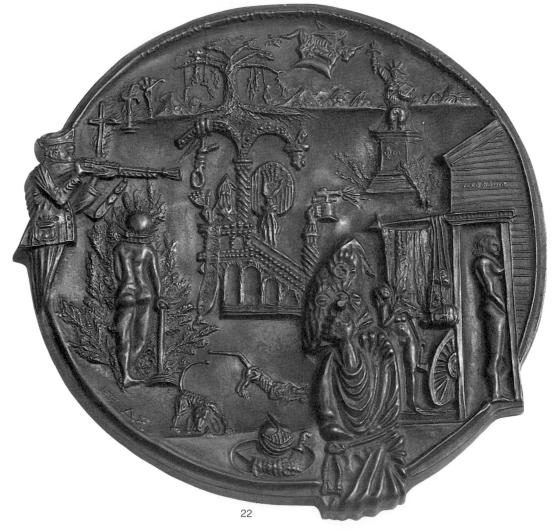

22

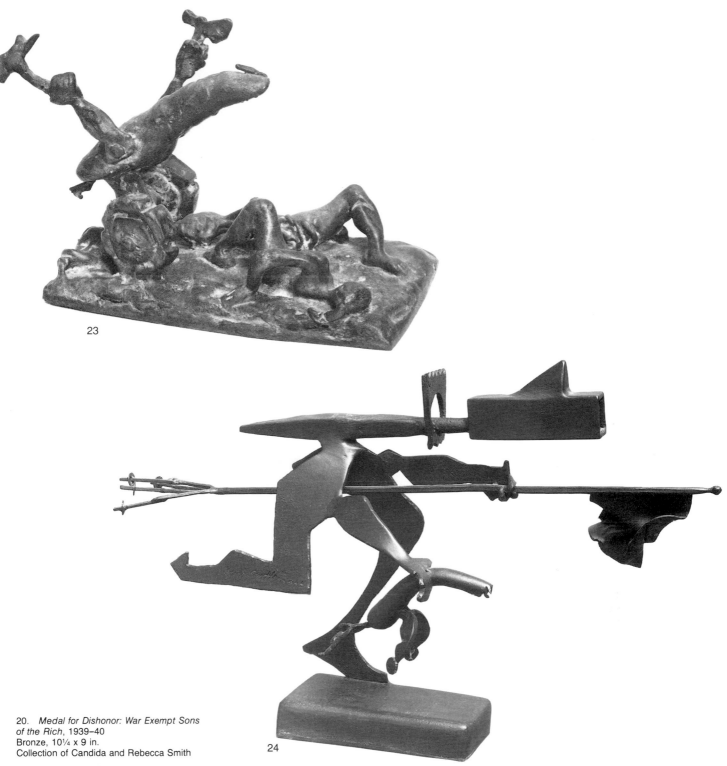

23

24

20. *Medal for Dishonor: War Exempt Sons of the Rich*, 1939–40
Bronze, 10¼ x 9 in.
Collection of Candida and Rebecca Smith

21. *Medal for Dishonor: Death by Bacteria*, 1939
Bronze, diameter: 10⅜ in.
Collection of Candida and Rebecca Smith

22. *Medal for Dishonor: Private Law and Order Leagues*, 1939
Bronze, 10½ x 10½ in.
Collection of Candida and Rebecca Smith

23. *Atrocity*, 1943
Bronze, 5½ x 6¾ x 8 in.
Private collection

24. *War Spectre*, 1944
Steel, painted black, 14½ x 6¾ x 22⅝ in.
Museum of Fine Arts, Houston, Texas

among those that triggered recollections of the illustrations in his childhood bible; it is obvious that the imagery of the Medals taps Smith's deepest feelings and most intense beliefs. When they were exhibited at the Willard Gallery in 1940, he provided each one with a poetic explanation. Whatever the shortcomings of the Medals, compared to Smith's other sculpture of the period, there is no doubt that he attached a great deal of importance to them, to their meaning and to insuring that that meaning was unambiguous and comprehensible.

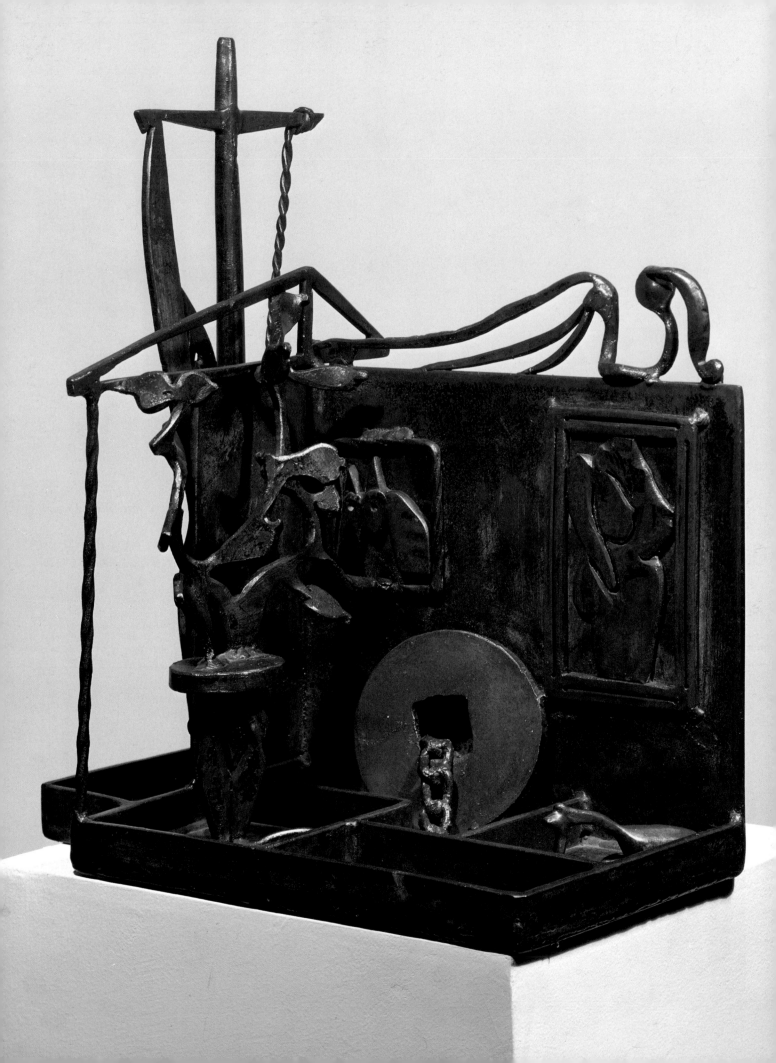

2 The 1940s

In 1940 the Smiths moved permanently to Bolton Landing. The rather primitive, rigorous life of the farm appealed to them. Dehner remembers that they grew vegetables, planted an orchard, and raised chickens, with the help of pamphlets from the Department of Agriculture. Smith hunted—and worked as a machinist in Glens Falls. The Smiths presumably hoped for more self-sufficiency than they had had in the city, to allow both of them to concentrate on painting and sculpture, but their new life at Bolton Landing was almost immediately altered by the United States' entry into World War II.

In spite of his profound antifascism, Smith was not enthusiastic about the possibility of being drafted. In a letter to his dealer, Marian Willard, dated September 22, 1940, he wrote: "I must stay out of an army camp. It would spoil my work and ruin me as well." Dorothy Dehner suggests that Smith was acutely aware of the violent side of his nature and feared what licensed, organized violence might do to him.

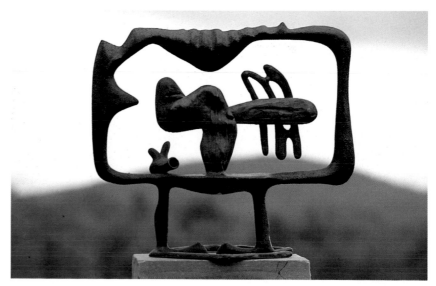

25. *Home of the Welder*, 1945
Steel, 21 x 17⅜ x 13⅝ in.
Collection of Candida and Rebecca Smith

26. *Head as a Still Life*, 1940
Cast iron and bronze, 15½ x 17½ x 7¾ in.
Collection of Candida and Rebecca Smith

26

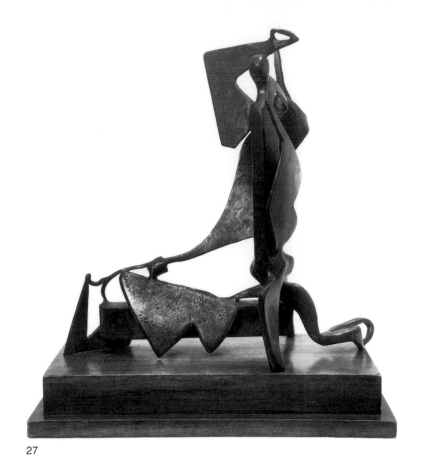

27

Smith tried hard to find a means of contributing his abilities as a sculptor to the war effort, including applying for a job in the design department of the American Locomotive Company in Schenectady. He was unsuccessful, but in 1942 he was hired by them as a welder and remained until 1944. He lived in Schenectady and spent weekends at Bolton Landing working on maquettes for small bronzes. Otherwise, he had little time for sculpture, and metal, in any event, was difficult to obtain. As a result, a large number of drawings from this period are carefully and elaborately worked out, surrogates for finished sculpture.

Smith managed to try his hand at carving, using power tools to
29 cut stone at a tombstone works in Saratoga. *Sewing Machine* (1943) is one of the few pieces that remain of the series, since he was never happy with marble as a medium. The notion of cutting away, rather than assembling elements, was antithetical to Smith. At the locomotive plant, he welded stainless steel armor plate on tanks. He was always fond of drawing parallels between his jobs as a machinist and welder and his life as a sculptor; in this case, the experience is reflected directly in his later use of stainless steel in some of his major works of the 1950s and '60s. It is a recalcitrant medium, demanding special skills that Smith undoubtedly perfected in Schenectady.

In 1944 Smith was called up, in spite of his employment in a war-related industry. To his relief, he was found physically unfit, because of sinus trouble. He left the locomotive plant soon after, finally able to return to full-time sculpture making and to realize in three dimensions the ideas he had pursued as drawings. The mar-
25, 34 velous *Home of the Welder* (1945), with its "millstone which

27. *Bathers*, 1940
Cast iron and bronze, 14 x 14 x 8 in.
Willard Gallery, New York

28. *Head as a Still Life I*, 1942
Cast aluminum, 8½ x 12 x 4½ in.
Des Moines Art Center
Gift of Jesse R. Fillman, Boston, in honor of
James S. Schramm, 1977

29. *Sewing Machine*, 1943
Danby Blue Marble, 13¾ x 23¼ x 2½ in.
Mr. and Mrs. Bernard Lewis, Los Angeles

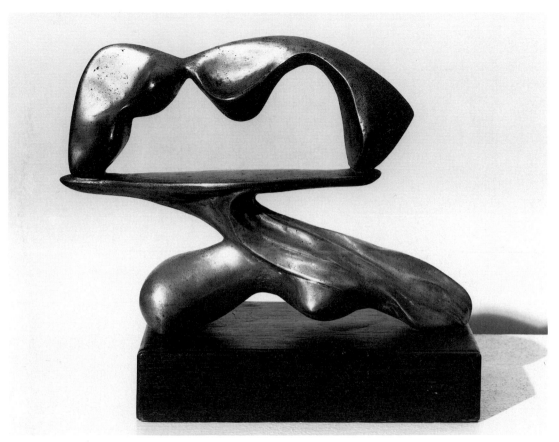

28

29

30

hangs around his neck related to his job," is perhaps the most directly related to the years at the locomotive factory. The enormous variety, high quality, and sheer numbers of sculptures made in 1945 and '46 make them landmarks of Smith's early production. There are pieces that are startling for their physical density and for the density of their allusions, and there are others, no less complex, that present related themes with great economy and sparseness. They range from the tactile, modeled bronze and politically slanted content of *Spectre Riding the Golden Ass*, to the uncompromising two-dimensionality and neutral, studio imagery of *Steel Drawing I*. The latent surrealizing element of Smith's work of the 1930s becomes more overt in these sculptures, but at the same time, less specific. The private symbolism of works such as *Pillar of Sunday*, *Reliquary House*, and *Spectre of Mother* makes them more sug-

30. *Spectre Riding the Golden Ass*, 1945
Cast bronze, 11¾ x 12¼ x 4 in.
The Detroit Institute of Arts
Gift of Robert H. Tannahill

31. *Steel Drawing I*, 1945
Steel, 22¼ x 26 x 6 in.
Hirshhorn Museum and Sculpture Garden,
Smithsonian Institution, Washington, D.C.

31

gestive, more ambiguous, and more open to multiple interpretations than any previous works. As a group, they are surprisingly inventive, as though Smith were deliberately testing the limits of what sculpture could be. Instead of the relatively traditional heads and figures of his prewar years, he tackled such unprecedented themes as hermetic containers (*Reliquary House*), totemic displays (*Pillar of Sunday*), and landscapes (*Landscape with Strata*). Single heads and single figures recur as well, but in spatially ambiguous guises—*Head as a Figure*, for example. But while I would not discount Smith's sculptural inventiveness, I believe that the intense expressiveness of these pieces (and the obsessive notebook drawings that relate to them) suggest a kind of childlike lack of detachment in their making. Distanced, critical judgment was obviously at work in making final decisions, but these are intuitive, charged

113

33

32

structures—cathartic sculptures about working in order to feel better. Just as the child who draws a landscape or outer space battle inhabits that scene as he creates it, so Smith seems to have inhabited, and consequently animated, the forms he was inventing.

The potency of *Home of the Welder*, for example, depends a great deal on the arresting idea of sculpture as an open box with things in it; a great deal on the unexpectedness of the things within that box, on the interplay of such images as mast, plant, and a "wife made of locomotive parts"; and finally, a great deal on the wordless emotional associations that these juxtapositions evoke. Dorothy Dehner has perceptively suggested that abstraction appealed to Smith as a disguise, a way of making use of his strongest feelings without revealing himself entirely, as more specific imagery

32. *Spectre of Mother*, 1946
Steel and stainless steel, 20⅜ x 23⅝ x 9¼ in.
S. M. Feldman

33. *Head as a Figure*, 1945
Steel, painted cobalt green, 16 x 9 x 17½ in.
Private collection

34. *Home of the Welder*, rear view
See plate 25

35. *Reliquary House*, 1945
Bronze and steel, painted black, 12½ x 25½ x 11¾ in.
Mr. and Mrs. David Mirvish, Toronto

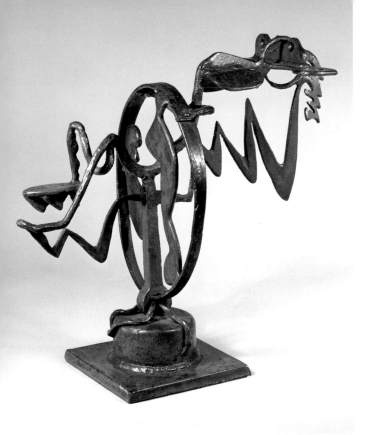

33

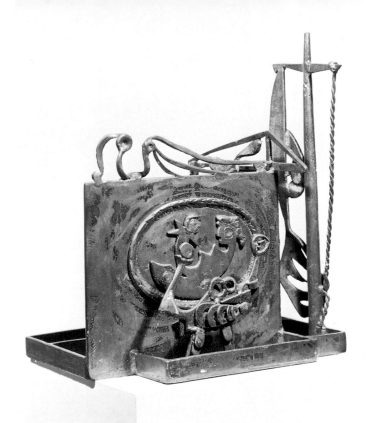

34

35

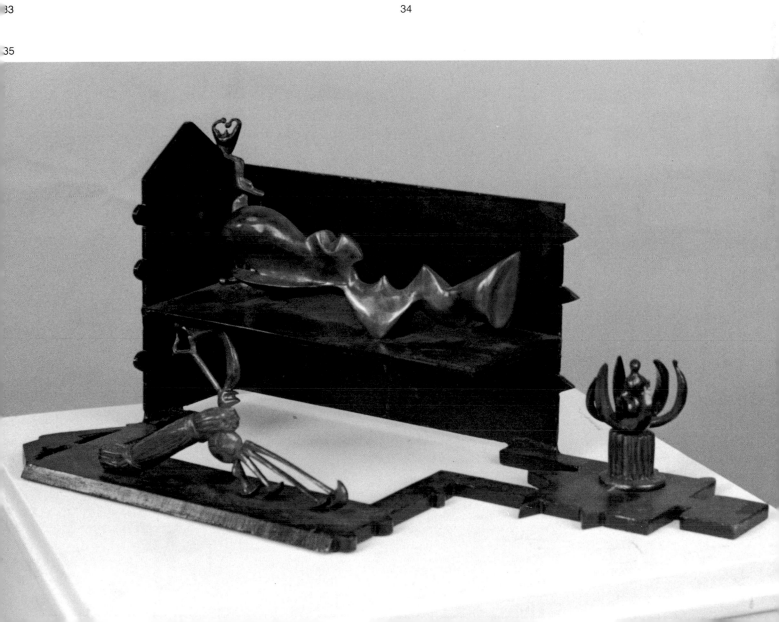

would. It also permitted him greater freedom of invention, allowing him to fuse many images in one, and gave license to an enriching ambiguity.

37, 38　　Smith's detailed, annotated drawings for *Home of the Welder* tell us that at least some of its images were suggested by men's room graffiti, but the sculpture's tight, roomlike compartments and the way we must peer down into them make it seem likely that Smith was also thinking of the Metropolitan's collection of Egyptian

36　building models of the Eleventh Dynasty. These domestic miniatures—houses, gardens, a bakery, and even a slaughterhouse complete with victims—were buried with their owner in order to perpetuate his everyday comforts. Smith's notebooks document his interest in Egyptian objects, especially those having to do with mummification and burial, and he later referred quite explicitly to

40　canopic jars for the storage of viscera in some sculptures of the 1950s. At about the time he made *Home of the Welder*, he dealt more abstractly with a similar theme of enclosure and display in *Reliquary House*. This sculpture has been convincingly linked to both a seventeenth-century engraving illustrating the influence of the moon on women and a medieval reliquary (a reliquary, like a canopic jar, is a repository for material that has been preserved and sanctified).

Even apparently simple works of this period reveal suprisingly diverse sources. *Spectre Riding the Golden Ass* (1945) was identified by Smith as being about "the false values and evils of our civilization . . . a vulgar broken winged spectre blows a trumpet through the mouth of a broken-down but golden ass, loud brass and false noises."[24] The spectre is a familiar Hieronymous Bosch-

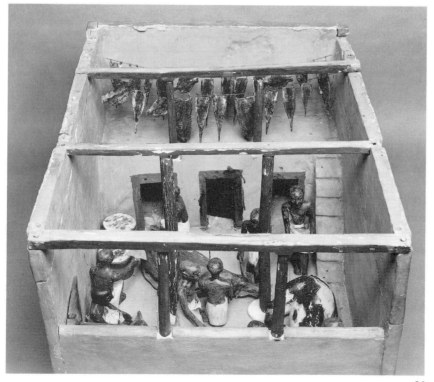

36

36. *Funerary Furnishings—Slaughterhouse Model, Tomb of Meket-Re*
The Metropolitan Museum of Art, New York, Museum Excavation, 1919–20
Rogers Fund supplemented by contribution of Edward S. Harkness

37. *Sketch for "Home of the Welder,"* 1945
India and blue inks with white tempera and brown wash over graphite and touches of red pencil, 10 x 7¼ in.
Fogg Art Museum, Harvard University, Cambridge, Massachusetts
Gift of David Smith

38. *Sketch for "Home of the Welder,"* 1945
Pen and wash with india and blue inks over graphite on white paper, 10 x 7¼ in.
Fogg Art Museum, Harvard University, Cambridge, Massachusetts
Gift of David Smith

39. *Untitled (Home of the Welder)*, 1946
Tempera on paper, 22¾ x 29 in.
Collection of Candida and Rebecca Smith

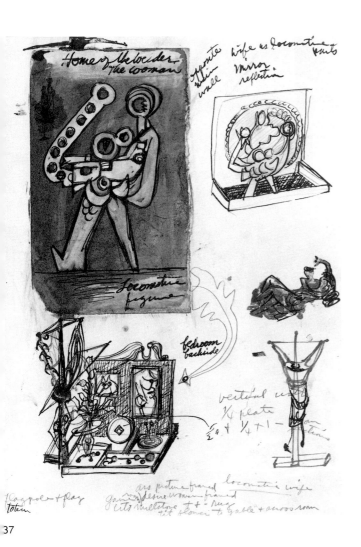

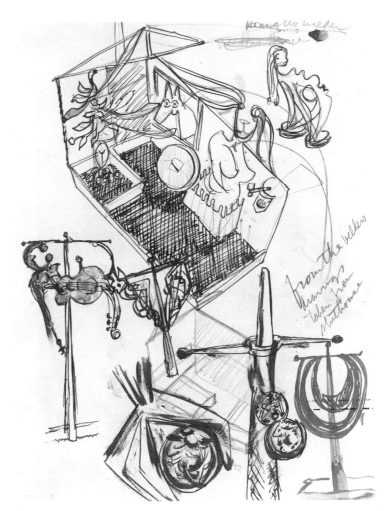

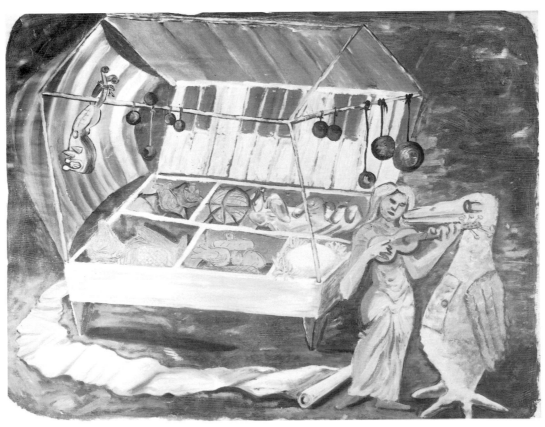

39

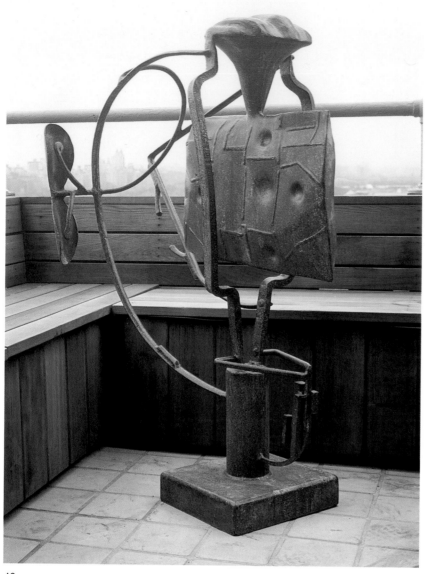

40

style hybrid, a relative of Smith's recurring cannon-phalluses and embryo-bird-fish-phalluses. The ass, with its open mouth, flaring nostrils, and stretched ears, owes a great deal to Picasso's tortured horses; its collapsing pose is almost identical to that of the gored horses in the drawings related to *Guernica*. The image of the horrifying rider also has precedents in Picasso's *The Dream and Lie of Franco*, while Smith's notebooks suggest an unexpected connection with a thirteenth-century German aquamanile shaped like a lion-centaur, in the collection of the Metropolitan Museum. The point is that these various and overlapping sources cannot be isolated. Smith assimilated them all. Their reverberations serve to inform, but neither to define nor explain his sculpture.

Smith exhibited regularly during the 1940s and by the end of the decade he had acquired a small group of admirers. He sold few pieces, and those mostly to friends and acquaintances, but some of the sales during this period were significant. The Museum of Mod-

40. *Canopic Head*, 1951
Steel, 44 x 33 x 18½ in.
Ted Ashly

41. *Pillar of Sunday*, 1945
Steel, painted pink, 30½ x 18 x 9½ in.
Indiana University Art Museum, Bloomington

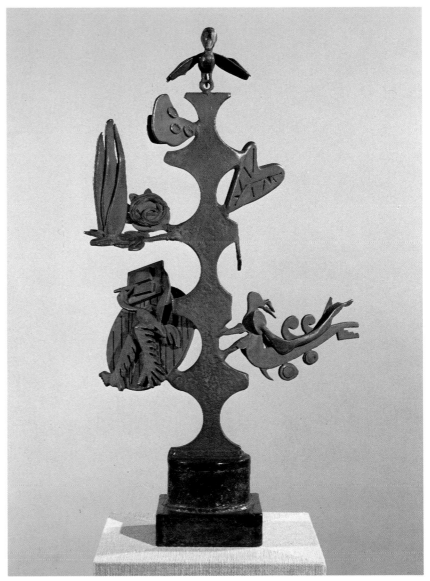

41

ern Art was given a 1938 head (admittedly a modest work) in 1943; in 1946 the Whitney Museum of American Art purchased *Cockfight Variation*; in 1947 the Detroit Institute of Arts was given *Spectre Riding the Golden Ass* and the Saint Louis Art Museum acquired *Cockfight*. In 1946 Joseph Hirshhorn bought several of Smith's early works, the first of a group now in the collection of the Hirshhorn Museum and Sculpture Garden. Most of the articles written about Smith during these early years dedicate more space to the sculptor's size and bulk and to the fact that he made art with industrial methods than to the work itself, but as early as 1943 Clement Greenberg wrote some of the first insightful and enthusiastic reviews of Smith's sculpture. In *The Nation*, January 23, 1943, he wrote: "Smith is thirty six. If he is able to maintain the level set in work he has already done, he has a chance of becoming one of the greatest of all American artists." In 1944 Marian Willard's husband, Dan Johnson, introduced Greenberg

and Smith, and a close friendship developed. Greenberg's responses to the sculpture were important to Smith for the rest of his life, and Greenberg's writings on the works remain some of the most sympathetic and illuminating.

After the war there were significant changes in Smith's life and work. Privately the late 1940s were a painful time. Despite the optimistic note sounded by the Smiths' designing and building a new studio and a new "mouseproof" house to replace their old wooden farmhouse, the couple separated permanently in 1950. Professionally, however, it was a time of great achievement and slowly increasing reputation. After about 1947 Smith began to be offered teaching and lecturing positions; although they were welcomed and accepted chiefly for financial reasons, they were also indications of some sort of recognition.

More substantial recognition came in 1950, when Smith was awarded a Guggenheim Foundation Fellowship, which was renewed in 1951. It was a major award, carrying with it great prestige and—more practically—the means to allow Smith to work uninterruptedly and to acquire materials in unprecedented quantities. The increased size of the works of this period and Smith's use of expensive stainless steel in some of these large pieces were direct results of the short-lived financial security afforded him by the Guggenheim. He had always wanted to make large sculpture; the modest scale of his works of the 1930s and '40s was as much a function of economy as it was of technology or aesthetics. As Smith pointed out in a later interview: "The greatest part of American art in the

42

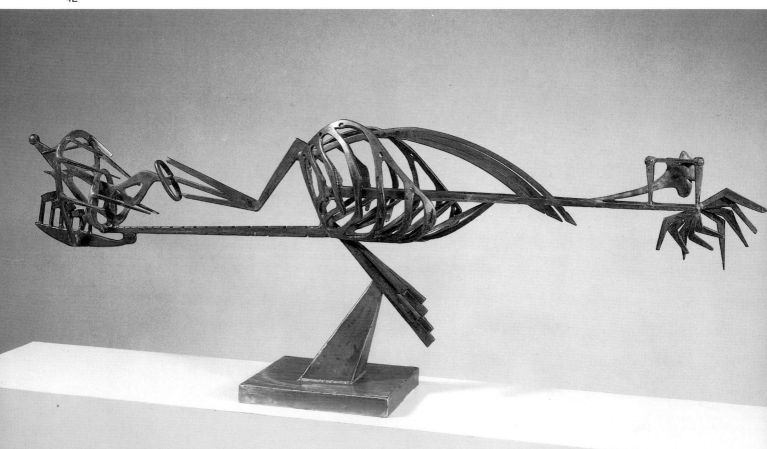

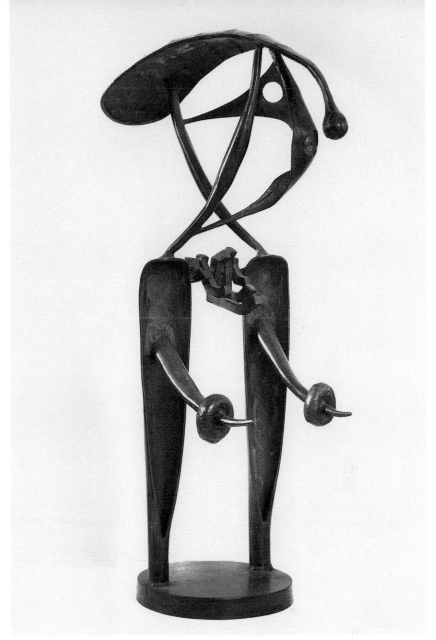

43

1930s and 1940s and even the 1950s was never built because the artists didn't have enough money to make them bigger and greater."[25]

Especially after his liberation from the locomotive plant, Smith was prolific and productive, but after 1950, his pace of work notably quickened. It was partly a result of not having to work full time at other jobs—for the most part he was able to support himself with intermittent teaching or lecturing—but he also simply worked more. He produced approximately two hundred fifty sculptures between 1950 and 1960 (to say nothing of hundreds of paintings and drawings), a number that means more when we see that in the ten years preceding 1950, he had made fewer than one hundred sculptures.

Smith's work increased dramatically in scale during this period, not simply because each sculpture was larger, but because it was made up of larger, simpler elements. His approach seems to have become less premeditated and more improvisatory. He made fewer careful preparatory drawings and included fewer (and less complex)

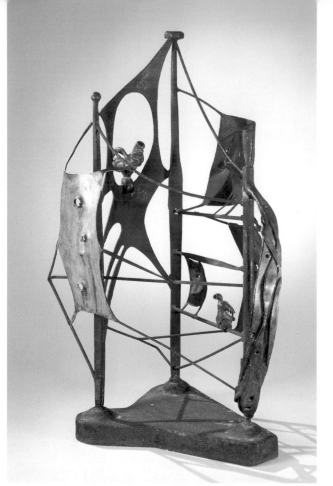

44

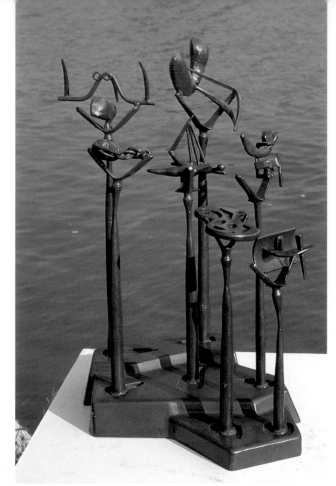

45

46

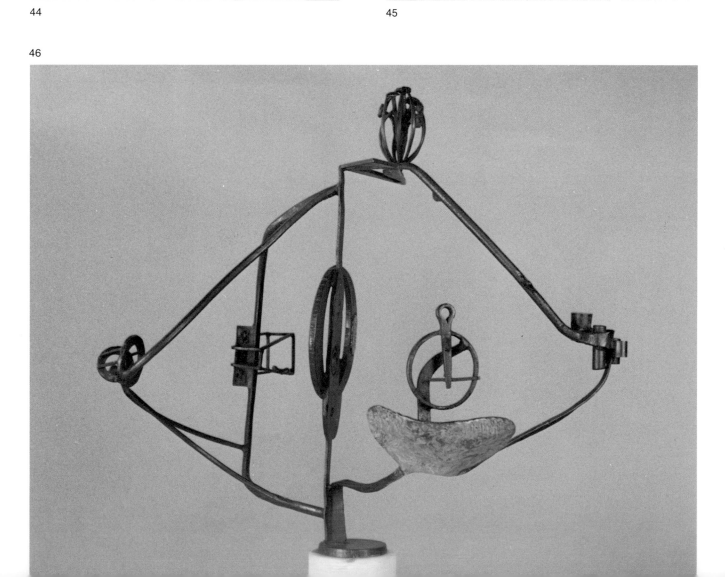

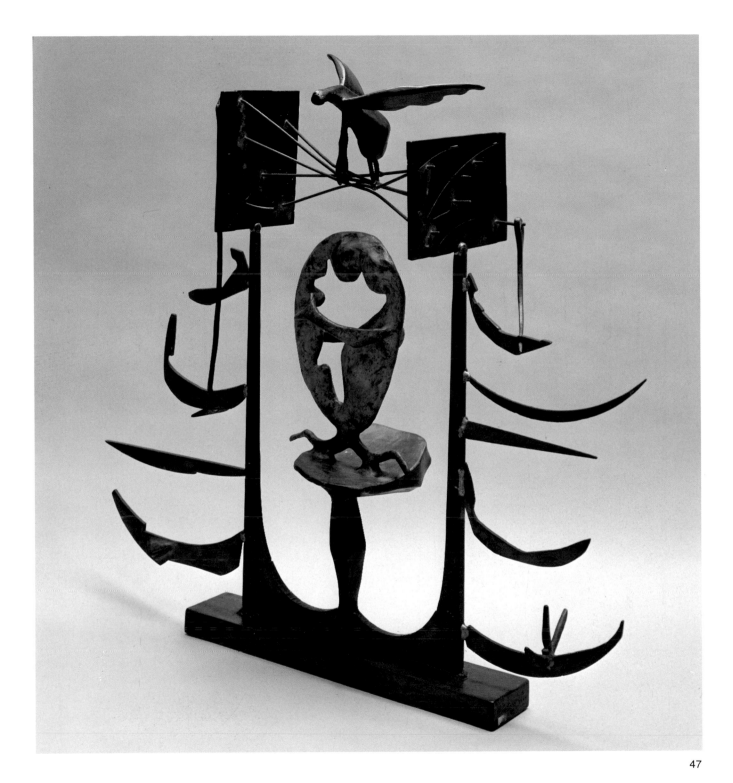

47

44. *Eagle's Lair*, 1948
Steel and bronze, 34¾ x 19 x 21¼ in.
Toby and Rita Schreiber

45. *The Sacrifice*, 1950
Steel, painted brown with a reddish cast,
31⅝ x 19⅝ x 20⅞ in.
Harold E. Rayburn

46. *Blackburn: Song of an Irish Blacksmith*,
1949–50
Steel and bronze, 46¼ x 40¾ x 24 in.
Wilhelm-Lehmbruck-Museum, Duisberg, West
Germany

47. *Royal Incubator*, 1949
Steel and bronze, partly rubbed with red oxide,
37 x 38⅜ x 9⅞ in.
Mr. and Mrs. Bagley Wright

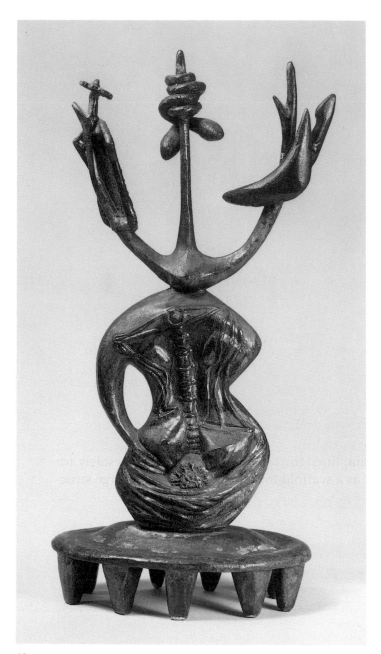

48

49

46

specially forged or cast elements, preferring to work more directly and spontaneously with the steel and found objects of his stockpiles. He seems to have become even more willing to depend upon unexpected juxtapositions suggested by his materials themselves, rather than upon preconceived images, so that the intricate, *made* "glyphs" of *Pillar of Sunday* or *The Sacrifice* were replaced by the boldly sliced and manipulated farm implements of the Agricolas. 45

In the mid-1940s, in works such as *Pillar of Sunday* or *Home of the Welder*, Smith frequently appears to have thought of the large structure of his sculpture primarily as an untraditional means of supporting and unifying groups of these allusive glyphs. It was an approach not unlike that of his friend Adolph Gottlieb, whose Pictographs of the 1940s were based on a schematic grid that served to organize, but not contain, a lexicon of suggestive forms. Like Smith's modeled and cast sculptures of the period, such as *Perfidious Albion* (1945–46), his glyphs are not insubstantial, pictorial objects, but discrete, fetishlike *things*, usually quite complex and realized in the round. However disguised and ambiguous, these forms often seem to be the carriers of the symbolic, implied content of the sculpture. In many works, a variety of linear structures display or enclose the glyphs, without taking precedence over them, but in the larger pieces of the late 1940s, these relatively neutral "supports" become more expressive and dominant, as in *Blackburn* or *Royal Incubator*. By the early 1950s the glyphs are 46,47 either completely subsumed by the larger structure, or disappear. No matter how simplified the sculpture, it seems to exist solely for its own sake, not as a scaffold for references. Yet these large structures are neither neutral nor arbitrary; they in turn take on the composite, expressive qualities of the glyphs. Instead of supports for small units of meaning, we are confronted by large constructions that seem at once unlike anything familiar and laden with allusive overtones.

Although Smith's work never lost the sense of highly charged persona that had characterized even his earliest pieces, the new economy and larger scale of his sculptures of the 1950s combined to make them appear more abstract, or at least less specific, than any of his earlier production. The shift toward greater abstraction was not sudden—Smith's work had rarely been literal—nor did he abandon his previous imagery or formal concerns; but in many respects, the sculpture he made after about 1951 can be seen as belonging to a new phase of his evolution. It is more ambitious and assured than what preceded it, and, without undervaluing the best of the earlier pieces, it is often even more inventive.

48, 49. *Perfidious Albion*, 1945–46, two views
Bronze and cast iron, green patina made with acid, 14⅜ x 4½ x 2⅝ in.
Dorothy Dehner

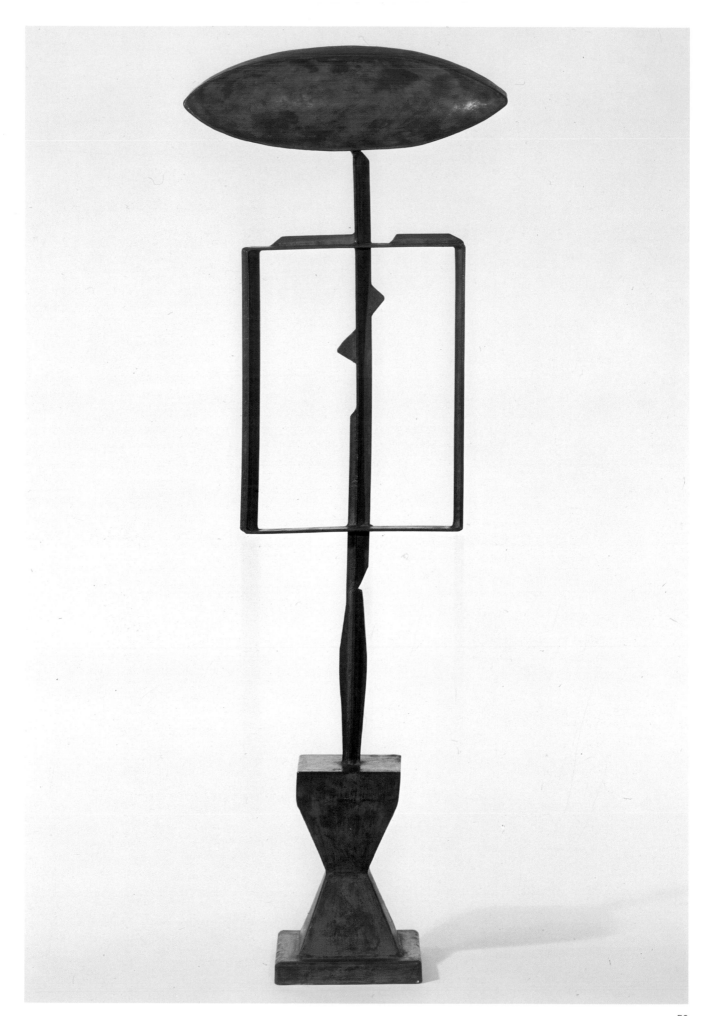

3 The 1950s

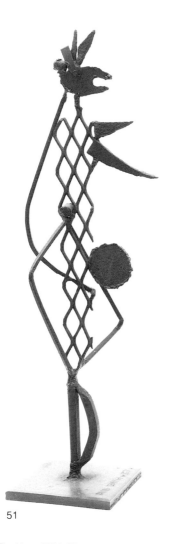

51

50. *The Hero*, 1951–52
Steel, painted with red lead, 73¾ x 25½ x
11¾ in.
The Brooklyn Museum
Dick S. Ramsay Fund

51. *Vertical Figure (Construction
Perpendicular)*, 1937
Steel and iron, 24½ x 6⅞ x 6 in.
Kenneth Noland

In the 1950s we can see the genesis of many of Smith's major themes—not, as in earlier works, as suggestions legible with the advantage of hindsight—but in clearly realized forms. There are the extraordinary pictorial landscapes and tableaux, such as *Hudson River Landscape* (1951); the great hovering, predatory steel drawings, such as *Australia* (1951); and the looming, upright "figures" such as *The Hero* (1951–52) and the Tanktotem series. By this time, too, Smith had established one of the outstanding characteristics of his sculpture: its liberation from the pedestal. Even in his early works, which, because of their small size, were meant to be mounted on something, Smith had often made the way the sculpture touched its support into a significant, expressive element. (He also made plinths for these sculptures to rest on and even designed zigzag, Brancusi-like columns as supports.) As the work increased in scale, the elements required to hold the piece up were increasingly integrated as part of the piece itself. Their supporting function was never disguised. If anything, the forthright "stalks," tripods, pallets, and wheels of Smith's mature work *emphasize* the fact that the sculptures rest upon the ground, as we do and as the ordinary objects of our world do. But whether elevated on a stick, or delicately balanced on legs, or poised on wheels, Smith's mature work, unlike that of any of his predecessors, occupies our own space, instead of being physically isolated on a pedestal. As a result, if it is to succeed, it is forced to declare its otherness from the ordinary, to establish its own psychological and visual distance, while we are forced to acknowledge that otherness and distance.

In the 1950s, too, Smith began to associate works in series, loosely grouping the rather disparate permutations of a particular notion by means of serial titles and numbers. This bringing together of often quite different works under similar titles can create a misleading notion of how Smith arrived at these groupings, and even where there is an evident continuity of concerns, it must be emphasized that Smith did not work in series in the usual sense of the term. The Agricolas, Tanktotems, and Sentinels, for example, were not made sequentially, in a systematic exploration of related configurations; they are repeated declarations of preoccupations

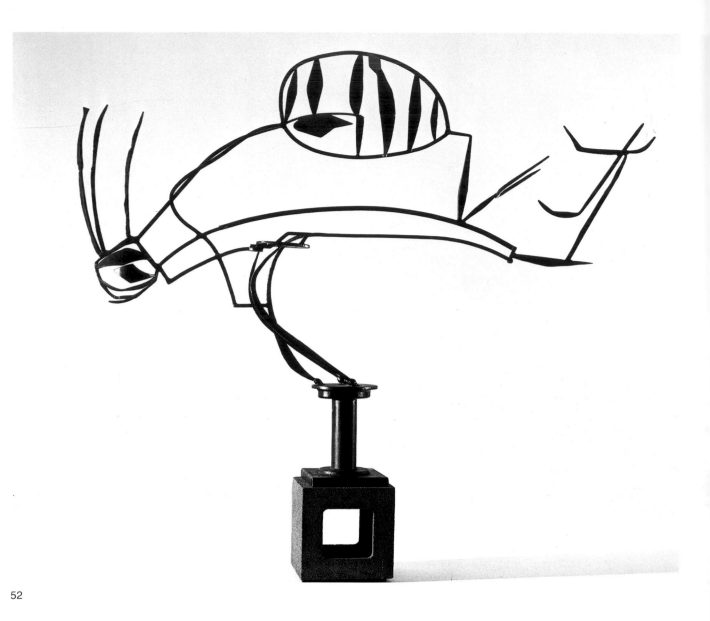

52

or obsessions in various guises. The sixteen Agricolas were made at intervals between 1952 and 1959, the ten Tanktotems between 1952 and 1960, and the nine Sentinels between 1956 and 1961. As a series, the Agricolas derive their unity more from the fact that each incorporates objects scavenged from farm machinery than from a strong family resemblance. The Sentinels are equally elusive as a group, ranging from narrow, stacked towers of painted steel to frontal arrangements of intersecting stainless steel planes.[26]

The Sentinels, in fact, exemplify the difficulties that the notion of series raises within Smith's work. Not only are they quite different from one another, but they are not easily separated, conceptually or formally, from the rest of Smith's work of the 1950s. In spite of his insistence on the special kinship of the Sentinels, the isolated, upright "figure" is one of his dominant themes, extending beyond the confines of any one group and becoming, in fact, his major preoccupation. We see it first, on a smaller scale, in early
51 works such as the 1937 *Vertical Figure* (*Construction Perpendicular*), then, much larger and less playfully, as *The Hero*. Throughout the 1950s, the image recurs in the casually associated group of

52. *Australia*, 1951
Steel, painted brown, 79½ x 107⅞ x 16⅛ in.
Museum of Modern Art, New York
Gift of William Rubin

53. *Star Cage*, 1950
Various metals, painted dark blue, 44⅞ x
51¼ x 25¾ in.
University Art Museum, University of
Minnesota, Minneapolis
John Rood Sculpture Collection

54. *Agricola I*, 1951–52
Steel, painted red, 73½ x 55¼ x 24⅝ in.
Hirshhorn Museum and Sculpture Garden,
Smithsonian Institution, Washington, D.C.

55. *Hudson River Landscape*, 1951
Steel and stainless steel, 49½ x 75 x 16¾ in.
Whitney Museum of American Art, New York
Purchase

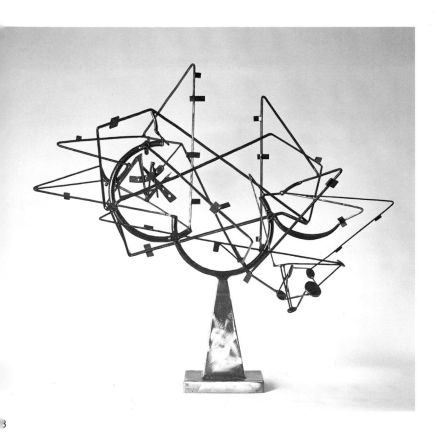

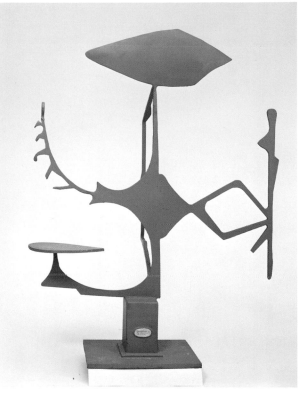

54

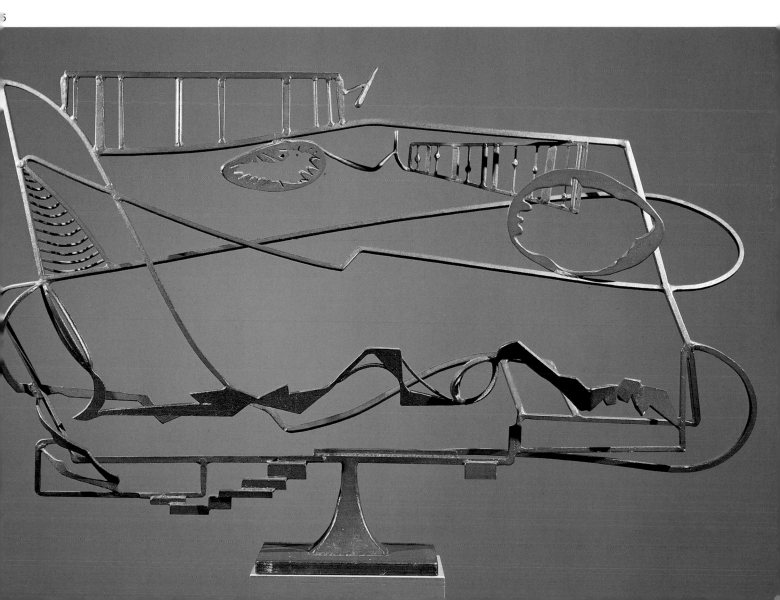

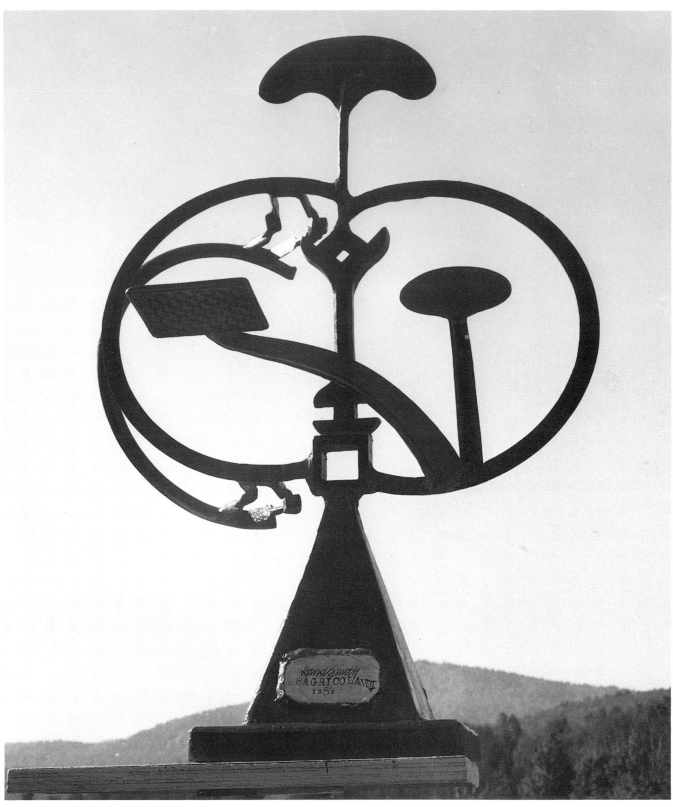

56

56. *Agricola VIII*, 1952
Steel and bronze, painted brown, 31¾ x
21¼ x 18¾ in.
Collection of Candida and Rebecca Smith

57. *Agricola IX*, 1952
Steel, 36¼ x 55¼ x 18 in.
Collection of Candida and Rebecca Smith

58. *Agricola XIII*, 1953
Steel and stainless steel, 33½ x 42 x 10½ in.
Dr. and Mrs. Arthur E. Kahn, New York

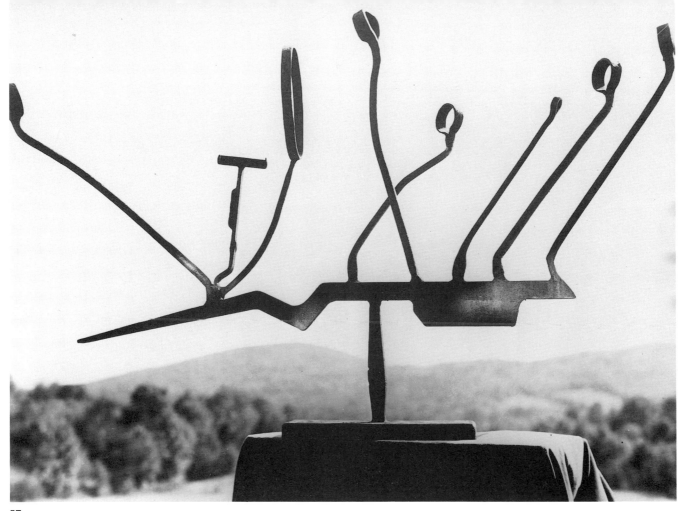

57

58

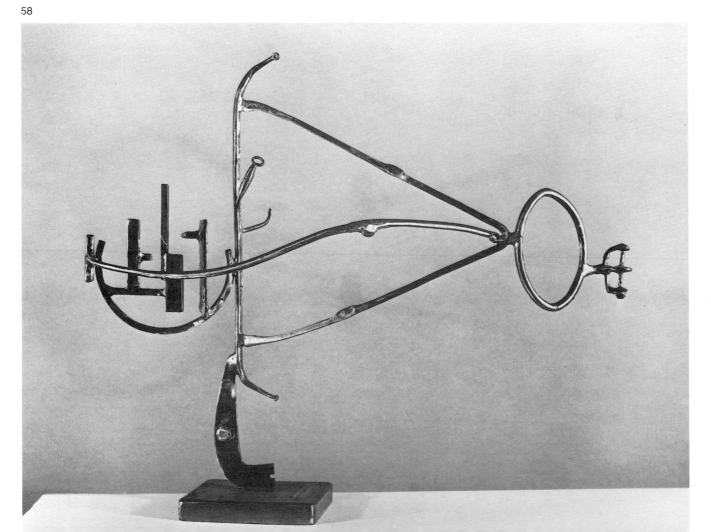

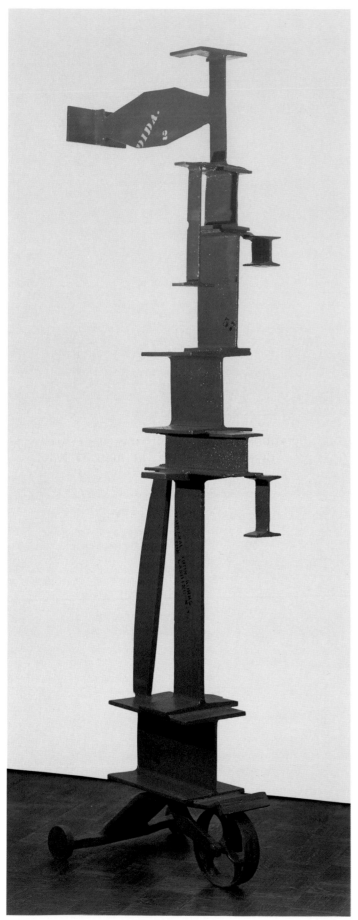

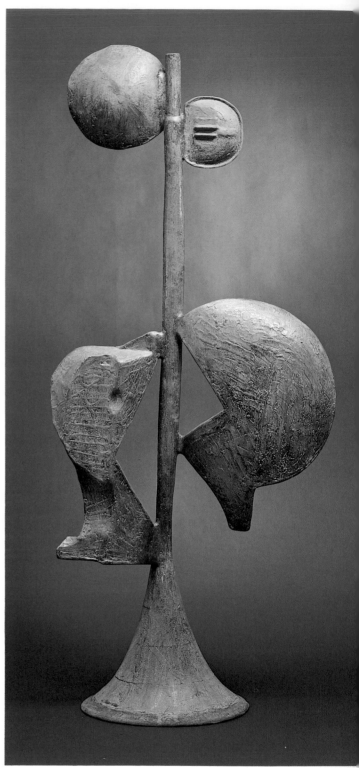

60

59. *Sentinel III*, 1957
Steel, painted red, 83¾ x 27 x 16¼ in.
Private collection, Boston

60. *Auburn Queen*, 1959
Bronze, 86⅜ x 36¾ x 21⅝ in.
Hirshhorn Museum and Sculpture Garden,
Smithsonian Institution, Washington, D.C.

61. *History of Leroy Borton*, 1956
Steel, 88¼ x 26¾ x 24½ in.
The Museum of Modern Art, New York

59

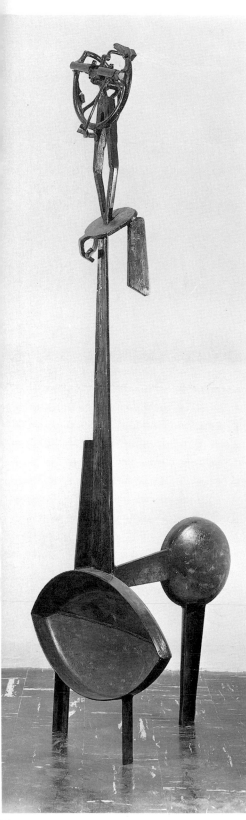

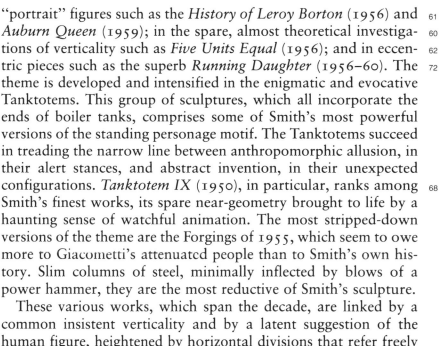

"portrait" figures such as the *History of Leroy Borton* (1956) and *Auburn Queen* (1959); in the spare, almost theoretical investigations of verticality such as *Five Units Equal* (1956); and in eccentric pieces such as the superb *Running Daughter* (1956–60). The theme is developed and intensified in the enigmatic and evocative Tanktotems. This group of sculptures, which all incorporate the ends of boiler tanks, comprises some of Smith's most powerful versions of the standing personage motif. The Tanktotems succeed in treading the narrow line between anthropomorphic allusion, in their alert stances, and abstract invention, in their unexpected configurations. *Tanktotem IX* (1950), in particular, ranks among Smith's finest works, its spare near-geometry brought to life by a haunting sense of watchful animation. The most stripped-down versions of the theme are the Forgings of 1955, which seem to owe more to Giacometti's attenuated people than to Smith's own history. Slim columns of steel, minimally inflected by blows of a power hammer, they are the most reductive of Smith's sculpture.

These various works, which span the decade, are linked by a common insistent verticality and by a latent suggestion of the human figure, heightened by horizontal divisions that refer freely to head, torso, and limbs without resembling them specifically. These sculptures are no less abstract, but their verticality and their overwhelming presence force us to read them as confronting personages, not as mere upright assemblages of metal.

The early 1950s for Smith was both a time of great artistic growth and of major alterations to his domestic life. In 1952 he and Dorothy Dehner were divorced. In 1953, he married Jean Freas, of Washington, D.C. In 1954 Smith's first child, Rebecca, was born, and a second daughter, Candida, followed in 1955. Although the marriage did not last long, the children continued to visit Bolton Landing for extended periods, apparently very special times for both father and daughters.

The breakup of Smith's second marriage left him relatively alone at Bolton Landing, and, on a rather simplistic level, the great number of large sculptures he produced in the last ten years of his life, from 1955 to 1965, can be interpreted as a way of literally filling this aloneness. He began to set sculptures in the fields surrounding the house at Bolton Landing about this time—a 1954 film by Ilya Bolotowsky shows Smith placing *Agricola I* in the north field—and during the next decade both the north and south fields were gradually filled with pieces, installed on concrete pads. There is no doubt that Smith benefited from seeing pieces grouped together; it may have been one way of determining what was to be included in the ongoing series, and he seems to have enjoyed seeing his work against the distant Adirondack landscape. He found it important to be surrounded by his work, to have immediate evidence of what he had achieved, but there were also practical reasons for the outdoor installation. Smith made a great many sculptures, most of which were too large to be stored indoors. He sold few works, so that most of what he made remained with him at Bolton Landing. The fields were an obvious solution to the problem of where to put his growing oeuvre.

Nevertheless, the image persists of Smith, during his last decade,

as an isolated, obsessed artificer, defending himself against private demons by making sculpture and surrounding himself with the products of his effort. It is worth noting, though, that one of the most intimate of Smith's statements and one of the most revealing of his sense of himself, comes much earlier. During the winter of 1951–52, he wrote:

And so this being the happiest—is disappointing, the heights come seldom— the times of true height are so rare some seemingly high spots

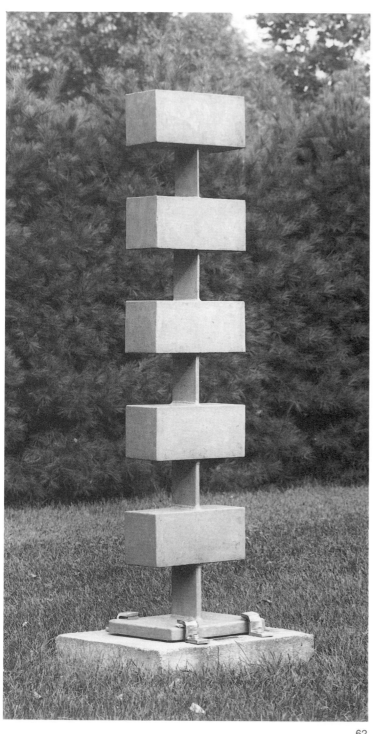

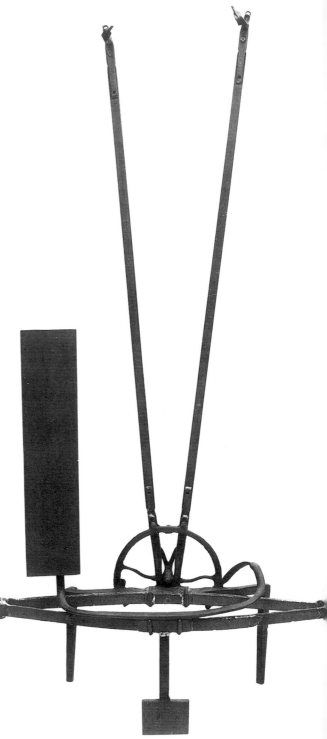

62

63

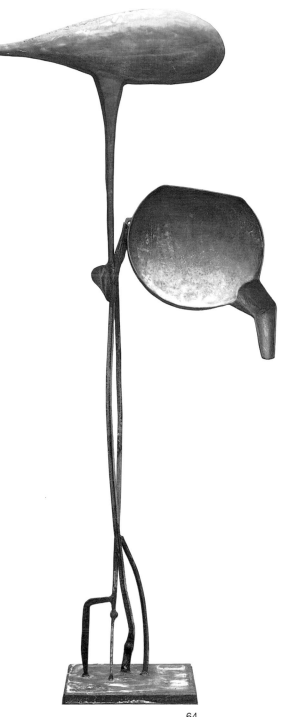

64

62. *Five Units Equal*, 1956
Steel, painted chartreuse, 73¼ x 16¼ x
14¼ in.
Storm King Art Center, Mountainville,
New York

63. *The Five Spring*, 1956
Steel, stainless steel, and nickel, 77⅝ x 36 x
15 in.
Collection of Candida and Rebecca Smith

64. *Tanktotem I*, 1952
Steel, 90 x 39 x 16½ in.
The Art Institute of Chicago
Gift of Mr. and Mrs. Jay Z. Steinberg

65. *Tanktotem II (Sounding)*, 1952
Steel and bronze, 80½ x 49½ x 19 in.
The Metropolitan Museum of Art, New York
Fletcher Fund, 1953

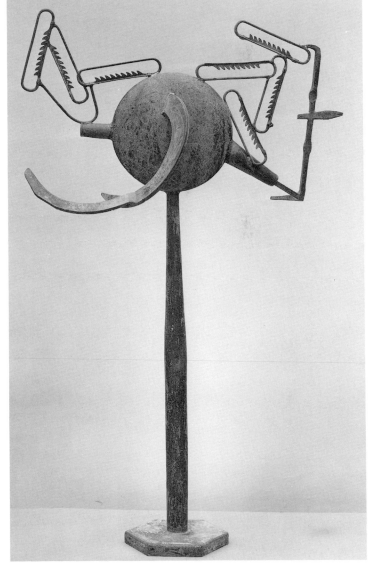

65

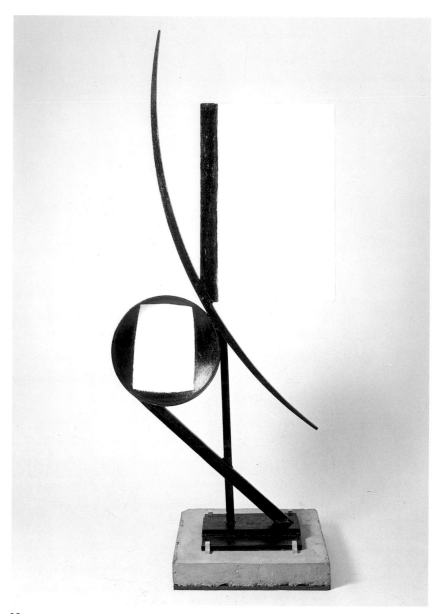

66

being suspected later as illusion—such being those contacts with people wherein elation comes related to or in dependence with others—the worth of existence is doubtful but if stuck with it—seems no other way but to proceed—the future—the factory or the classroom both undesirable yet possible at present but in 20 years neither will be open—and, my cause may be no better—can I change my pursuit—not, and have even this much all of which I should be happy with—and nothing has been as great or as wonderful as I have envisioned. I have confidence in my ability to create beyond what I have done, and always at the time beyond what I do—in what do I lack balance—ability to live with another person—that ability to have acquaintances—and no friends—what degrees make the difference—or am I unable to give what it takes—apparently I don't know what it is or is it illusion in middle minds—it would be nice not to be so lonesome sometimes—months pass without even the acquaintance of a mind. Acquaintances are pure waste—why do I measure my life by

66. *Tanktotem VII*, 1960
Steel, painted blue, dark blue, and white,
84 x 36½ x 14¼ in.
Storm King Art Center, Mountainville,
New York

67. *Tanktotem III*, 1953
Steel, 84½ x 27 x 20 in.
Mr. and Mrs. David Mirvish, Toronto

68. *Tanktotem IX*, 1960
Steel, painted blue, black, and white,
90 x 33 x 24¼ in.
Collection of Candida and Rebecca Smith

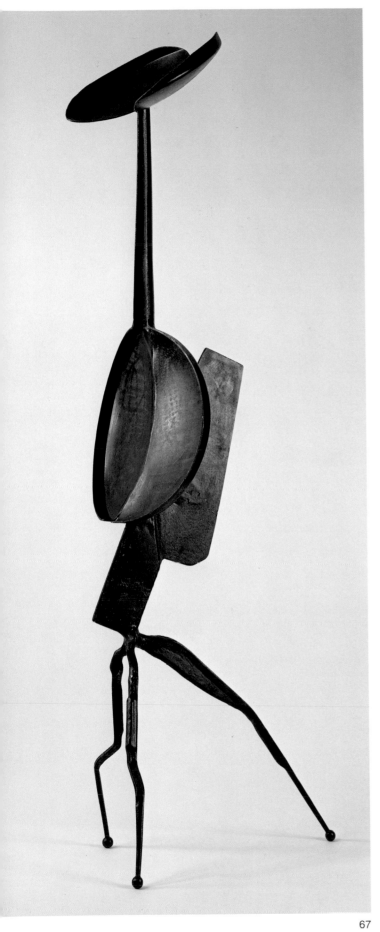

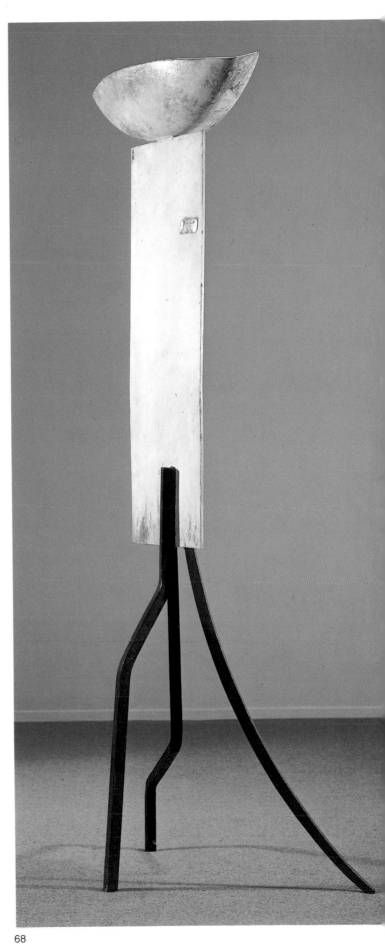

67

68

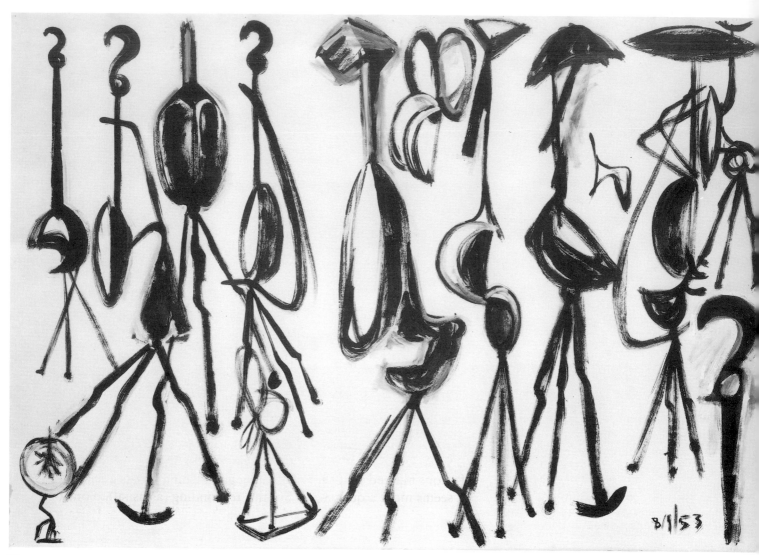

69

69. *Untitled (Tanktotem)*, August 1, 1953
Brush, ink, and gouache, 29¾ x 42⅜ in.
The Museum of Modern Art, New York
Gift of Alexis Gregory

70. *Bridge End (Egyptian)*, 1956
Bronze, 10¾ x 14⅞ in.
Collection of Candida and Rebecca Smith

71. *Bones Fly*, 1956–57
Bronze, 9⅝ x 13⅝ in.
Collection of Candida and Rebecca Smith

70

works—the other time seems waste—can the measured life by work be illusion—yet this standard seems farthest from illusion of any measure—and the way it stands much is lacking—and a certain body time tells that it can't be had, if it didn't come by now and so much work yet to be done—it comes too fast to get it down in solids—too little time too little money—why can't it stay as vision—for who else do I make it?[27]

It is tempting to justify this passage by the fact that Smith had spent a good part of the preceding two years more or less alone at the farm, after his separation from Dorothy Dehner. And, even though it is foolhardy and ultimately pointless to try to correlate an artist's life and work, it is nevertheless tempting to look for evidence of change in Smith's work after his remarriage in 1953 and the birth of his children over the next two years. It has been suggested that there are indications of Smith's desire to link his role as a father with the activity that absorbed most of his time, attention, and physical and emotional energy. While one can speculate about his intentions in naming works *Hirebecca* or *Hicandida*, or in painting "Becca" and "Dida" on *Sentinel III*, it is just as 59 probable that he stenciled his daughters' names on the piece simply because they came by the studio at an appropriate moment. The most one can say is that a small linear work called *Walking Dida* (1959) suggests a child stepping and oddly recalls one of Picasso's paintings of his daughter, Paloma, as a small girl. At least one major piece, *Running Daughter*, derives directly from a now-famous blurred snapshot of a young girl dashing across a field, but 73 it seems more a question of Smith's responding (as usual) to one of an infinite number of visual triggers than of a specific desire to make an image of the child.

Not unexpectedly, there is no break in either the continuity or the quality of Smith's sculpture at any time during this period. Ideas implicit in earlier work appear in pieces made during the

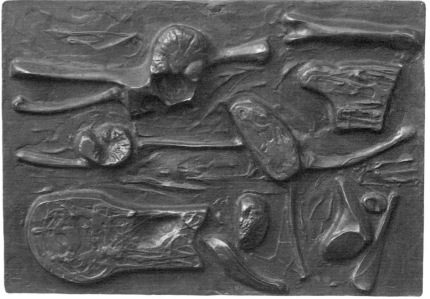

71

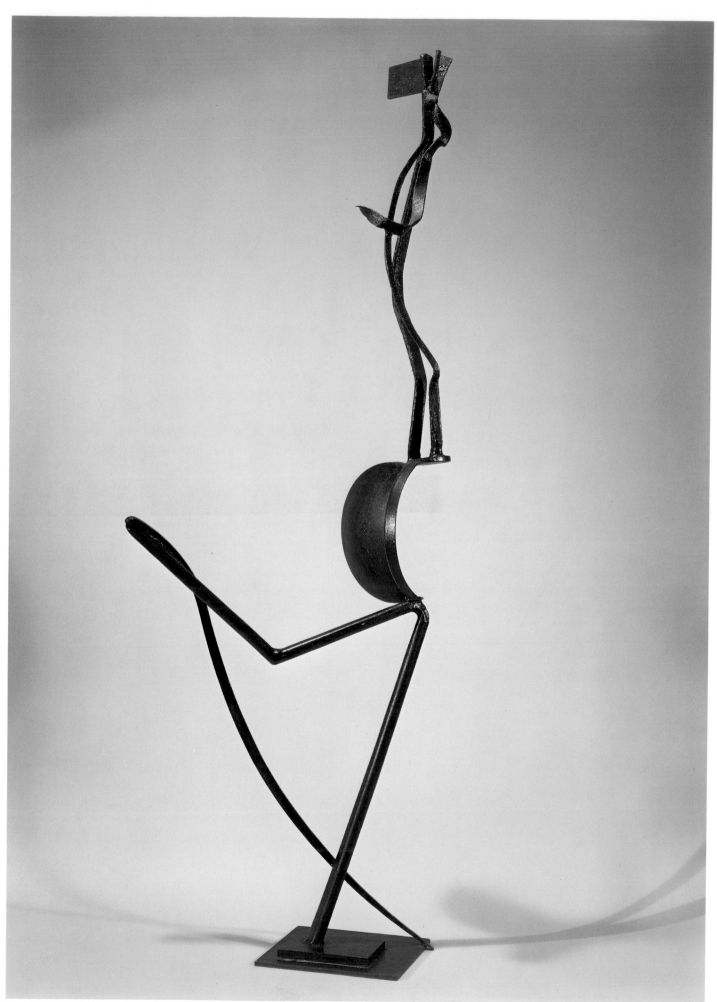

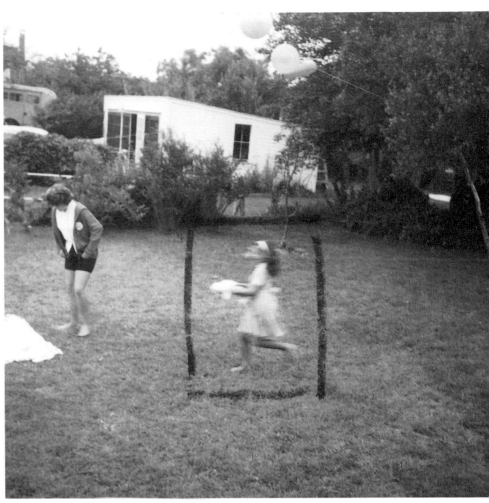

73

72. *Running Daughter*, 1956–60
Steel, painted red, 100½ x 36 x 17½ in.
Whitney Museum of American Art, New York
50th Anniversary Gift of Mr. and Mrs. Oscar
Kolin

73. Photograph by David Smith of his
daughter, 1958

early 1950s, and also recur in later works. There are miraculous successes and notable failures throughout the decade, as at any other time in Smith's working life. Whatever his emotional fluctuations, his work stream remained fluid and unceasing.

Despite the emphasis on loneliness in the passage from the 1951–52 notebook, some of Smith's most enduring friendships developed during this period. Clement Greenberg had continued to be a valued and stimulating visitor ever since he and Smith had met in the mid-1940s, and through Greenberg, Smith met Helen Frankenthaler in 1950. About a year later, she, too, began to visit Bolton Landing. Smith also met Kenneth Noland in 1950 and saw him frequently, both because of their common association with Greenberg and because Noland's wife, Cornelia, and Smith's second wife, Jean, were friends who had gone to college together. Smith's friendship with Robert Motherwell dates from the latter part of the 1950s. They had met in 1947, when Motherwell was art editor of the short-lived review *Possibilities*. The first (and only) issue included two of Smith's prose poems and reproduced nine of his sculptures. The deeper friendship between the two men, however, began about the time of Motherwell's marriage to Frankenthaler, in 1958.

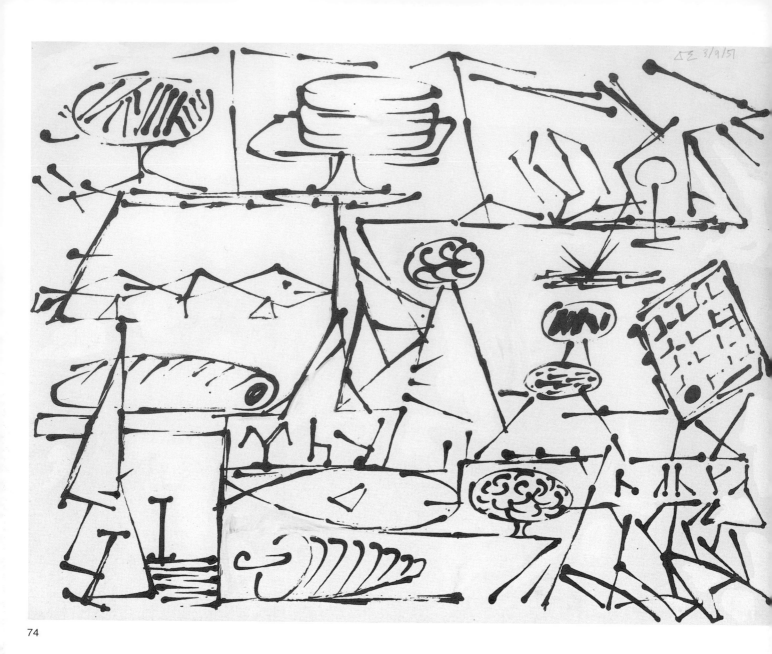

74

As the decade that had begun with the Guggenheim award progressed, it brought Smith increasing recognition. Although sales of his work remained very limited, he was beginning to be esteemed as one of the leading artists of his generation. In addition to his regular one-man shows, between 1951 and 1959 he represented the United States twice at the São Paulo Bienal, twice at the Venice Biennale, and was included in the second Kassel Documenta, which was devoted to sculpture. In 1957 the Museum of Modern Art mounted the most important exhibition Smith had yet had, a twenty-five-year retrospective (1932–57) with an informative *Bulletin* article by Sam Hunter. As if to document these years of official recognition, *Arts Magazine* devoted a special issue to Smith in February 1960, with a perceptive essay by Hilton Kramer.

74. *Study for the Banquet*, 1951
Black egg ink with gray and white tempera, 19¾ x 26 in.
Collection of Candida and Rebecca Smith

75. *Timeless Clock*, 1957
Silver, 21 x 27 x 12 in.
Mr. and Mrs. Harry W. Anderson

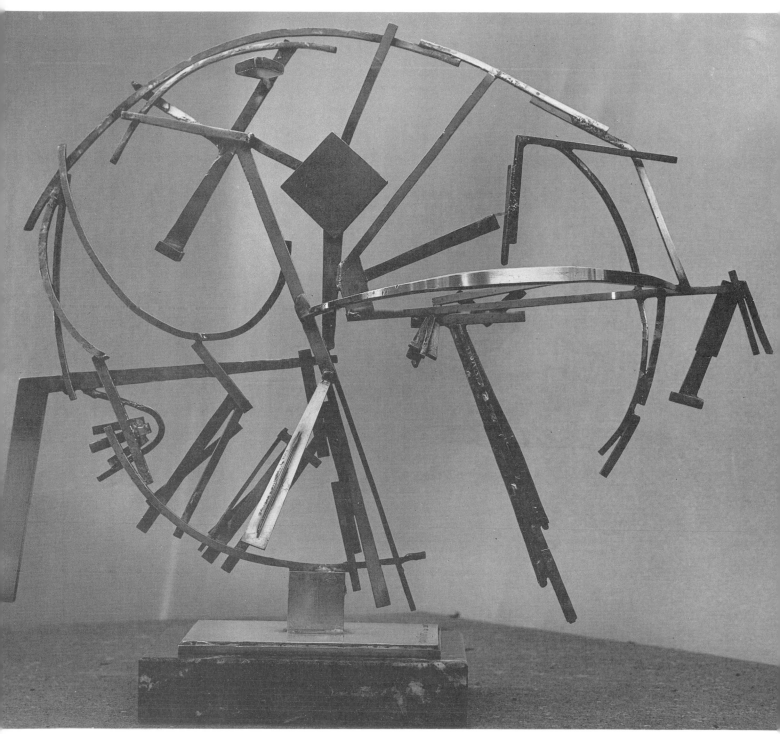

75

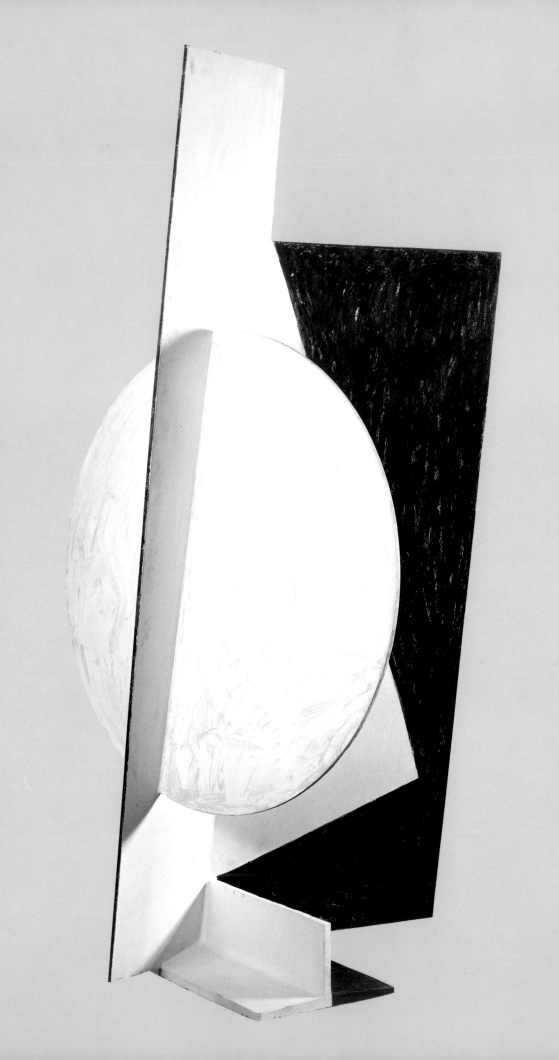

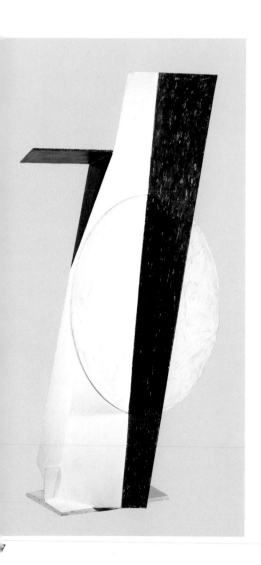

4 The 1960s

It is convenient to simplify Smith's career into tidy decades, but as I have said before, his working life is marked by continuous, overlapping explorations of many different sculptural notions, rather than by neat sequences. When we look at Smith's production at any given time, we are often more struck by the catholicity of his concerns than by their relatedness. Contemporaneity is no guarantee of likeness in Smith's work; the singlemindedness of his development is best seen over a longer period.

The startlingly diverse major groups of the 1960s were made more or less simultaneously. Smith worked on Zigs, Circles, Voltri-Boltons, Wagons, and Cubis, apparently interchangeably, at various times between 1961 and 1965. (Only the Voltris, made in a single, intense month in Italy, constitute a "traditional" series, but the Voltri-Boltons, made later that same year and the next, are the direct heirs to the original group.) There were times of concentration on a single group of sculptures, of course, but just as Smith drew and painted to refresh himself after making sculpture, he seems to have similarly varied his sculptural modes.[28]

This was not just a way of developing as fully as possible the implications of a single work. The pattern had been established early in Smith's career, when, as we have seen, he explored many different directions within short periods of time. Just as Smith saw himself able to embrace, and even amalgamate, painting, drawing, and sculpture, he saw his sculpture as able to embrace seemingly contradictory ideas—flatness *and* volume, or thinness *and* mass—sometimes in the same work. Particular series may differ radically from one another, or may not.

The Circles and Zigs, for example, initially seem unrelated. The polychrome Circles are flat and insistently frontal. Whether they succeed fully or not, they are extreme examples of Smith's attempt to claim territory for sculpture previously held by painting. It is interesting that although the Circles were conceived as single units, Smith, to judge by his photographs, seems to have become more satisfied with them when he lined up several of them. Each flat, rather uninflected unit then became part of a spatial whole, so that it articulated the interval between it and the next circle, instead of

76, 77. *Black and White Backward*, 1961, two views
Steel, painted black and white, 100⅛ x 53¼ x 48½ in.
Private collection

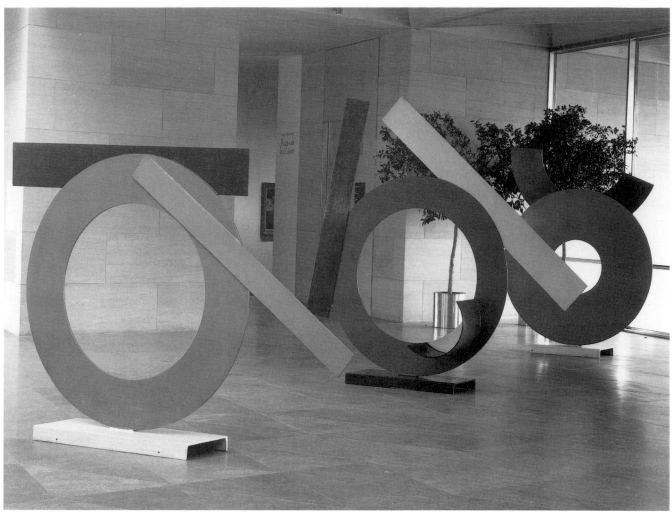

78

remaining isolated and diagrammatic.

The Zigs, on the other hand, are unequivocally three-dimensional. The first of the series—towering, fortresslike structures—depend upon a strongly differentiated play of convex and concave planes. The later, masterly *Zig IV* and its provocative fellow, *Zig VII*, are more elusive structures, subtler and more complex than the "fortress" Zigs. Elements virtually unseen from a single viewpoint are hinted at by penetrations. Their tipped masses are defused and made less threatening by their wheeled bases, which subvert their aggressive mortarlike connotations and shift them into the realm of giant children's pull-toys. The painting of the Zigs seems to set up a counterpoint to their physical structure, either by differentiating parts in an illogical way, or by softening and homogenizing strongly articulated planes. The various sections of *Zig VII*, for example, are accentuated by being painted yellow, red, and blue in a fairly arbitrary way, while in *Zig IV* every part of the sculpture is painted in the same color, with the same brushy strokes. Smith must have wanted to emphasize the separateness of the elements of *Zig VII*, while in *Zig IV* he created a uniform surface deliberately at odds with the complicated, angular structure of the piece. This

78. *Circles I, II, and III*, 1962
Steel, painted various colors
National Gallery of Art, Washington, D.C.
Ailsa Mellon Bruce Fund, 1977

79. *Zig IV*, 1961
Steel, painted red-orange and chartreuse,
94⅞ x 84¼ x 76½ in.
Lincoln Center for the Performing Arts,
New York
Photograph by David Smith

79, 114

is in marked difference to the Circles, in which shape and color are perfectly congruent.

The two series seem to investigate quite different ideas of what sculpture can be, yet *Zig VIII* seems to restate, in more sculptural terms, notions implied by the Circles. The painted, targetlike disc stresses the flatness of the elevated diamond plane, whose four-square frontality makes it a surrogate for an easel-mounted canvas. At the same time, the various projections, especially the angled, piercing bar, reach audaciously into space, canceling out purely pictorial associations. Smith grouped this work with the Zigs, but it could also have taken its place as a logical development of the Circle series.

The continuity of Smith's preoccupations is further demonstrated by pieces such as *Black and White Backward* and later versions of the Sentinel motif, such as *Lectern Sentinel* and *Two Circle Sentinel*, all of which play with ideas of concealment and articulation related to the Zigs. As in the Zigs, too, their painted or burnished surfaces are consciously at war with their literal structure. By way of contrast, the small-scale Albany series of the early 1960s seems to refute many of Smith's concerns in sculptures made just previously or at about the same time. They are robust, rather chunky

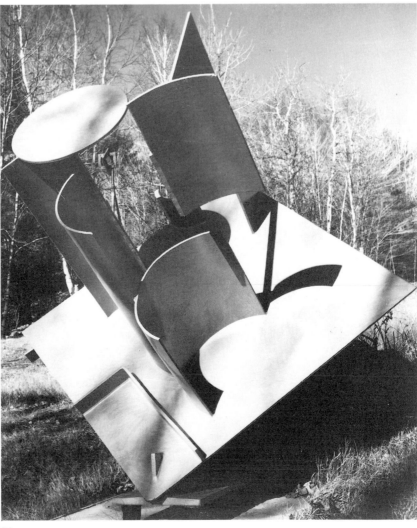

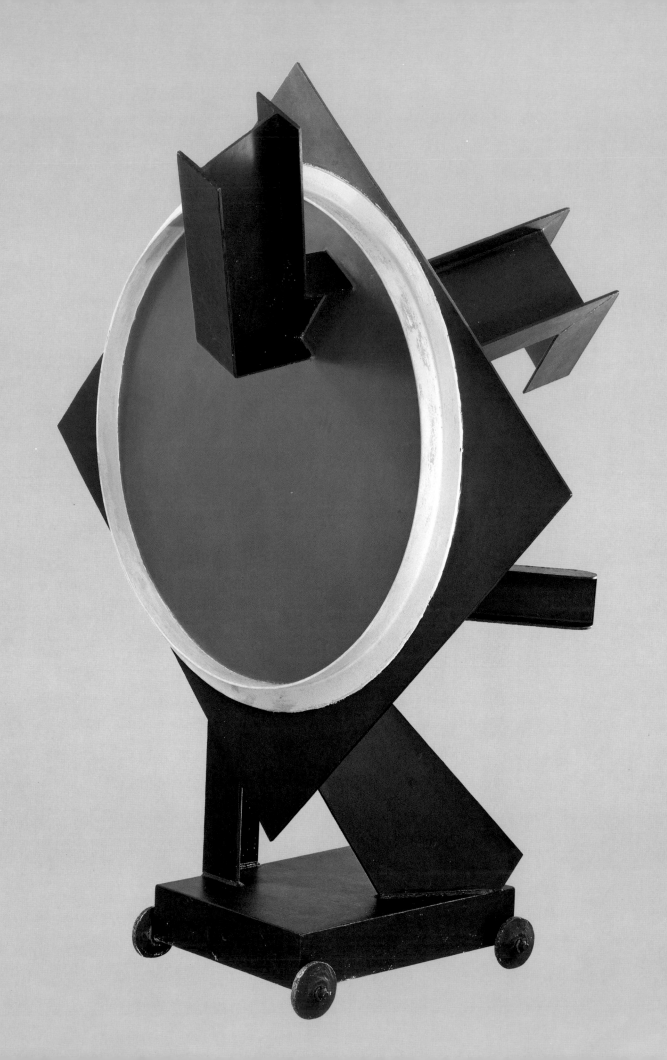

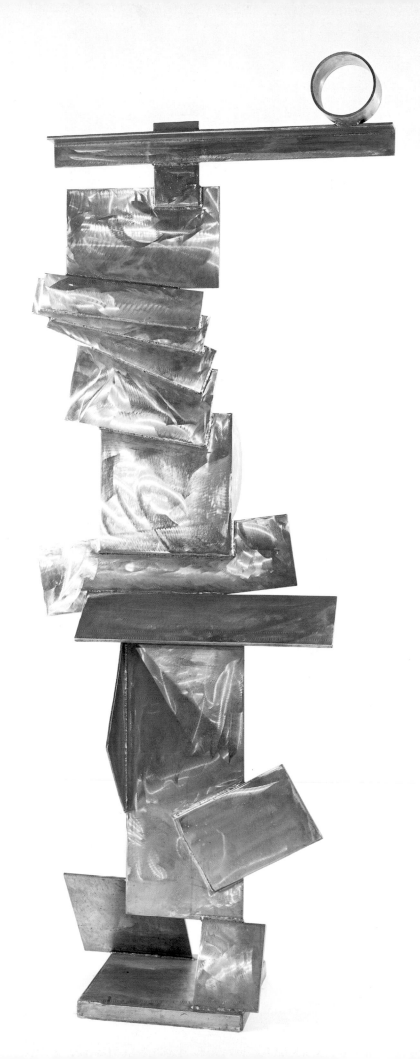

80. *Zig VIII*, 1964
Steel, painted red, white, and black, 100¾ x
91½ x 83 in.
Museum of Fine Arts, Boston
Centennial Purchase Fund

81. *Lectern Sentinel*, 1961
Stainless steel, 101¾ x 33 x 20½ in.
Whitney Museum of American Art, New York
Gift of the Friends of the Whitney Museum of
American Art and Purchase

works, as if in reaction to the imposing scale and dominant verticality of the Sentinels and Tanktotems. (There is, however, one Tanktotem very like a giant Albany.)

These near-fugal repetitions and variations are typical of Smith. They bear witness to characteristic ways of putting things together, which announce Smith's presence but are never merely habitual. Like any good mature artist, Smith knew how to take advantage of his own idiosyncracies but at the same time he remained sensitive to unexpected suggestions that came from his materials or from the experience of working. In 1961 he described the process:

I try to approach each thing without following the pattern that I made with the other one. They can begin with a found object, they can begin with no object. They can begin sometimes even when I'm sweeping the floor and I stumble and kick a few parts and happen to throw them into an alignment that sets me off thinking and sets off a vision of how it would finish if it all had that kind of accidental beauty to it. I want to be like a poet, in a sense. I don't want to seek the same orders. Of course, I am a human being. I have limited ability and there's always an order there. People recognize my work even if I think I've really been far out in this work.[29]

This dialogue between the unavoidable and the unexpected is documented by Smith's next major series, the Voltris and the Voltri-Boltons, of 1962 and 1963. In 1962 Giovanni Carandente invited Smith to participate in the exhibition *Sculpture in the City*, which he conceived for that spring's Festival of the Two Worlds, at Spoleto. The director of the festival, Gian Carlo Menotti, reinforced the invitation. Smith was offered an opportunity to spend thirty days in May and June making sculpture at one of the factories of the Italian national steel company, Italsider. The results were to be exhibited in the small Umbrian hilltown where the festival of music, theater, and dance is held.[30]

On his arrival, Smith altered his original plan of working in stainless steel at the modern Cornegliano plant, and instead was allowed the run of five abandoned, obsolete factories at Voltri. A great many tools and outmoded pieces of equipment remained in the factories, along with discarded scrap steel, and Smith was given the right to appropriate any of this treasure trove for his sculpture. It was the ideal working arrangement for him: the factory setting he felt at home in, a wealth of materials that were both familiar because of their function and new because of their provenance, and a group of workmen-assistants. Italsider also provided an interpreter, since Smith spoke no Italian. Smith made a prodigious amount of sculpture in his thirty days at Voltri: twenty-seven works, of which all but four are large scale. He later explained that "not speaking Italian I had not known I had been asked to make 1–2 pieces," but it is obvious that he simply couldn't resist the possibilities offered by the factories and a month of uninterrupted work. It is not just the number of Voltri sculptures, but their high rate of success that makes the effort impressive. The exhibition of Smith's work, ranged on the tiers of Spoleto's Roman amphitheater, was one of the high points of the Festival. (The stainless steel *Cubi IX*, shipped from the United States in anticipation of Smith's mak-

82

82. *Two Circle Sentinel*, 1961
Stainless steel, 86¼ x 53 x 27½ in.
Private collection

83. *Voltri XIX*, 1962
Steel, 55¼ x 45 x 50 in.
Private collection, Boston

ing related works at the Cornegliano factory, was exhibited elsewhere in the town.)

The Voltris, as a group, have evident connections with configurations that Smith had investigated before coming to Italy. It was logical to begin working, in a new place and in a new setting, with motifs that had proved themselves comfortable and challenging. Smith painted a worktable in the factory white, to provide a surface against which he could position pieces of steel, just as he did at home at Bolton Landing, on white painted "palettes." But at Voltri, Smith also had new kinds of materials that offered forms he had never used before: handmade tools, the debris of the factories, the soft-edged rolling-mill ends he called "chopped clouds." Smith not only employed these new elements in ways familiar to him (*Voltri XX*, for example, is closely related to *Running Daughter*), but the new elements also suggested new kinds of sculpture. The broad, fluent curves of the Voltris are quite different from the stacked rectangular planes of the Sentinels or the sharp, nervous lines of the Tanktotems. Some of the Voltris, such as *Voltri XII*, 87 anticipate the Circles Smith was to make in the autumn of 1962, although the notion of the monstrancelike "sculpture on a stick" goes back to his work of the 1940s. The soft-edged "chopped

83

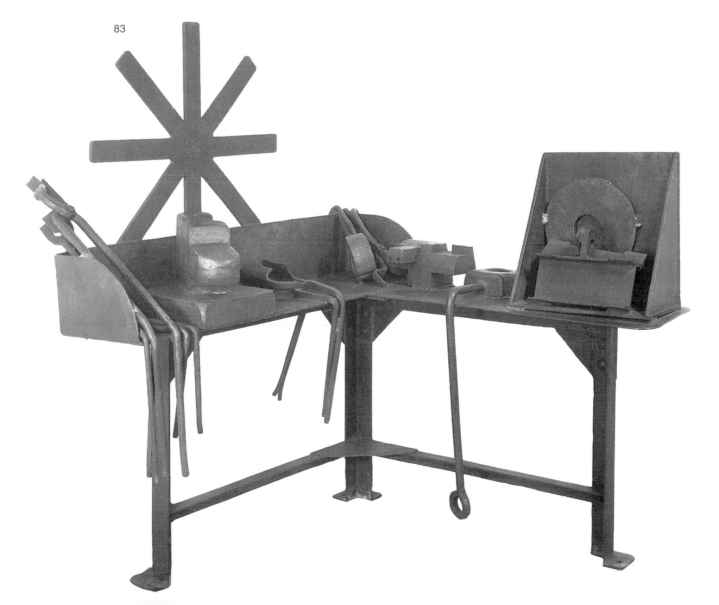

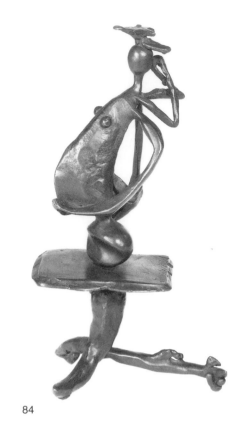

84

clouds" were also elevated and presented, in works such as *Voltri IV*, or used in plastically complex structures such as *Voltri XVII*.

The most radically new of the Voltri images are the workbench still lifes and the chariots, in which Smith made fairly literal use of the functional elements found in the factories: the tongs used to handle the hot metal and the wheeled shanks used to move large amounts of it. In the workbench still life *Voltri XIX* (and the related *Volton XX* made at Bolton Landing the following year), Smith came closer to "traditional" Cubist use of the found object than at any other time in his career. These remarkable works, which manage to be serious, fully realized sculpture despite their novel subject matter, seem at first acquaintance to be unprecedentedly literal, for Smith, and seem to depend upon their associations with the ordinary. Tools, tongs, the stuff of the factory, are placed on workbenches, exactly where you would expect to find them. The objects appear neither to have been altered physically, nor to be transformed by their setting. But Smith also used identical elements in other works of the series, in noticeably nonliteral ways, more characteristically subordinating them to their new contexts.

A possible parallel exists in the 1973 Veduggio series by the English sculptor Anthony Caro. Like Smith's Voltris, the Veduggios

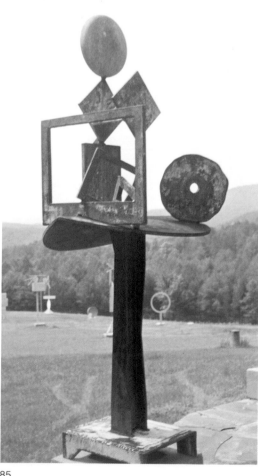

85

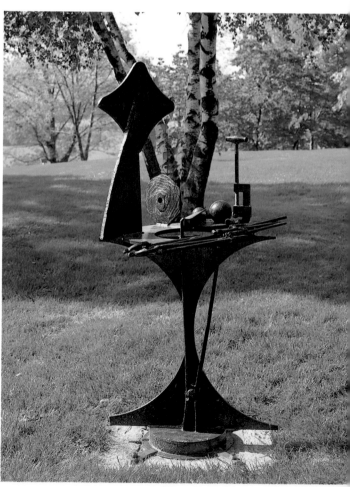

86

74

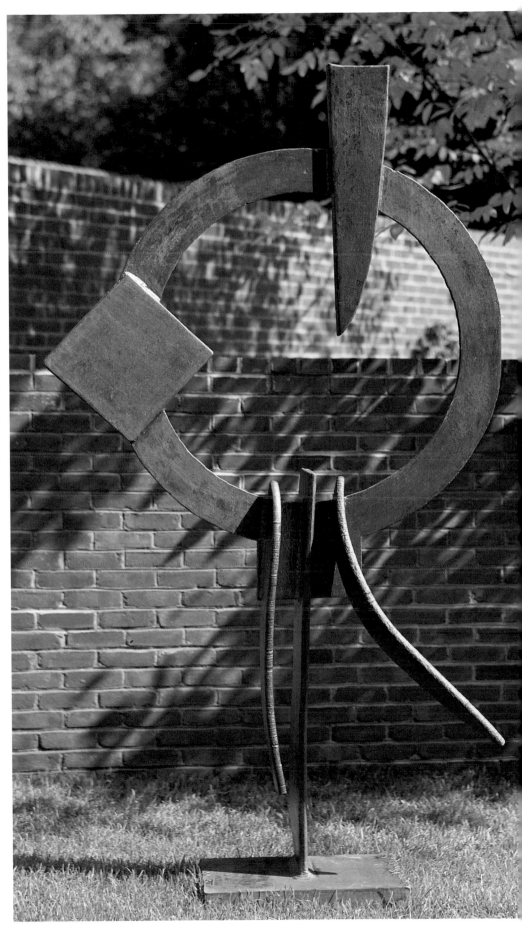

84. *Table Torso*, c. 1942
Bronze, 10 x 4¼ x 5⅝ in.
Rose Art Museum, Brandeis University,
Waltham, Massachusetts
Charna Stone Cowan Collection

85. *Voltri-Bolton XXIII*, 1963
Steel, 69¼ x 24 x 25½ in.
Sara Greenberg, New York

86. *Volton XX*, 1963
Steel, 62½ x 29 x 37½ in.
Storm King Art Center, Mountainville,
New York

87. *Voltri XII*, 1962
Steel, 86¾ x 49¾ x 13½ in.
Mr. and Mrs. Gilbert H. Kinney, Washington,
D.C.

87

75

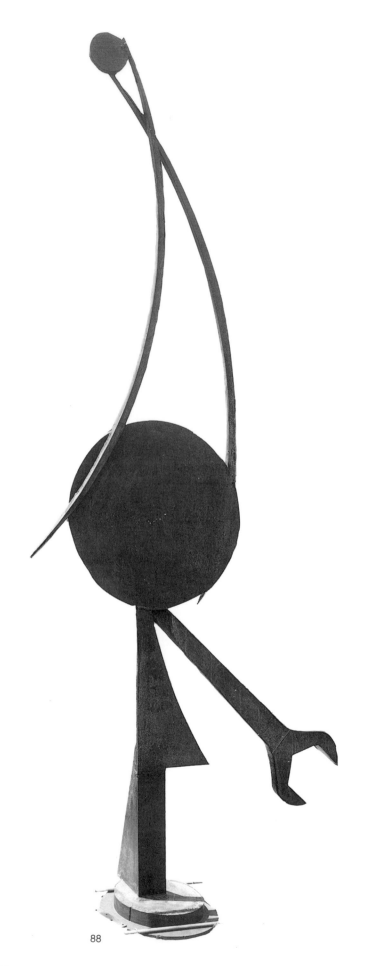

88

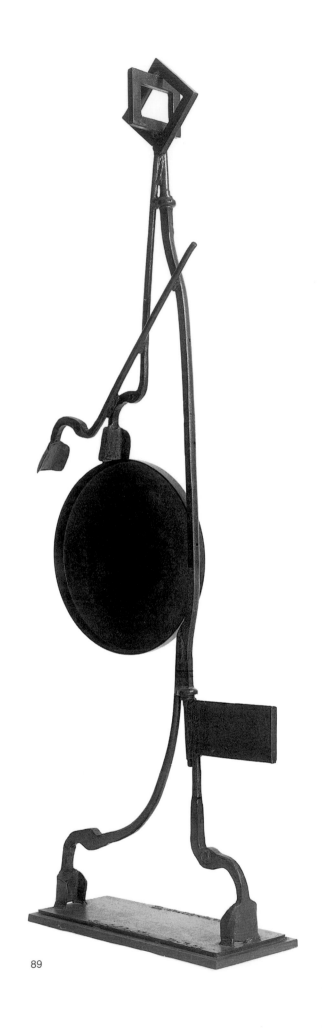

89

76

were made in a factory, on Caro's first working trip to Italy. He has spoken of his excitement at seeing large sheets of steel suspended from gantries in the strong Italian light. "At first," Caro has said, "the steel looked so beautiful against the light that all I could think to do was get some legs on it."[31] It is conceivable that Smith's reaction was similar. While he was able to use the wealth of material he found in the Voltri factories in ways customary to him, his affection and admiration for such objects as the marvelous hand-made drop-forging tongs prompted him to "display" them, apparently as is. Even so, the Voltri and Volton still lifes prove more equivocal on closer acquaintance. Some tools and objects remain recognizable, while others are severely altered, and still other forms are geometric inventions. Oddly, the very fact that they have been combined and arranged helps distance these objects from their earlier existence. They become a machine-age metaphor for the fruit, cloth, and crockery of the time-honored *nature morte*.

Smith was so entranced with the Voltri material that he had a large amount shipped back to the United States. The Voltri-Boltons (or Voltons or VBs or any of the variations on the name) were all works made at Bolton Landing out of Italian factory material. They continue and develop the notions stated in the Voltris (some may even have been started in Italy). *VB XXIII*, for example, is a 85 typical Smith hybrid, a table-personage, which combines two of the Voltri themes. It is not an unprecedented motif for Smith: in the 1940s, he had made *Table Torso* and included an odd torso- 84 based plant stand in *Home of the Welder*, both quite explicit and both small in scale. Some of the "portrait" sculptures of the 1950s, such as *Sitting Printer*, also incorporate still-life elements with humanoid configurations, on a larger scale. But *VB XXIII* is utterly and evocatively ambiguous. Neither image takes precedence. Instead Smith gives us a new kind of object that exhibits the symmetry and stability we associate with inanimate objects and, at the same time, has the uncanny presence and implied mobility of the animate. Other Voltri-Boltons, such as *V*, are recognizable restatements of 90 Smith's familiar upright figure, while still others, such as *Volton* 3 *XVIII*, retain the upright stance but seem notably independent of more specific references to the body. They become instead celebrations of the material from which they were made, enlivened in Smith's usual manner by a distant memory of the figure and by the inevitable sense of confrontation that verticality elicits.

The three large Wagons, made in 1963 and 1964, form a distinct, self-contained group, but they are also related to the wheeled carts and chariots made at Voltri. The notion of a sculpture on wheels is an arresting one, but within the context of Smith's work, it seems less eccentric. There are early notebook drawings of wheel-based cannons and composite harpies with wheels instead of claws. As early as 1957, Smith mounted a sculpture on wheels, a deliberate aesthetic choice that may have originated in his having placed work on a wheeled dolly to make it easier to move. Smith is often quoted as saying that he wanted to make a sculpture with a flatcar as its base, and toward the end of his life he seems to have been buying up old tractors for a similar purpose. The idea seems particularly in keeping with Smith's vernacular, improvisatory approach,

88. *Voltri-Bolton I*, 1962
Steel, 112¼ x 44⅞ x 15½ in.
Dr. and Mrs. Paul Todd Makler

89. *Voltri-Bolton VI*, 1962
Steel, 87 x 33½ x 10¾ in.
Mr. and Mrs. David Mirvish, Toronto

and his ambitions toward a grand scale, but there are small-scale precedents within the history of art as well—notably Giacometti's bronze *Chariot* of 1950, which seems, in turn, to have Etruscan prototypes.

Smith himself believed that he got the idea for the wheels from Hindu temples: "They carve them out of stone on the temples to represent the processions where they carry copies of the temples down the streets on wagons. Carved stone wheels. It's a fascinating idea."[32] The ambiguity of the symbolic temples being placed on

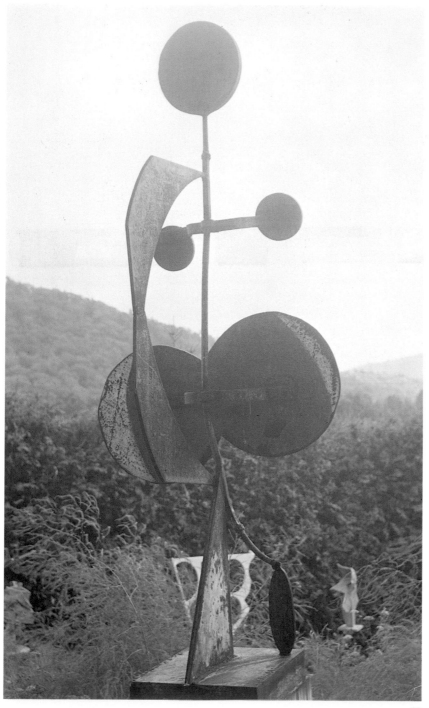

90

90. *Voltri-Bolton V*, 1962
Steel, dry brushed with orange, 86 x 33½ x 28½ in.
Patricia Bransten, San Francisco

91. *Wagon I*, 1963–64
Steel, painted black, 88½ x 121½ x 64 in.
National Gallery of Canada, Ottawa
Photograph by David Smith

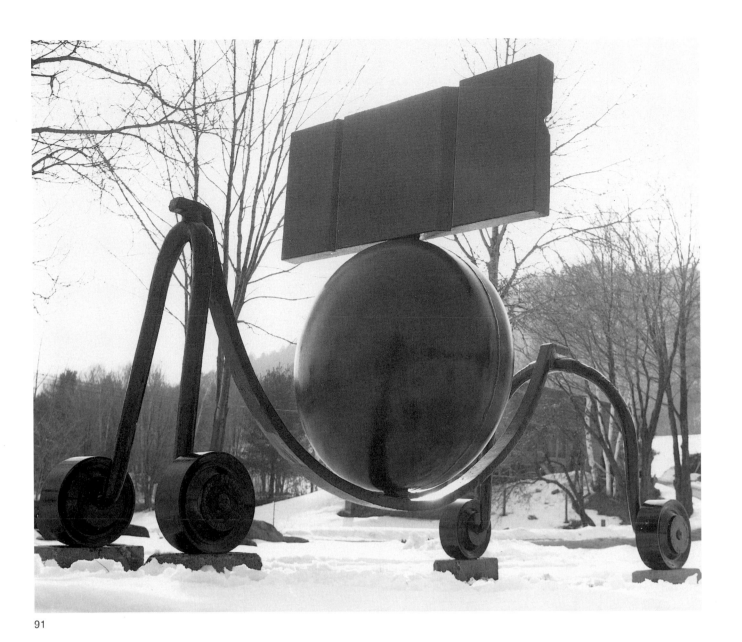

91

real wheels, and those wheels then being turned into symbols carved on real temples, must have appealed deeply to Smith. He, in turn, restored the stone wheels' utility by using factory-produced functional wheels on his sculptures.

Yet the Wagons were not an entirely new kind of sculpture for Smith: the mounted figure goes back to *Spectre Riding the Golden Ass*, and there are even similarities between the splay-legged, swaybacked ass and the shape of the wheeled wagon-bases. Unlike the elongated, slightly flaccid Voltri chariots, the Wagons are energetic, self-contained structures. In *I* and *II*, the "rider" seems to weigh 91, 92 heavily on the spine of the wagon, turning it into a springy, taut bow, a catapultlike arc that then negates the implied weight of the upper element. The uneven sizes of the wheels adds to the sense of erratic energy.

This kind of tension is critical to the success of Smith's late sculptures. The works in his last series, the stainless steel Cubis, often fail because they remain simply stacks of steel boxes. Despite this, the Cubis are among Smith's best-known works, and the

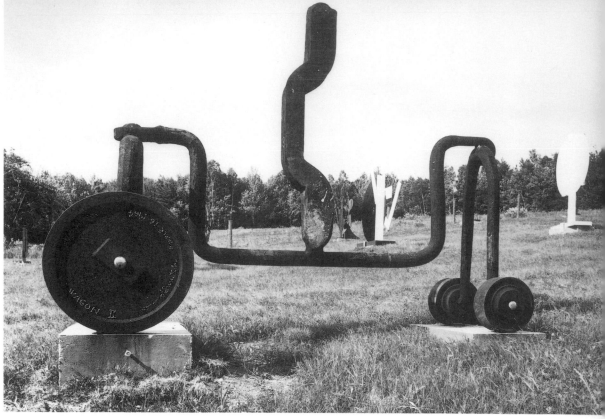

92

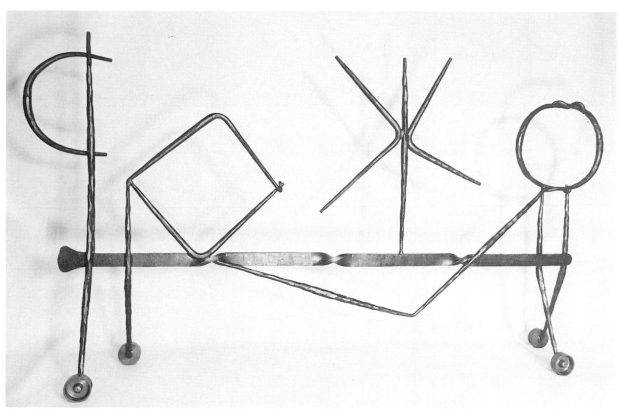

93

92. *Wagon II*, 1964
Steel, 107½ x 111¼ x 44 in.
Collection of Candida and Rebecca Smith

93. *Wagon III*, 1964
Steel, 99½ x 165 x 29⅜ in.
Hallmark Cards, Incorporated, Kansas City,
Missouri

94. *Cubi XIX*, 1964
Stainless steel, 112¾ x 58¼ x 40 in.
The Tate Gallery, London

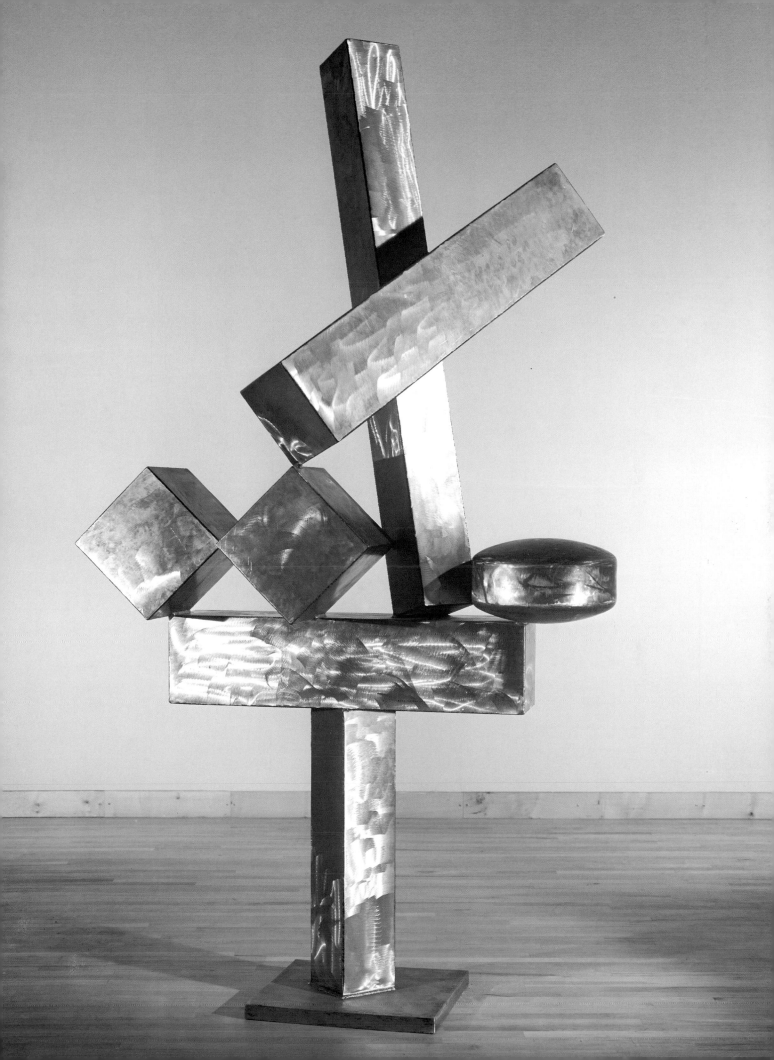

most eagerly collected by institutions. This is probably because they were perceived as "art of the 1960s" at the time of their making. Their sleek geometry could easily be compared to the minimally inflected expanses of color and clean edges of the paintings made by Smith's contemporaries, and although they are far less monumental than their photographs suggest, the large-scale Cubis could also be related to the enormous size of many American paintings of the period.

Smith began the series in 1961 and was exploring its permutations, extending its limits, when he died in 1965. He had worked in stainless steel and with geometric shapes before, but always in terms of planes. The volumetric "boxes" and "cushions" of the Cubis were new. That Smith wanted to experiment with real, rather than implied, volumes seems inevitable. When he began to work in metal, the open, drawinglike quality that construction in steel both permitted and encouraged was a sign of modernism. Mass and literal volume seemed to belong to the exhausted tradition of the monolith, and Smith more or less deliberately excluded it from his sculpture, making voids where solids could be expected, and inventing, along the way, new possibilities for three-dimen-

95

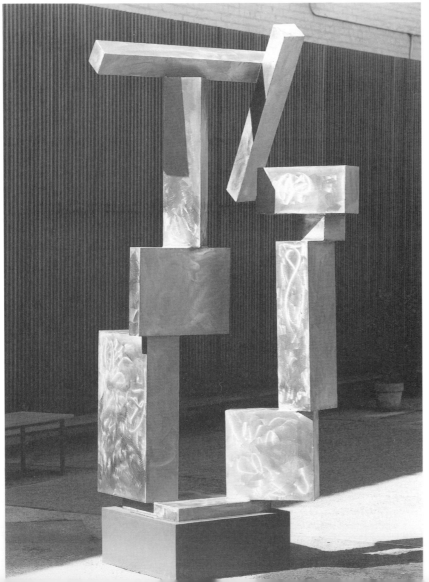

96

95. David Smith working on studies for *Cubis IV* and *V*
Photograph by Dan Budnik

96. *Cubi IX*, 1961
Stainless steel, 106¼ x 56 x 45 in.
Walker Art Center, Minneapolis
Gift of the T. B. Walker Foundation

97. *Cubi VI*, 1963
Stainless steel, 112 x 28⅞ x 21½ in.
The Israel Museum, Jerusalem
Gift of Mr. and Mrs. Meshulam Riklis,
New York

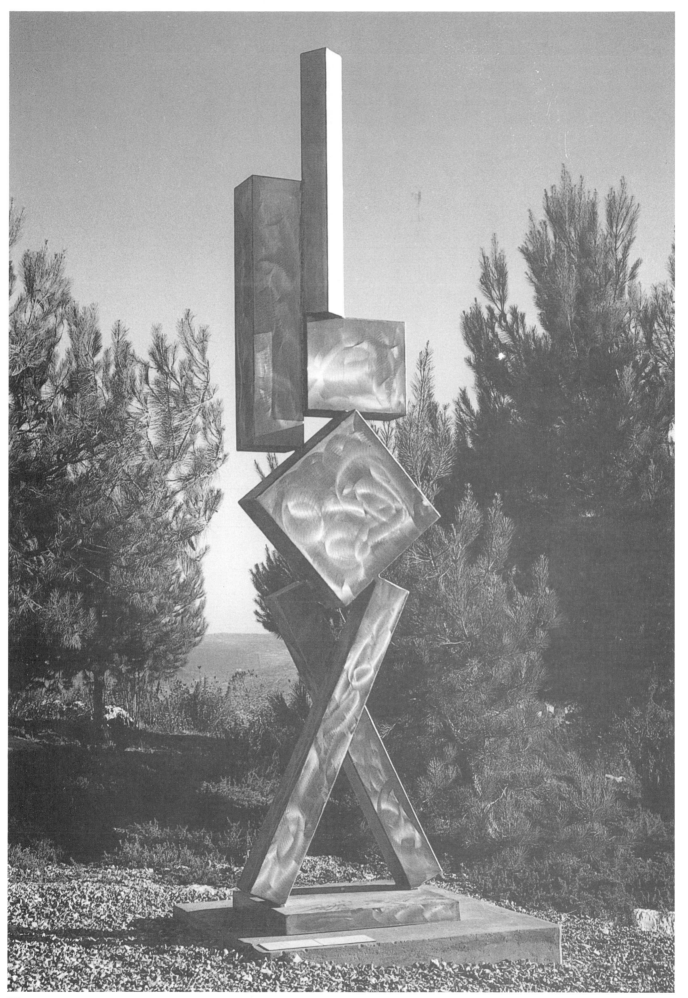

98

sional objects. But by the 1960s, Smith's kind of open construction had a thirty-year history, and it may have seemed time to challenge the notion that sculpture, in order to be new, had to be thin or open. The Cubis may also have had something to do with Smith's wish to make larger, more imposing sculpture, since they offered a way of gaining more mass and making larger gestures.

The Cubis are still additive "collage" sculptures, begun, according to a now-famous story, as constructions of cardboard cartons and liquor boxes. There were practical reasons for this. Smith could weld stainless steel, but he lacked the equipment to cut it, so the components of the Cubis had to be precut, and the sections assembled to make a lexicon of cubes, boxes, and "cushions" of various sizes. Perhaps because of this unusual degree of preconception, many of the series seem curiously inert, lacking the mysterious animation of the Voltri-Boltons, the Tanktotems, and the Wagons. One of the difficulties is the tendency of the box forms to

98. *Cubi XXVI*, 1965
Stainless steel, 119½ x 151 x 25⅞ in.
National Gallery of Art, Washington, D.C.
Ailsa Mellon Bruce Fund, 1978

99. *Untitled (Candida)*, 1965
Stainless steel, 101 x 119¾ x 30¾ in.
Collection of Candida and Rebecca Smith

remain just that: hollow volumes that force us to speculate about what they might contain. In the best of the Cubis, such as *IX* or *XIX*, the sheer energy of the piece, its sense of "all-at-onceness," overwhelms any other considerations. Smith may have felt similar dissatisfaction, in spite of his reluctance to make distinctions between finished works, because some of the last Cubis, such as *XXVI* and *XXVIII*, abandon the literal stack of volumes in favor of more spatially audacious "gates" and freewheeling extended structures. By being more open, these large works claim and animate more space than the stacked Cubis; the steel volumes become less oppressive and the sculpture is often better. In still other late, fine works, such as *Becca* and *Candida*, Smith gave up the closed volume entirely, making instead generously scaled structures of flat, overlapping planes.

Smith intended the Cubis and the related stainless steel sculptures to be seen out-of-doors. He was enthralled by the idea of

96
94

98, 101

99, 100

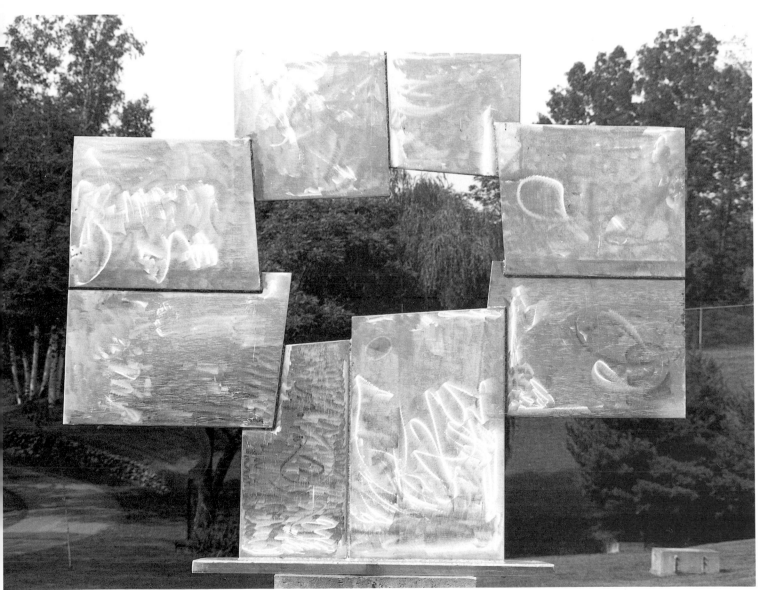

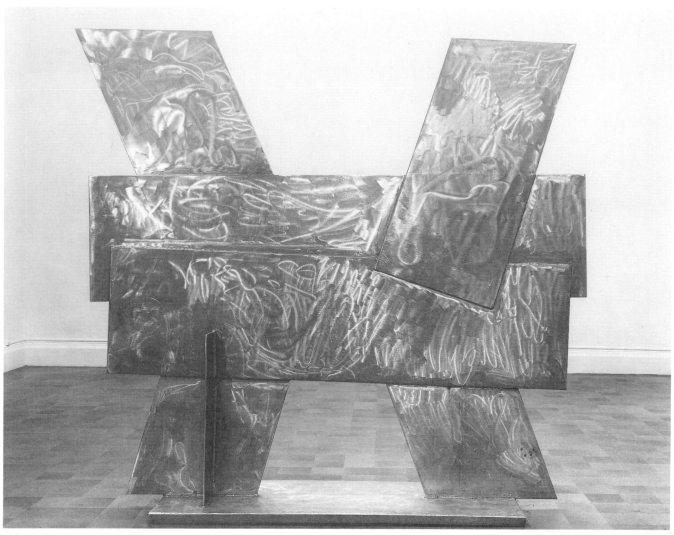

100

surfaces that would change as the light of day changed, and so, in a sense, they are the final development of his lifelong preoccupation with the possibilities of color in sculpture. But the burnished, light-diffusing surfaces of Smith's stainless steel sculpture serve both to focus attention on those surfaces and to make them seem insubstantial. We have seen the handwriting of the burnishing before—in the rough, brushy surfaces of the Zigs, for example—but here the skin of paint, which often seemed at odds with the structure of the work, has been replaced by an optical dazzle that appears to be an inherent property of the material itself.

We can only speculate about how Smith would have developed the implications of the Cubis, about what he might have done with his newly acquired tractors. There is no doubt that Smith made more first-rate sculpture in the last decade of his life than at any other time, and despite my reservations about the Cubis as a group, the best of them are every bit as good as the best of any other period. Smith was clearly at the height of his powers when, on May 23, 1965, he was killed in an automobile crash near Bennington, Vermont. He was fifty-nine years old.

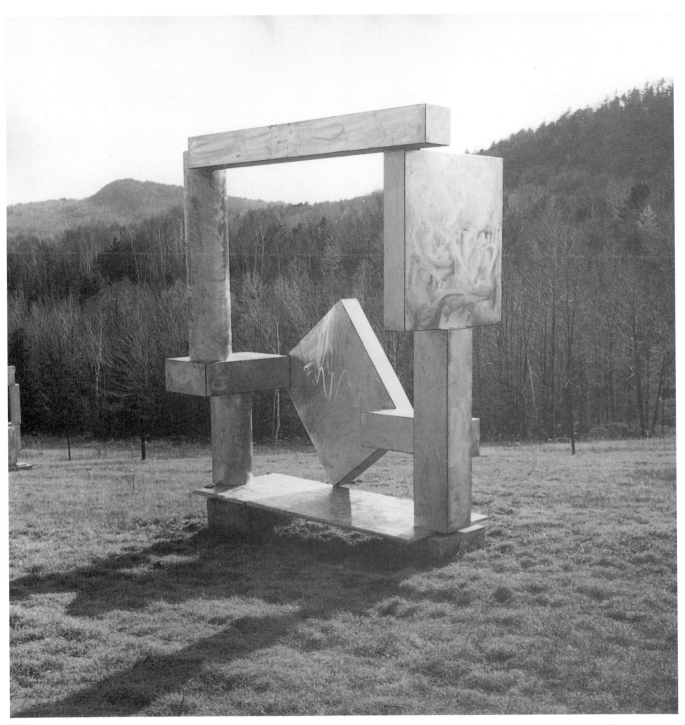

101

100. *Becca*, 1965
Stainless steel, 113¼ x 123 x 30½ in.
The Metropolitan Museum of Art, New York
Bequest of Adelaide Milton de Groot,
Exchange, 1972

101. *Cubi XXVIII*, 1965
Stainless steel, 108 x 112⅛ x 39 in.
Sid Richardson Foundation, Fort Worth, Texas

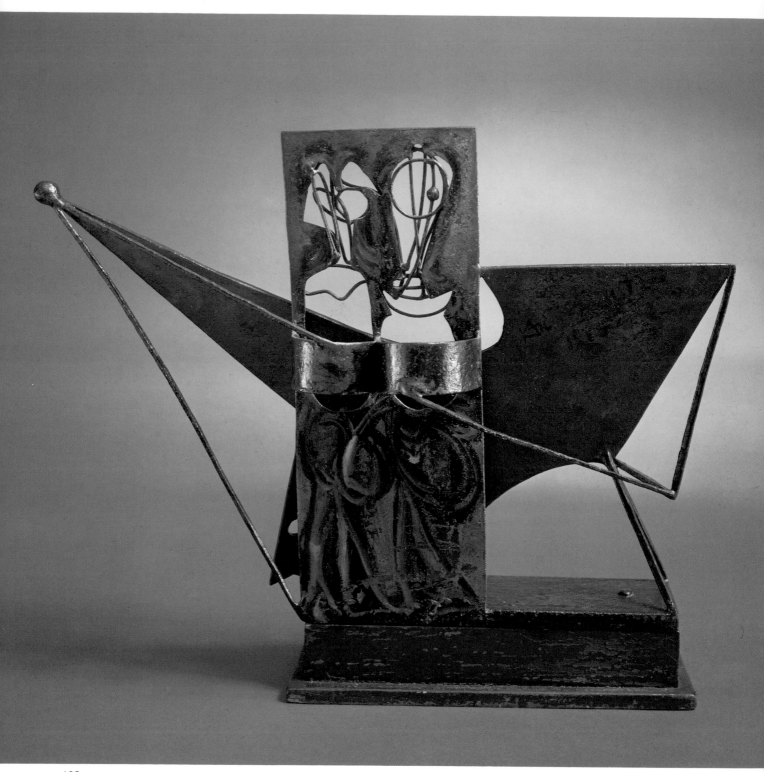

 # Sources and Successors

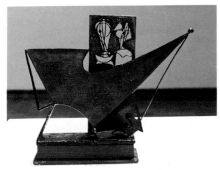

103

102, 103. *Billiard Player Construction*, 1937,
two views
Iron, painted with encaustic, 17¼ x 20½ x 6⅜ in.
Dr. and Mrs. Arthur E. Kahn, New York

One view of David Smith holds that because he was trained primarily as a painter, he had no preconceptions when he began to make three-dimensional objects and so was able to avoid sculptural clichés. Yet even if Smith had studied sculpture formally at the Art Students League, he would have been able to see few modernist examples exhibited in New York at the time. More importantly, there was no established tradition of welded construction for him to draw upon. Picasso and González began collaborating on their metal constructions in 1928; Smith made his first welded pieces in 1933. Unlike the Fauvists and the Cubists, who had Cézanne as a guide, Smith was virtually on his own. No matter what his training, because he had so little firsthand experience of advanced sculpture, he was more or less forced to make it up as he went along.

This is not to say that he lacked ancestors. He learned from Picasso and González, in particular, but also from Giacometti, Pablo Gargallo, and Miró, among others. When he began to make sculpture, he was already at home with Cubism. He responded to almost everything he encountered, quickly absorbing whatever he saw. Some recent writing on Smith has suggested that there are direct relationships between certain sculptures of his and particular works of art by older masters, but while it is clear that Smith was unusually alert to the implications of even the most unexpected sources, the evidence points to an imprecise, often indirect link between the things that stimulated him and his own work.[33] Just as there is no single interpretation of even Smith's most explicit sculpture, there is no single source.

Smith's early notebooks testify to his omnivorous appetite for visual information. They record (among other things) protozoa, ancient musical instruments, medieval and Egyptian artifacts, embryos, Northern Renaissance painting, and modern dancers. Smith frequented the Museum of Natural History as well as the Metropolitan; he saved magazine photos of odd insects and fish, billiard players, heavy weapons, and girls in bathing suits. The large library he accumulated was equally catholic. Smith's mature works are less specifically documented in the notebooks, but their imagery implies his continuing fascination with tools and machines,

104

artillery, highway signs, gates, and vernacular structures of all sorts, as well as his dialogue with other art. The stimuli were multiple and their manifestation in his work no less so.

Smith was as responsive to found objects as he was to found imagery, but it was almost always the formal properties of the object rather than its original function that interested him. In Smith's best works, throughout his career, found objects are exploited for their peculiarities of shape and form, as drawing and mass, and are completely subsumed by the whole. Usually, when the origin of the object remains too obvious, the sculpture can seem whimsical, and often suffers. Success, in fact, frequently depends upon Smith's ability to dematerialize the found object and force it to take its place in a new kind of nonliteral structure. This habitual interruption and disguising of components allies Smith more closely with González than with Picasso. In Picasso's colander *Head* of 1931 or the 1943 *Bull's Head* made from bicycle seat and handlebars, for example, we are meant to be acutely aware of the former existence of the elements, and to acknowledge Picasso's role in having placed them in a witty new relationship. For Smith, as for González, the new autonomous image takes precedence.

Obviously it is part of the legacy of Cubist collage to make sculpture by sticking an assortment of things together, but Smith's approach goes beyond this assembly of preexisting parts to an even more fundamental idea of Cubism. Many of his sculptures deal with collaged perceptions, not collaged things. The Cubist painters set a precedent for this when they amalgamated several different views of the same object or person in a single composition, but Smith extended even this notion by inventing self-contained sculptures based on a great variety of different elements that attracted his attention.

104. *Study for "Billiard Player Construction,"* c. 1935 (?)
Pencil and black ink on handmade rice paper, 17⅛ x 22¼ in.
Collection of Candida and Rebecca Smith

105. *Notebook Drawing of Locomotion in Amoebas*
Smith Papers, on deposit at the Archives of American Art, Smithsonian Institution, Washington, D.C. (reel 4/16)

106. *Notebook Drawing of Embryos*
Smith Papers, on deposit at the Archives of American Art, Smithsonian Institution, Washington, D.C. (reel 4/89)

105

106

102 *Billiard Player Construction* (1937), for example, can be interpreted as a fusion of the surface of a pool table and the players. The sculpture's development is illuminated by Smith's notebooks

104 and drawings, and by carefully saved clippings from a *Life* magazine photo-essay on Willie Hoppe. Then, too, Smith and Adolph Gottlieb used to shoot pool together in Brooklyn billiard parlors, in the early 1930s. But the sculpture is anything but literal. Smith not only flattened and truncated the central figure, turning him into a shape continuous with the surface of the table, but he also telescoped space, linking disjointed forms into single planes. When the sculpture is compared to the drawings that relate to it, it is clear that Smith laid claim to a great many forms that he observed in his surroundings and compressed them into new relationships that owe little to their original scale or their original placement in space. From the drawings, we can see how Smith appropriated the back wall and lights of the billiard hall, the players, the cues, the balls and the table, and used them freely, in often illogical but visually satisfying ways, in his sculpture.

 This kind of synthesizing, all-inclusive vision is a painter's habit. As long as art retained any reference to visible reality, it was the painter's task to distill the random variety of the perceivable world into a lucid, two-dimensional unity. Traditional freestanding sculpture proceeded from an entirely different premise. The monolith held itself apart from its surroundings, instead of absorbing those surroundings into itself. Isolated on its pedestal, it was obviously self-sufficient, yet because it referred to familiar, visible reality, usually the human figure, it was immediately comprehensible. When sculpture became drawinglike and visually transparent, and when, as much of Smith's work did, it deserted the pedestal to occupy the same space as the viewer, it had to find new ways of detaching itself from the rest of the world. Smith's sculpture declares its self-sufficiency by looking like nothing except itself, but paradoxically, this individuality often results from his having willfully brought together—visually—a great many disparate parts of the world around him. Instead of setting itself apart from its surroundings as the traditional monolith did, Smith's sculpture frequently absorbs those surroundings, the way a two-dimensional painting does. It is as though in order to avoid conventional sculptural relationships dictated by known, existing forms, Smith tried to encompass everything in sight.

107 A 1937 drawing, *The Photographer Leo Lances Photographing a Sculpture*, provides a key to this general attitude and to the

108 specific imagery of the 1937 sculpture *Interior*. The drawing marries the photographer, his equipment, the sculpture, its support, and the paraphernalia of the room, and finally allows us to decipher the tangled center of *Interior*. Space in the sculpture is elided, near and far elements are forced into the same plane, and solids are dissolved into lines. The same kind of compressing, dissecting vision, which brings discontinuous things into close proximity and pierces solid forms, is evident in one of Smith's first mature masterpieces, *Hudson River Landscape*.

 If the structure of many of Smith's sculptures is made more complex by his inclusive vision, their imagery is often made equally

107

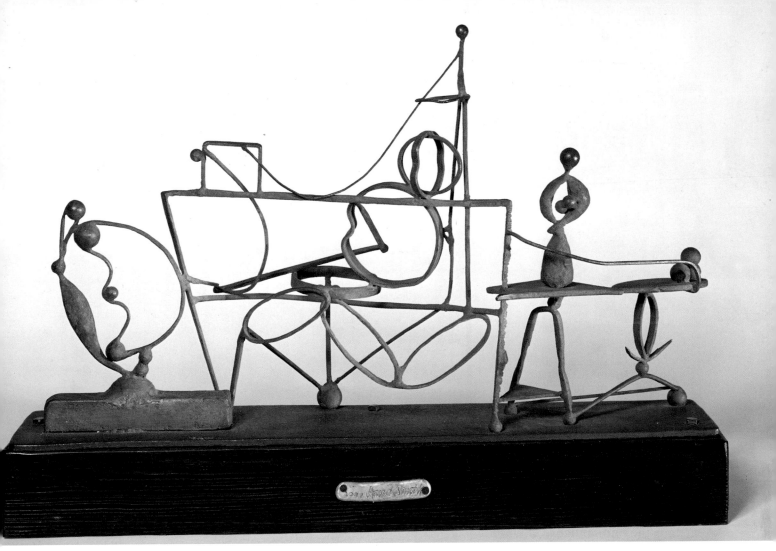

108

107. *The Photographer Leo Lances Photographing a Sculpture*, 1937
Pen and black ink with gray tempera on white paper, 6¾ x 10 in.
Fogg Art Museum, Harvard University, Cambridge, Massachusetts
Gift of David Smith

108. *Interior*, 1937
Steel with cast iron balls, painted with red oxide, 15½ x 26 x 5¼ in.
Weatherspoon Art Gallery
University of North Carolina at Greensboro

complex by a kind of conceptual inclusiveness, a sort of visual punning. Smith frequently combined many tenuously related images in single forms that described nothing literally but reverberated with overtones of all the things they were like. Because of their deliberate ambiguity, it obviously is dangerous to draw too many conclusions about Smith's images, but their multiple associations are undeniable. We have frequently seen a composite cannon-phallus and a cannon-phallus-embryo, which often has birdlike or fishlike qualities as well. In some works, such as *Jurassic Bird* ¹⁰⁹ (1945), the layered imagery is even more elaborate.

Jurassic Bird, at first glance, is a suggestive hierarchy of apparently unrelated elements. A birdlike skeleton is "flown" above a platform that supports two lively winged cannon-phalluses, and is in turn supported by coiling fish forms. A group of notebook drawings conflates the bird skeleton with an Egyptian funerary ¹¹⁰ boat model and renders the fish in the lower levels quite explicitly. ¹¹¹ Another entry itemizes "two fish, one lungfish" and a "foetus form," and in the same book, Smith pasted a clipping about a lungfish revived after spending four months dormant in its container of mud. Significantly, the fish in the drawing for *Jurassic Bird* are given the distinctive limblike ventral fins of lungfish, and the resulting form is an inverted version of the familiar winged

93

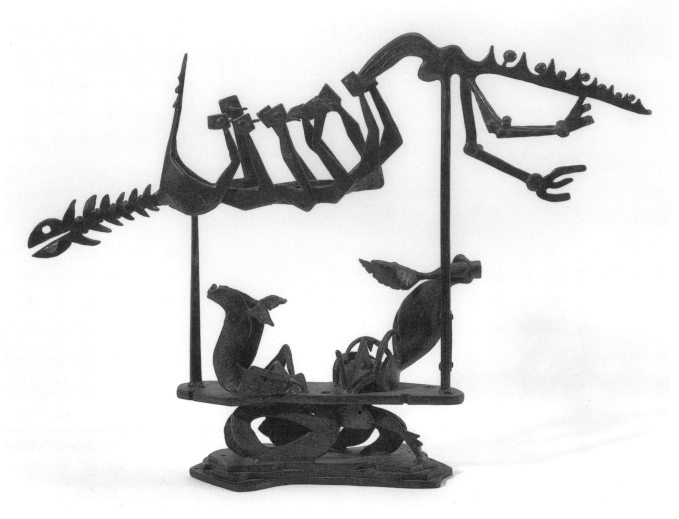

109

cannon-phallus. *Jurassic Bird* is evidently a personal metaphor for hermetic transformation, or preservation, or even the passage of time and the endurance of life, but the allusion is ultimately so private that it remains an undertone rather than a declaration.

Smith's Cubist forebears used visual puns, too, but they were limited to superficial physical similarities: a still life might emphasize the likeness between the circular shapes of grapes, a bottle mouth, and a wine glass, or a portrait stress the equivalence of eyes, nostrils, and buttons. Compared to Smith's palimpsests of meaning, these Cubist puns seem lighthearted and playful, more accurately described as rhymes. Smith, on the other hand, compressed a dreamlike multiplicity of meanings into his images, in a kind of visual free association. He made complex, serious visual puns layered with significance, much like James Joyce's portmanteau words. (Smith admired Joyce greatly and often alluded to his writing in relation to his own work.) Smith's visual punning was perhaps not wholly conscious, but he was certainly aware of using associations. In a talk at Williams College in 1951, he said: "A pear is a violin, a pear is a woman's hips. Pear and violin have

109. *Jurassic Bird*, 1945
Steel, 25⅝ x 35¼ x 7½ in.
Edward Broida

110. *Notebook Drawing for "Jurassic Bird"*
Smith Papers, on deposit at the Archives of
American Art, Smithsonian Institution,
Washington, D.C. (reel 3/70)

111. *Funerary Furnishings—Boat Model,
Tomb of Meket-Re*
The Metropolitan Museum of Art, New York,
Museum Excavation, 1919–20
Rogers Fund supplemented by contribution of
Edward S. Harkness

110

strings, woman has hair. Pear and woman have seeds, violin has notes, soft violin, hard woman, sour notes—associations can go on indefinitely. . . ."[34]

Smith's fondness for this kind of interrelationship arises from the same source as his receptiveness to suggestions that came from the development of a sculpture and his alertness to the possibilities inherent in found objects. His recognition of overlapping characteristics in apparently unrelated images also allowed him to conceal the original, generating image, to dissemble his deepest feelings but at the same time to draw upon them.

Literal, as well as metaphorical, concealment is a recurring motif in Smith's work. *Widow's Lament* (1942) has as its central element a series of hollow square tubes that contain tiny "secret" sculptures. A notebook drawing identifies them as standing for "simplicities of childhood, knots of adolescence, complexities of marriage," and "sorrow," yet they are not only presented as minute, nonspecific geometry, but they are all but hidden within the depths of the narrow tubes. *Landscape with Strata* (1946) retreats from the viewer, turning in on itself. As one moves around the sculpture, elements are obscured, or turn away, rather than revealing themselves more fully. The complex, layered "medallions" of landscape forms that make up the work could be seen fully only if the viewer were within the sculpture.

Some of the Zigs are equally elusive and secretive. The large rectangular planes of *Zigs IV, VII,* and *VIII* are barriers to sight. We intimate the structure of the sculpture because of the elements that penetrate the planes, but our memory of other views obscured by the tilted planes determines our perception as much as our vision. The last burnished steel pieces are equally hard to grasp visually. When they are seen in the outdoor light that Smith intended, the light-diffusing scribbled drawing of the Cubis virtually dissolves their surfaces and obscures their mass. Rather than the physical barriers of the Zigs, we are faced with a purely optical camouflage, which, when it succeeds, transforms the boxy, potentially inert forms of the sculptures.

112
113
114

111

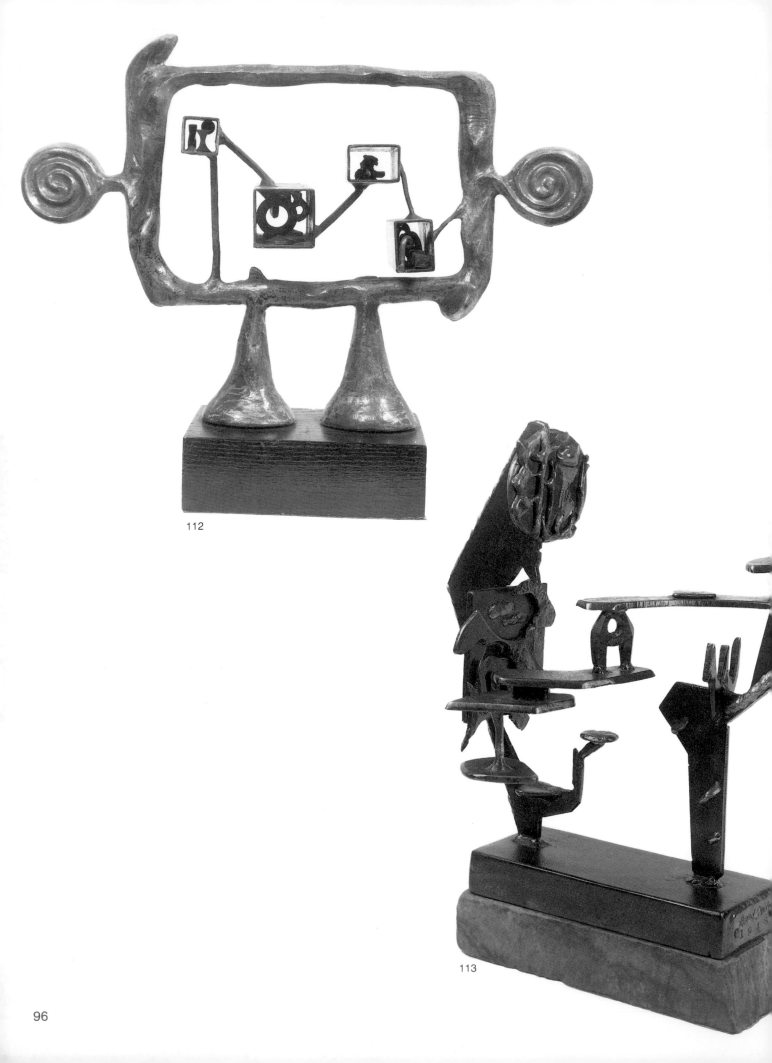

112

113

This visual elusiveness is sometimes due to Smith's tendency to make front and back views of his sculpture radically different from end views. Since each side is autonomous, we cannot imagine one from the information provided in another. This is, to an extent, simply a function of the thinness or, at least, the flatness of many of the elements in Smith's sculptures, and of the open, drawinglike way he usually assembled them. It is also a legacy of the fact that large-scale pieces were almost always started on the floor, laid out flat against white painted surfaces, like the positives of Smith's stenciled spray paintings. During this stage of making the sculpture, the frontal view was the only view and the piece was often fairly well developed before it was hoisted up and considered as a freestanding object. But the unlikeness of the sides of Smith's sculptures is also the result of a deliberate choice: his refusal to fulfill the expectations aroused by a single side, his refusal to treat a three-dimensional form in a conventional "in the round" manner.

When Smith first hit his stride, he seemed consciously to avoid

116

112. *Widow's Lament*, 1942
Steel and bronze, 14½ x 20 x 6⅝ in.
Private collection

113. *Landscape with Strata*, 1946
Steel, bronze, and stainless steel, 16⅞ x 21 x 8½ in.
Dr. and Mrs. Arthur E. Kahn, New York

114. *Zig VII*, 1963
Steel, painted yellow, red, and blue, 94 x 106 x 85 in.
Collection of Candida and Rebecca Smith

114

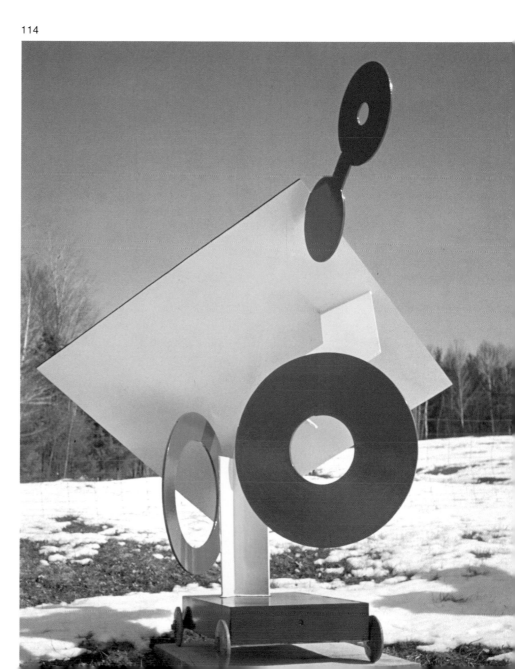

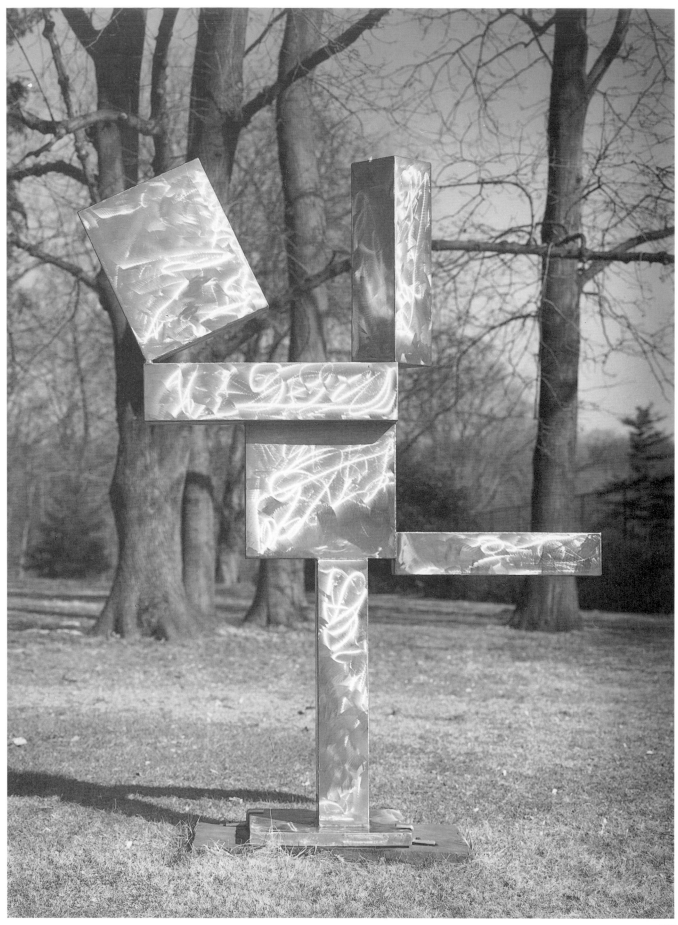

116

traditional sculptural themes, or at least, he seemed consciously to embrace nontraditional motifs for sculpture: interiors, buildings, landscape, still life. (There is relatively little still life, which may have something to do with the fact that Picasso had already claimed that territory.) In the 1950s and '60s, however, Smith apparently felt able (or compelled) to deal with the time-honored theme of the vertical confronting figure, without compromising his modernism. In time, verticality and confrontation became his dominant motifs, so much so that the insistent horizontality of Anthony Caro's early work seems as much a conscious avoidance of Smith's example as it is a way of making objects that have no latent sense of the figure. For it is the verticality and confrontational nature of Smith's sculpture that makes us see them as personages. Of course, we tend to anthropomorphize most three-dimensional things, translating a bridge's span into a "leap" across a river, or perceiving an extended steel bar as the gesture of an arm, but uprightness makes this sensation more acute. Smith's often-quoted insistence that he made only "girl sculptures" obviously can't be taken too literally, since a great many works of the 1950s and '60s are far from humanoid, while others seem aggressively masculine, hermaphroditic, or at least androgynous. The great majority, however, do allude to the figure—but only from certain views. From other aspects, because of Smith's habit of strongly differentiating each side of his sculptures, allusive forms can dissolve into transparent, nonallusive structures.

This is characteristic of González's work, too. In his early portrait masks, we may read a witty but fairly literal image from one viewpoint, but other views are unexpectedly open and inventive. González learned from these side views and eventually treated all aspects of his constructed sculpture with the same audacity. Smith was never as literal as González, but the structure of his sculptures often functions in similar ways. There is the same unexpectedness of various views.

The fact that sculptures that look fairly solid from particular viewpoints can be seen through from others, as is the case in *Voltri XVII*, has been used as evidence of Smith's conflicting sense of desire and denial of the human body.[35] While this is neither provable nor disprovable, it is worth noting that the simultaneous solidity and transparency of Smith's sculptures has other functions and explanations as well. The phenomenon has its origins in the notion of "*passage*" in modernist painting. When painting began to depend upon the relationships of detached strokes and planes, instead of the illusion of continuous form set within a coherent space, *passage* provided an implied connection between these discontinuous touches, a purely visual relationship of separate strokes across the expanse of the canvas. A case can be made for the assumption of a similar role by space and interval in modernist constructed sculpture, when solid forms were replaced by open, drawinglike structures. In painting, even the most staccato touches are physically united by the unbroken surface of the canvas (although variations of color and value sometimes appear to destroy that unity). In open constructed sculpture, however, there is a great degree of physical separateness. No matter how solid Smith's

115. *Cubi V*, 1963
Stainless steel, 96 x 73 x 22 in.
Mrs. H. Gates Lloyd, Haverford, Pennsylvania

116. *Untitled*, 1962
Spray paint on paper, 19¾ x 26 in.
Collection of Candida and Rebecca Smith

sculpture may appear from certain viewpoints, there is actual distance between the elements, actual space between shapes and forms. This space has to be bridged mentally, and the overall unity of the sculpture must overcome the distances, if the work is to succeed.

To interpret these voids as evidence of anxiety about the body seems to me excessively literal-minded. Smith's sculptures are metaphorically, not physically disembodied. It can be argued just as convincingly that his habit of obscuring our vision from one point of view and then allowing us to penetrate the sculpture from another point of view serves to make the works more physically present, not less. Since little in their facture is concealed, our preconceptions are dislocated and we are forced to look at what is really there. The edges of planes, their abutment and joining, the articulation of plane to plane are all laid bare. The radical differences between end views and frontal views accentuate the three-dimensional characteristics of even Smith's flattest sculptures, making the smallest variations from flatness seem eloquent. Since our notion of the work is forcibly altered as we move around it, our sense of the sculpture as a physical object is heightened.

We are acutely conscious of the presence of Smith's hand, even in large, obviously machine-worked pieces. The sense of his singular and delicate touch, of the sculpture having been wrought by a particular individual, is overwhelming. The surprising twist of the steel bars in *Wagon III*, its crosslegged stance, the nudging out of true of its elements are all typical manifestations of the sensitivity to nuance that characterizes Smith's best work. The sculptures seem to need this sense of touch in order to succeed. Its absence in the works made of precut and almost prefabricated stainless steel may account for their frequent failure, while the gestural burnishing of their surfaces may be, in part, a way of Smith's getting the human hand back in. (The hand guiding the burnishing grinder was, however, sometimes that of Smith's assistant.)

But at the same time that Smith's sculptures assert their physical presence, they are undeniably sculptures for the eyes only, wholly dependent upon visual association for their unity. This is of particular interest because of Smith's close association with painters, rather than with sculptors. Yet like so much about Smith's work, the relationship between his sculpture and the painting of his friends and colleagues is loose and ambiguous. (Interesting, though, is the almost complete lack of relationship between Smith's painting and that of his painter friends.) In the early years it is easy to find Smith sharing common preoccupations with his close friend Adolph Gottlieb. The similarities between Gottlieb's Pictographs of the 1940s and sculptures such as *The Letter* are quite evident. Later, Smith's long-lasting friendships with Helen Frankenthaler, Robert Motherwell, and Kenneth Noland had curious reverberations in his sculpture. (The reverse is true of their painting as well.) Smith's response to the concerns of his painter colleagues is arguably no different from his response to anything else that stimulated him visually, but the fact that Smith's echoes of Frankenthaler's, Motherwell's, or Noland's works were not provoked by casual viewings but by a prolonged interest and involvement makes the connections more intriguing.

93

119

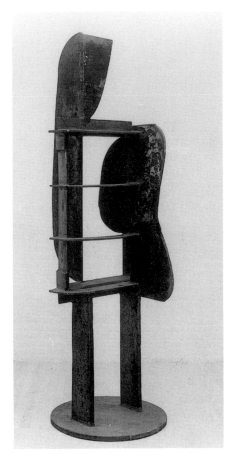

117

117. *Voltri XVII*, 1962
Steel, 95 x 31⅜ x 29¾ in.
Lois and Georges de Menil

118. *Tanktotem IV*, 1953
Steel, 92⅝ x 34 x 29 in.
Albright-Knox Art Gallery, Buffalo, New York
Gift of Seymour H. Knox, 1957

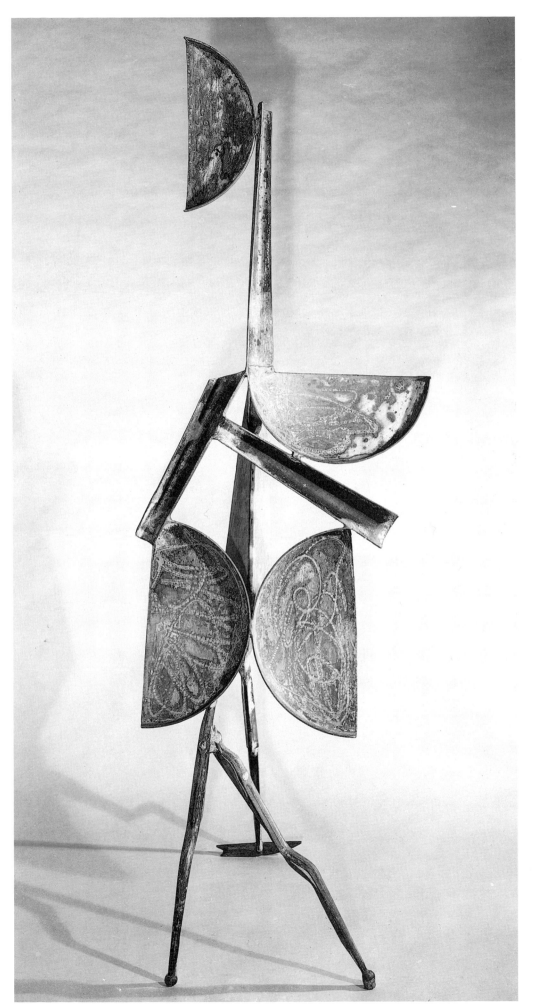

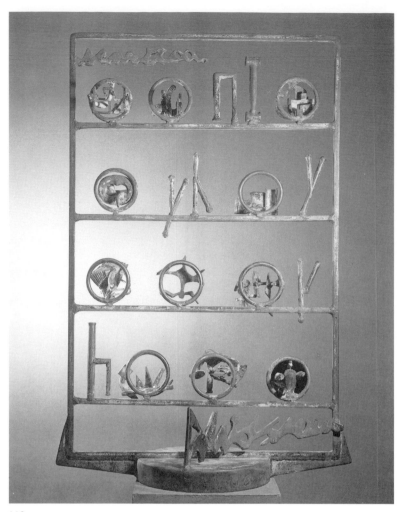

119

120 At least one of Smith's sculptures of the early 1960s, *Gondola*
121 (1961), seems quite directly based on a Motherwell Elegy. Mother-
well recalls Smith's having proposed a collaboration: he would
help the painter make sculptural versions of the Elegies. Motherwell
declined, ". . . because I could never imagine what an Elegy would
look like from the side."[36] Smith, however, appears to have pro-
ceeded on his own. *Gondola* is unusual in that the several shapes
derived from the ovals and bars of the Motherwell image have been
cut already joined out of a single sheet of steel, rather than being
collaged together as one would expect. The general paintinglike
quality of the piece has many precedents in Smith's work, but the
uninflected flatness and literalness of the translation of the image
is less typical.

122 Something similar occurs in the Circle series, which have fre-
quently been compared to Kenneth Noland's Targets. Like *Gondola*,
the Circles can be read as painted figures that have been cut out
from their grounds and arranged in space. It seems odd that Smith,
whose own amalgamating vision ought to have made him see
Motherwell's or Noland's pictures as indivisible wholes, should
have chosen to isolate the characteristic configurations of the Ele-
gies and the Targets. Perhaps because of this rather uninspired
"translation," neither the Circles nor *Gondola* ranks among Smith's
best work.

119. *The Letter*, 1950
Steel, 37⅝ x 22⅞ x 11 in.
Munson-Williams-Proctor Institute, Utica,
New York

The Circles also suggest a connection with Jules Olitski's stain Core pictures, painted between late 1961 and 1963. The generous, floating rings of color in these pictures imply some kinship with the Smith sculptures. Smith and Olitski would have been aware of each other's work at this time, since both were exhibiting at French and Company, and shared common friendships with Noland and Greenberg. Of course, the Core paintings may also reflect Olitski's awareness of Noland's Targets, but the bumptious energy of Olitski's pictures seems closer to the vernacular, improvised quality of Smith than to the cool elegance of Noland. In fact, the near-precision of the Circle sculptures—their clean edges, pure geometry, and smooth paint—the attributes that make them seem particularly close to Noland's sensibility, set them apart from most of Smith's production. (The Circles are even more clean edged than most of the Targets.)

If there are specific instances of relationship between Smith's work and that of Motherwell and Noland, there are more unexpected parallels and far stronger congruences of attitude in the work of Frankenthaler and Smith. Like Smith's early sculpture, Frankenthaler's early paintings employ a vocabulary of partly revealed private allusions; like Smith, Frankenthaler combines an idiosyncratic, personal handwriting with a fundamentally Cubist notion of construction. For both artists, the conception of Cubism is tempered and ultimately profoundly altered by even stronger notions of openness and expansiveness. And for both Frankenthaler and Smith, the tension between the insinuated, almost recognizable image and the work's existence as "pure" painting or sculpture is an important part of its impact.

Perhaps the most obvious resemblance between the work of the two artists can be found in the soft-edged shapes in Smith's Voltris, which are like solidified versions of Frankenthaler's pours. (Since Smith's "chopped clouds" are solidified remains of once-molten steel, the analogy is not farfetched.[37]) Smith seems to have been following Frankenthaler's lead just as he had alluded to Motherwell's Elegies the year before. Since Frankenthaler was more than twenty years younger than Smith and since she had met him at the very beginning of her career, it is easy to assume that she would have been the one to have been influenced. But the evidence of the Voltris implies that once again, Smith was alert to suggestions offered by a great variety of sources, and that the relationship between the work of Frankenthaler, Motherwell, and Smith remains a provocative issue.

On a practical level, Smith's working habits set a kind of example for his younger colleagues. Kenneth Noland has remarked that Smith ". . . knew more about how to go about working than any other artist I've ever known personally. . . ."[38] Smith's energetic way of getting on with the task, of making more sculpture and learning from previous works, rather than laboriously readjusting them in pursuit of the unique masterpiece, was influential. (This is not to say that masterpieces were not produced.) Smith's large stockpiles of painting and sculpture materials also had their effect. While they may have been a legacy of the factory production system on which he modeled his studios, the quantity of stuff at his disposal

123

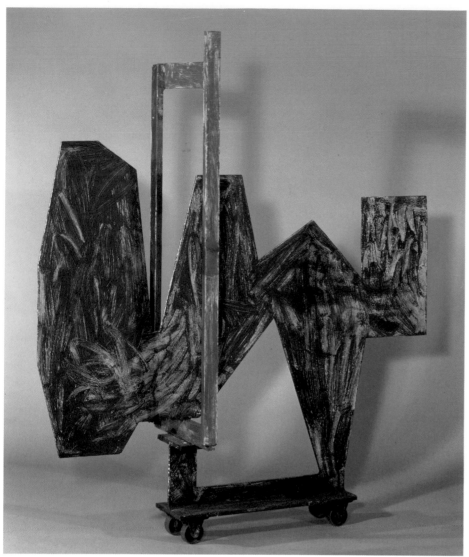

120

afforded him enormous freedom and liberated him from any lingering sense of the preciousness of materials. Smith's colleagues were quick to adopt many of his beneficial practices.

On another level, the influence of Smith's aesthetic on younger sculptors has been at once overwhelming and slightly indirect, being, until recently, often filtered through Anthony Caro. Caro, whom the older man influenced profoundly, showed a subsequent generation a way around Smith's influence, and his example, in turn, became the stumbling block for many younger artists who shared Smith's and Caro's beliefs of what sculpture could be. It is ironic that Smith's importance has not only been subject to dilution, because of Caro's influence, but that some of the most visible work attributable to his example is the result of misinterpretation of what Smith was about. A debased notion of the Cubis can be seen in the work of many Minimalist sculptors although the intent was entirely different. The anonymity of these objects is, of course, antithetical to Smith's concerns.

However, a younger generation of sculptors seems to be rediscovering Smith and to be finding the powerful sense of the hand apparent in his work to be of special interest. This seems related to

121

the reintroduction of freely stroked, worked surfaces in the painting of the past decade, after the smoothness and lack of inflection of so many pictures of the 1960s and early '70s. For similar reasons, the quirky idiosyncrasy of Smith's work now seems to speak to younger artists, whereas ten years ago it was his (uncharacteristic) geometry that engaged their attention. There is even some evidence that he offers them a way of approaching his Cubist predecessors.

If Smith's current influence is diverse and not easy to identify, his relationship to his own generation and to Abstract Expressionism in general is just as elusive. While he and his New York contemporaries often shared similar experiences during their formative years, Smith seems to have separated himself from many of those early colleagues. (Motherwell was almost a decade younger than Smith, and they became close only when Smith was over fifty and Motherwell in his forties). Smith's attitudes and aspirations, in terms of expressiveness and formal invention, are certainly shared by the best American abstract artists of his generation, but his sculpture eschews the look of orthodox Abstract Expressionism. Except for his brushy painting of some sculptures, and except for a small group of aggressively textured pieces of the 1950s, Smith's work seems to have few of the qualities closely associated with the Abstract Expressionist aesthetic. His colleagues usually liked their art to demonstrate graphically how it evolved, to appear unpremeditated and even still in progress. The "finished" work frequently gave the viewer clues to its previous states, at the same

122

120. *Gondola*, 1961
Painted steel, 69 x 61 x 18 in.
The Chrysler Museum, Norfolk, Virginia
Gift of Walter P. Chrysler, Jr.

121. Robert Motherwell
Elegy to the Spanish Republic, No. 134, 1974
Acrylic on canvas, 96 x 120 in.
Private collection

122. *Circle V (Circle: Black, White, and Tan)*, 1963
Steel, painted black, white, and tan, 77 x 92 x 20 in.
The First National Bank of Chicago

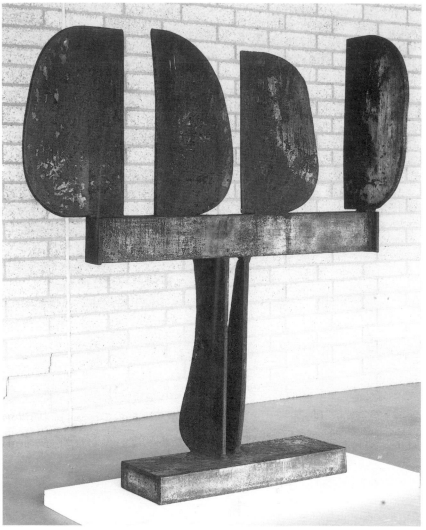

123

time that it suggested possible future states. Smith obviously val-
ued spontaneity and allowed his sculpture to reveal how it was
made, but he preferred an appearance of inevitability rather than
one of potential mutation. (If a sculpture did suggest possible
mutation or variation to him, he would realize this in subsequent
works, instead of leaving the suggestion unfulfilled.)

No matter how rich and ambiguous the meaning of Smith's
sculpture may be, its structure always affirms clarity and singleness.
He meticulously avoided the slide of one form into another or of
one layer over another—even when one part of the sculpture
concealed another, as in the Zigs.

He stressed instead the lucid articulation of part to part. The
sense of Smith's role in having shaped every part of the sculpture,
which I have remarked upon before, is a paramount aspect of his
art, yet it is not the near-obsessive manipulation—the layering,
excavating, and relayering—of, for example, de Kooning. Smith
announces his role in the making of the sculpture by demonstrat-
ing his decisiveness; he does not suggest the infinite number of
possibilities along the way to that decision. His best work is highly

123. *Voltri IV*, 1962
Steel, 68½ x 59¾ x 14½ in.
Rijksmuseum Kröller-Müller, Otterlo,
The Netherlands

charged, animated, and looks as though no part of it could be changed in any way.

If de Kooning's palimpsests represent one extreme of New York abstraction of Smith's generation, and Rothko's cool mysticism another, Smith's potent but ultimately unnameable objects claim a terrain of their own. While they share affinities with the work of his contemporaries, Smith's sculptures established new definitions of the concerns of Abstract Expressionism and set new standards for modernist sculpture. Smith was obviously of his time but not confined by it. When we are confronted by his insistent and unexpected inventions, we are in the presence not merely of a major American artist of the mid-twentieth century, but of a towering modern master.

NOTES

1. David Smith Papers, n.d., Archives of American Art, Smithsonian Institution, Washington, D.C., roll ND Smith 4, frame 360. Reprinted in Cleve Gray, ed., *David Smith by David Smith*, p. 17.

2. Sam Hunter, *David Smith*, p. 3.

3. Garnett McCoy, ed., *David Smith*, p. 177. Originally "The Secret Letter," interview by Thomas B. Hess, published as exhibition catalog, Marlborough-Gerson Gallery, New York, October 1964.

4. Ibid.

5. Ibid., p. 149. Originally "Memories to Myself," speech to the National Committee on Art Education, Museum of Modern Art, New York, May 5, 1960.

6. Ibid., p. 172. Originally an interview by David Sylvester, June 16, 1961, published in *Living Arts*, April 1964.

7. Gray, *Smith by Smith*, p. 24.

8. McCoy, *Smith*, p. 82. Originally a paper delivered at the symposium "The New Sculpture," Museum of Modern Art, New York, February 21, 1952.

9. For information of Smith's early years, I am indebted to Dorothy Dehner, in conversation, spring 1978, and to Esther Gottlieb, in conversation on various dates. See also Gray, *Smith by Smith*, pp. 24–33. Originally autobiographical notes, c. 1950.

10. For a complete list of exhibitions held in New York in the 1920s, see William S. Lieberman, ed., *Art of the Twenties* (New York: Museum of Modern Art, 1979), "Chronology."

11. Conversation with Dehner, spring 1978.

12. McCoy, *Smith*, p. 206. Letter to Jean Xceron, February 7, 1956. Xceron taught Smith how to write his name in Greek characters and devised the Greek inscriptions on Smith's Medals for Dishonor.

13. Ibid., p. 86. Originally notes kept in a sketchbook, c. 1952.

14. Ibid., p. 168. Originally Sylvester interview.

15. Ibid., p. 85. Originally notes, c. 1952.

16. Ibid., p. 82. Originally "The New Sculpture."

17. Ibid., p. 84.

18. Ibid., p. 85.

19. Among the most provocative of the early polychrome pieces, *Billiard Player Construction* not only has planes differentiated by contrasting red and blue paint, but also has a surprising illusionistic painted passage on the back, which completes, or at least continues, forms partially rendered in sculptural terms. *Helmholtzian Landscape*, one of the most spectacular of the early painted works, reflects Smith's interest at the time of its making in formal color theory such as that of Helmholtz and Chabrol.

20. Marcia Epstein Allentuck, *John Graham's System and Dialectics of Art* (Baltimore: John Hopkins Press, 1971), p. 154.

21. Christian Zervos, "Quelques notes sur les sculptures de Giacometti," *Cahiers d'art* 7/8–10 (1932): 337–42, reproduced *The Palace at 4 a.m.* It was included in the Museum of Modern Art's 1936 exhibition, *Fantastic Art, Dada and Surrealism*, and although Smith did not see the exhibition, the work was acquired by the museum in December 1936 and frequently exhibited.

22. McCoy, *Smith*, p. 40. Originally an address at the Forum on Abstract Art at the Labor Stage, New York, February 15, 1940. Excerpts published in *New York Artist*, April 1940.

23. Gray, *Smith by Smith*, p. 29. Originally autobiographical notes, c. 1950. "1940. . . . For three or four years I'd been working on the series of Medallions. I was trying to cast them at iron works out of block tin—I abandoned all of the first year's work on those medals due to unsatisfactory casting. Did a new series—which I *had* cast in bronze. Finally I wound up by finding a jeweler to cast them for me. See also McCoy, *Smith*, pp. 170–71. Originally Sylvester interview.

24. McCoy, *Smith*, pp. 203–4. Letter to Franklin Page, June 23, 1949.

25. Ibid., p. 179. Originally Hess interview.

26. The numbering and sequences of Smith's series are often irregular. The dates of making (or of completion) recorded on the works do not always correspond with the sequence of title numbers. See E. A. Carmean, Jr., *David Smith*, for detailed discussion.

27. Smith papers, c. 1952, Archives of American Art, Smith, roll 3, frame 360. Reprinted in Gray, *Smith by Smith*, p. 170.

28. For an exhaustive discussion of Smith's working methods and detailed discussion of the series Agricolas, Sentinels, Zigs, Circles, Voltri-Boltons, Wagons, and Cubis, see Carmean, *David Smith*. For detailed discussion of the Voltris, see E. A. Carmean, Jr., "David Smith: The Voltri Sculpture."

29. McCoy, *Smith*, p. 171. Originally Sylvester interview.

30. Also participating in the exhibition were Calder, Chadwick, Chillida, Consagra, Franchina, Lipton, Manzu, Marini, Moore, Pomodoro, Richier, and Rosati. Smith was originally contacted by the American sculptor Beverly Pepper, who was living in Rome. See Giovanni Carandente, *Voltron* (Philadelphia: Philadelphia Institute of Contemporary Art, University of Pennsylvania, 1964).

31. In conversation with the author, c. 1976.

32. McCoy, *Smith*, p. 185. Originally Hess interview.

33. See Carmean, *David Smith*, pp. 73–76.

34. Ibid., p. 78. Originally speech delivered December 17, 1951.

35. See Rosalind E. Krauss, *Terminal Iron Works: The Sculpture of David Smith*, chapter three, "Denial of Possession."

36. Carmean, *David Smith*, pp. 60–61.

37. E. A. Carmean, Jr., has also remarked upon this similarity. Letter to the author, 1981.

38. Carmean, *David Smith*, p. 17. Originally in Cleve Gray, ed., "David Smith," *Art in America* 54 (January–February 1966): 44.

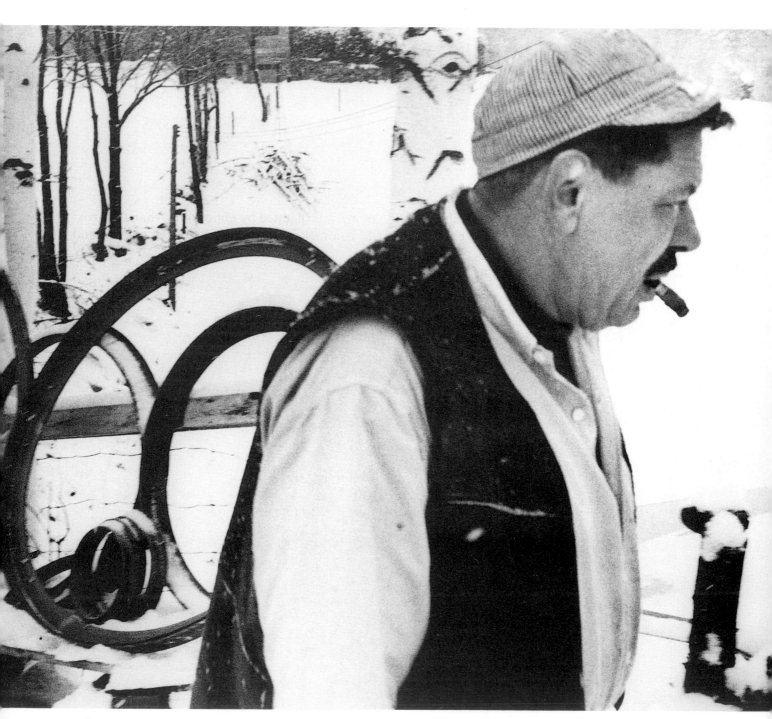

Artist's Statements

I believe that my time is the most important in the world—that the art of my time is the most important art—that the art before my time has made no immediate contribution to my aesthetics since that art is history, explaining past behavior, but not necessarily offering solutions to my problems. Art is not divorced from life. It is dialectic. It is ever changing and in revolt with the past. It has existed in the minds of free men for less than a century. Prior to this, the direction of art was dictated by minds other than the artist for exploitation and commercial use. The freedom of man's mind to celebrate his own feeling by a work of art parallels his social revolt from bondage. I believe that art is yet to be born and that freedom and equality are yet to be born.

If you ask why I make sculpture, I must answer that it is my way of life, my balance, and my justification for being.

If you ask for whom do I make art, I will say that it is for all who approach it without prejudice. My world, the objects I see are the same for all men of good will. The race for survival I share with all men who work for existence.

> Statement made at a forum held by the *New York Herald Tribune* and the New York City Board of Education, March 19, 1950; quoted in Cleve Gray, *David Smith by David Smith*, p. 63.

The words I use in talking about art do not bear close relationship to making art, nor are they necessary directives or useful explanations. They may represent views that govern some choice in sublimation—censored exchange or as opposites. When I work the train of thought has no words, it is simply all in the visual world, the language is image. If I write it is not at the expense of my work, it is done during travel and nonwork pursuit. . . .

My realities giving impetus to a work which is a train of hooked visions arise from very ordinary locales—the arrangement of things under an old board; stress patterns; fissures; the structure pattern of growth; stains; tracks of men, animals, machines; the accidental or unknown order of forces; accidental evidences such as spilled paint, patched sidewalks, broken parts, structural faults; the force lines in rock or marble laid by glacial sedimentation. Realistic all,

124. David Smith
Photograph by Dan Budnik

made by ancient pattern or unknown force to be recorded, repeated, varied, transformed in analogy or as keys to contemporary celebrations. Some works are the celebration of wonders. After several of these a specter. In my life, joy, peace are always menaced. Survival, not only from commercial destruction but the threat of daily existence, the battle of money for material—and welfare during.

Arts and Architecture (February 1952); quoted in Gray, *David Smith by David Smith*, pp. 78, 79.

Questions to Art Students

1. Do you make art your life, that which always comes first and occupies every moment, the last problem before sleep and the first awaking vision?

2. Do all the things you like or do amplify and enjoin the progress of art vision and art making?

3. Are you a balanced person with many interests and diversions?

4. Do you seek the culture of many aspects, with the middle-class aspiration of being well-rounded and informed?

5. How do you spend your time? More talking about art than making it? How do you spend your money? On art materials first—or do you start to pinch here?

6. How much of the work day or the work week do you devote to your profession—that which will be your identity for life?

7. Will you be an amateur—a professional—or is it the total life?

8. Do you think the artist has an obligation to anyone but himself?

9. Do you think his contemporary position is unique or traditional?

10. Do you think art can be something it was before? Can you challenge the ancients?

11. Have you examined the echoes of childhood and first learning, which may have once given you the solutions? Are any of these expectancies still operating on your choices?

12. Do you hold with these, or have you recognized them? Have you contradicted them or have you made metaphoric transposition?

13. Do you examine and weigh the art statements of fellow artists, teachers, authorities before they become involved in your own working tenets?

14. Or do the useful ideas place themselves in a working niche of your consciousness and the others go off unheard?

15. Do you think you owe your teachers anything, or Picasso or Matisse or Brancusi or Mondrian or Kandinsky?

16. Do you think your work should be aggressive? Do you think this an attribute? Can it be developed?

17. Do you think your work should hold within tradition?

18. Do you think that your own time *and now* is the greatest in the history of art, or do you excuse your own lack of full devotion with the half belief that some other time would have been better for you to make art?

125

125. *Blackburn: Song of an Irish Blacksmith,* 1949–50, side view
See plate 46

126. *Tanktotem VI,* 1957
Steel, painted brown, height: 103⅞ in.
Collection of Candida and Rebecca Smith

19. Do you recognize any points of attainment? Do they change? Is there a final goal?

20. In the secret dreams of attainment have you faced each dream for its value on your own basis, or do you harbor inherited aspirations of the bourgeoisie or those of false history or those of critics?

21. Why do you hesitate—why can you not draw objects as freely as you can write their names and speak words about them?

22. What has caused this mental block? If you can name, dream, recall vision and auras why can't you draw them? In the conscious act of drawing, who is acting in your unconscious as censor?

23. In the conceptual direction, are you aiming for the successful work? (To define success I mean the culminating point of many efforts.)

24. Do you aim for a style with a recognizable visual vocabulary?

25. Do you polish up the work beyond its bare aesthetic elements?

26. Do you add ingratiating elements beyond the raw aesthetic basis?

27. If you add ingratiating elements, where is the line which keeps the work from being your own?

28. Are you afraid of rawness, for rawness and harshness are basic forms of U.S. nature, and origins are both raw and vulgar at their time of creation?

29. Will you understand and accept yourself as the subject for creative work, or will your effort go toward adapting your expression to verbal philosophies by non-artists?

30. If you could, would you throw over the present values of harmony and tradition?

31. Do you trust your first response, or do you go back and equivocate consciously? Do you believe that the freshness of first response can be developed and sustained as a working habit?

32. Are you saddled with nature propaganda?

33. Are you afraid to exercise vigor, seek surprise?

34. When you accept the identification of artist do you acknowledge that you are issuing a world challenge in your own time?

35. Are you afraid to work from your own experience without leaning on the crutches of subject and the rational?

36. Or do you think that you are unworthy or that your life has not been dramatic enough or your understanding not classic enough, or do you think that art comes from Mount Parnassus or France or from an elite level beyond you?

37. Do you assert yourself and work in sizes comparable to your physical size or your aesthetic challenge or imagination?

38. Is that size easel-size or table-size or room-size or a challenge to nature?

39. Do you think museums are your friend and do you think they will be interested in your work?

40. Do you think you will ever make a living from museums?

41. Do you think commercial art, architectural art, religious art offer any solution in the maturing of your concepts?

42. How long will you work before you work with the confidence which says, "What I do is art"?

43. Do you ever feel that you don't know where to go in your work, that the challenge is beyond immediate solution?

126

44. Do you think acclaim can help you? Can you trust it, for you know in your secret self how far short of attainment you always are? Can you trust any acclaim any farther than adverse criticism? Should either have any effect upon you as an artist?

In particular, to the painter—

Is there as much art in a drawing as in a watercolor—or as in an oil painting?

Do you think drawing is a complete and valid approach to art vision, or a preliminary only toward a more noble product?

In particular, to the sculptor—

If a drawing is traced, even with the greatest precision, from another drawing, you will perceive that the one is a copy. Although the differences may deviate less than half a hair, recognizable only by perceptual sensitivity, unanimously we rule the work of the intruder's hand as non-art.

But where is the line of true art—when the sculptor's process often introduces the hands of a plaster caster, the mold maker, the grinder and the polisher, and the patina applier, all these processes and foreign hands intruding deviations upon what was once the original work?

> Undated transcript, c. 1953–54; quoted in Gray, *David Smith by David Smith*, pp. 111–13.

Art has its tradition, but it is a visual heritage. The artist's language is the memory from sight. Art is made from dreams, and visions, and things not known, and least of all from things that can be said. It comes from the inside of who you are when you face yourself. It is an inner declaration of purpose, it is a factor which determines artist identity.

> From a speech given April 17, 1959, at Ohio University; quoted in Gray, *David Smith by David Smith*, p. 147.

Notes on Technique

Smith prided himself on his mastery of a great range of techniques and wrote several articles and lectures about the technical aspects of twentieth-century sculpture making. He prided himself, too, on the factorylike working methods he adhered to and similarly published descriptions of his working day. He is his own best spokesman in discussing his working methods. The following quotations are excerpted from notes that Smith prepared for an article on his work by Elaine de Kooning in the September 1951 *Artnews*; the notes themselves were printed in *Artnews*, January 1969.

I follow no set procedure in starting a sculpture. Some works start out as chalk drawings on the cement floor, with cut steel forms working into the drawings. When the structure can become united, it is welded into position upright. Then the added dimension requires different considerations over the more or less profile form of the floor drawing assembly.

Sometimes I make a lot of drawings using possibly one relationship on each drawing which will add up in the final work. Sometimes sculptures just start with no drawing at all. . . . My drawings are made either in work books or on large sheets of linen rag. I stock bundles of several types, forgetting the cost so I can be free with it. The cost problem I have to forget on everything, because it is always more than I can afford—more than I get back from sales—most years, more than I earn. My shop is somewhat like the Federal Government, always running with greater expenditures than income and winding up with loans. . . . When I'm involved aesthetically I cannot consider cost, I work by the need of what each material can do. Usually the costly materials do not even show, as their use has been functional.

I have two studios. One clean, one dirty, one warm, one cold. The house studio contains drawing tables, etching press, cabinets for work records, photos, and drawing paper stock. The shop is a cinderblock structure, transite roofed, and has a full row of north window skylights set at a 30 degree angle. With heat in each end it is usable to zero weather. . . .

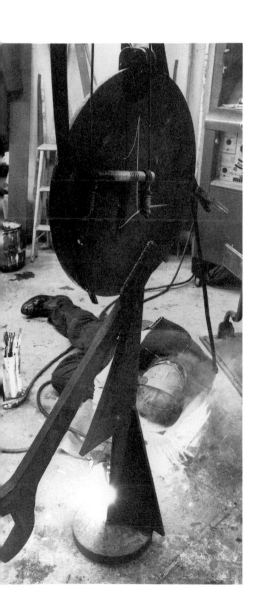

127. David Smith, 1963
Photograph by Dan Budnik

Stainless steel, bronze, copper, aluminum are stocked in ⅛ inch by 4 foot by 8 foot sheets for fabricating. Cold and hot rolled 4 foot by 8 foot sheets are stacked outside the shop in thicknesses from ⅛ inch to ⅞ inch. Lengths of strips, shapes, and bar stock are racked in the basement of the house or interlaced in the joists of the roof. Maybe I brag a bit about my stock, but it is larger since I've been on a Guggenheim Fellowship than it ever has been before. I mention this not because it has anything to do with art, but it indicates how important it is to have material on hand, that the aesthetic vision is not limited by material need, which has been the case too much of my life.

By the amount of work I produce it must be evident that the most functional tools must be used. I've no aesthetic interest in tool marks; my aim in material function is the same as in locomotive building, to arrive at a given functional form in the most efficient manner. . . . Each method imparts its function to varying materials. I use the same method in organizing the visual aesthetic end. I make no claim for my work method over other mediums. I do not use it to the exclusion of other mediums. A certain feeling for form will develop with technical skill, but imaginative form (viz. aesthetic vision) is not a guarantee for high technique.

I handle my machines and materials with ease—their physical resistance and the noise they make in use do not interfere with my thinking and aesthetic flow. The change of one machine or tool to the other means no more than changing brushes to a painter or chisels to a carver. . . .

Since 1936 I have modeled wax for single bronze castings. I have carved marble and wood, but the major number of works have been steel, which is my most fluent medium and which I control from start to completed work without interruption. There is gratification of being both conceiver and executor without intrusion. A sculpture is not quickly produced; it takes time, during which time the conviction must be deep and lasting. Michelangelo spoke about noise and marble dust in our profession, but I finish the day more like a greaseball than a miller. But my concepts still would not permit me to trade it for cleaner pursuits.

Distance within the work is not an illusion, it relates to the known measure as inches in most of our considerations. Inches are rather big, monotonous chunks related to big flat feet. The only even inch relationship will be found in the sculpture base wherein the units 4-6-8-12, etc., are used in mechanical support. Rarely will an even inch be involved in visual space, and when it is approached it will occur plus or minus in variants of odd thousandths, odd 64ths, 32nds, and 16ths. This is not planned consciously. It is not important, but is my natural reaction to symbolic life. Unit relationships within a work usually involve the number 7 or a division of its parts. I wasn't conscious of this until I looked back, but the natural selection seems influenced by art mythology.

My work day begins at 10 or 11 A.M. after a leisurely breakfast and an hour of reading. The shop is 800 feet from the house. I carry my 2 P.M. lunch and return to the house at 7 for dinner. The work day ends from 1 to 2 A.M. with time out for coffee at 11:30. My shop here is called the Terminal Iron Works, since it closer

128

128. David Smith at work on *The Cathedral*

129. *The Cathedral* in progress

130. *The Cathedral*, 1950
Steel, painted brown, 34⅛ x 24½ x 17⅛ in.
Private collection

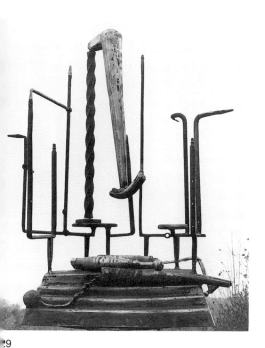

9

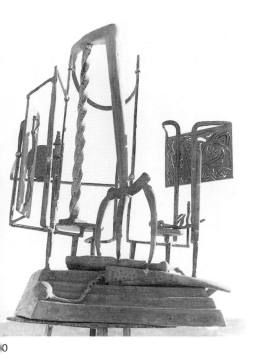

0

defines my beginning and my method than to call it "studio."

I like my solitude, black coffee, and daydreams. I like the changes of nature; no two days or nights are the same. In Brooklyn what was nature was all manmade and mechanical, but I like both. I like the companionship of music. . . . I use the music as company in the manual labor part of sculpture, of which there is much. The work flow of energy demanded by sculpture wherein mental exhaustion is accompanied by physical exhaustion provides the only balance I've ever found, and as far as I know is the only way of life.

After 1 A.M. certain routine work has to be done, clearing up, repairing machines, oiling, painting, etc. . . . After several months of good work, when I feel I deserve a reward, I go to New York, concerts at YMHA, gallery shows, museums, eat seafood, Chinese, go to Eddie's, Nick's, Sixth Avenue Cafeteria, Artists Club, Cedar Tavern, run into up-late artists, bum around chewing the fat, talk shop, finish up eating breakfast on Eighth Street, and ride it as hard and as long as I can for a few days, then back to the hills.

Sculpture is a problem. Both to me and to my dealer, the Willard Gallery. Aside from sales, the problem of transport and storage is immense. The intrinsic cost ofttimes is half its price, and never less than one-third. Only a few serious dealers handle it; some museums and a few collectors buy it. As dwelling space contracts, the size and concept of sculpture increases. I foresee no particular use, other than aesthetic, in society, least of all architecture. But demand was never the thing that made art in our period of civilization.

Sometimes I work on two and possibly four pieces at one time, conceptually involved on one, conceptually in abeyance on another waiting for relationships to complete; and on one or two others finished but for a casting to come from the foundry or grinding, finishing and a few hours of manual labor waiting to be done. Sometimes it's only a matter of mounting, weighing, measuring, and naming. Such detail work fits in schedule when the muse has gone. I maintain my identity by regular work, there is always labor when inspiration has fled, but inspiration returns quicker when identity and the work stream are maintained. Actually time overtakes much of my projects. I get only half of my vision into material form. The rest remains as drawings, which, after a certain time growth, I cannot return to because the pressing demand is the future. I have no organized procedure in creating. . . .

Smith worked with a great variety of media throughout his career and was fascinated by the particularities of each. He seems to have made a great effort to master wood carving, casting in bronze, and relief, as well as a number of painting and drawing techniques. Welding in steel, however, was his principal method, and he wrote the following statement about arc welding c. 1947:[1]

The arc-welding fabrication of sculpture has caused certain changes in aesthetic concepts, just as it has in industrial design. The aim is no longer to imitate a casting. The art concept must be in unity with the method—a recognition of the change of forces, knowledge of the material and respect for the virtues of the method, and a creative vision of the yet unlimited possibilities which the new method has opened.

1. For a detailed discussion of Smith's use of welding, see "David Smith at Work," in E. A. Carmean, Jr., *David Smith*.

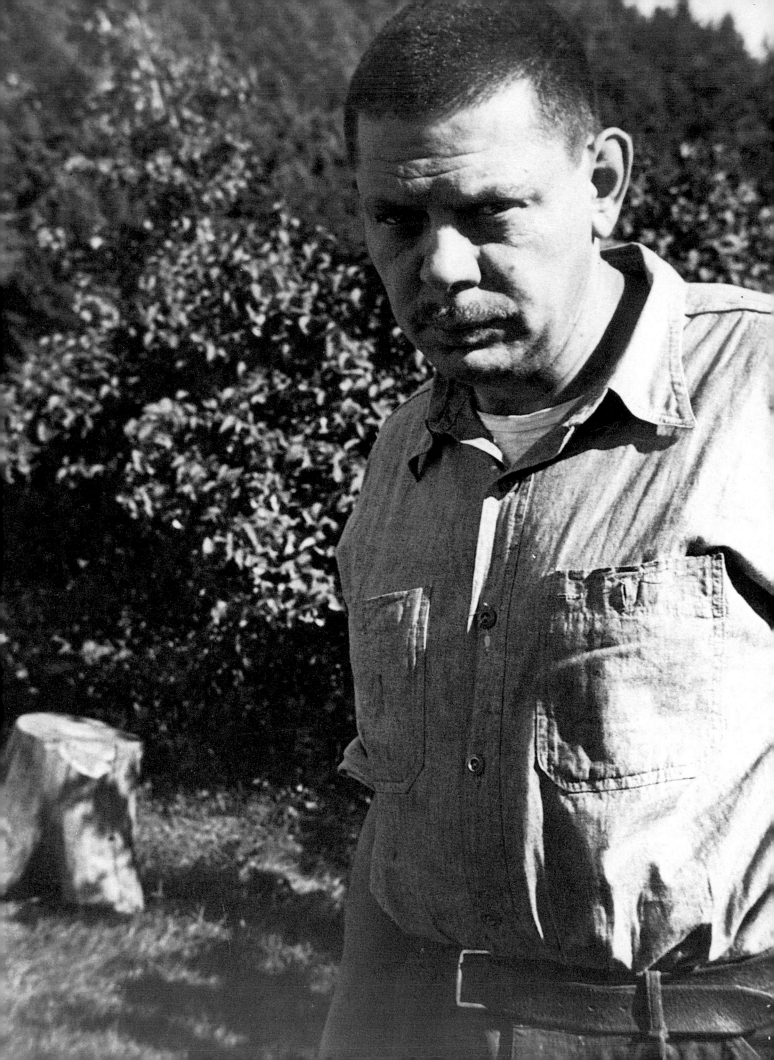

Chronology By Anna Brooke

1906 March 9—David Roland Smith is born to Golda Stoler Smith and Harvey Martin Smith in Decatur, Indiana. Father is a telephone engineer and part-time inventor. His mother is a schoolteacher. Attends grade school and one year of high school in Decatur.

1911 April 7—sister, Catherine, is born.

1921 Moves with his family to Paulding, Ohio, where his father is manager and part-owner of Paulding Telephone Company. Attends Paulding High School.

1923 Takes correspondence course in cartooning from Cleveland Art School.

1924 Spring—completes high school. Fall—enters Ohio University, Athens, for one year; takes art courses.

1925 Summer—works in South Bend, Indiana, as a welder and riveter at Studebaker plant. Fall—registers as a special student in Notre Dame University. Works for banking agency of Studebaker Finance Department, which transfers him to Morris Plan Bank in Washington, D.C.

1926 Moves to Washington, D.C. Lives at 1408 H Street, N.W. Summer—attends two poetry classes at George Washington University. Is transferred to New York City to work for Industrial Acceptance Corporation, West Fifty-seventh Street. Lives in a rooming house at 417 West 118th Street, where he meets Dorothy Dehner, a student at the Art Students League. Begins evening classes at the Art Students League with Richard Lahey.

1927 Early summer—transferred back to South Bend Studebaker office, then goes home at end of summer. Drives back to New York. Fall—becomes full-time student at the Art Stu-

dents League (until 1932). Studies with Jan Matulka (until 1931), Allen Lewis, John Sloan, and Kimon Nicolaides; also makes prints. Works at various part-time jobs. December 24 —marries Dorothy Dehner at City Hall. Moves to 15 Abingdon Square in Greenwich Village.

1928 February–May—works for A. G. Spaulding, the sporting goods store. Spring—works as a seaman on an oil tanker going from Philadelphia to San Pedro, California. Summer—Dehner joins him in Los Angeles and they visit her aunt in Pasadena. Returns to Bayonne, New Jersey, on a tanker. Fall—returns to Spaulding (until October 1931); moves to apartment in Brooklyn on Myra Court (later Beekman Place), Flatbush. Visits artists Thomas and Weber Furlongs' farm at Bolton Landing near Lake George.

1929 Summer—visits the Furlongs for one month. Buys "Old Fox Farm" in Bolton Landing. Fall—moves to 163 Sterling Street, Flatbush. December—makes illustrations for *The Sportsman Pilot* (until 1931).

1930 Meets the artist John Graham about this time. Works free-lance for *Tennis* magazine on layouts (until 1931). March—included in first group exhibition, *Fourth Annual Exhibition of American Block Prints*, Print Club of Philadelphia. Paints in abstract Surrealist style. Sees reproductions of Picasso's and González's welded-metal sculpture in *Cahiers d'art*.

1931 Summer—studies in private class with Matulka. August—goes to Bolton Landing. October—goes to Saint Thomas in the Virgin Islands for eight months.

1932 Makes constructions of wood, coral, and wire. June—returns to New York, then to Bolton Landing. Moves to apartment at 124 State Street, Brooklyn Heights. Buys welding outfit and air-reduction oxyacetylene torch.

1933 Makes carved wood sculptures; makes first all-metal sculptures. Spring and summer—works at Bolton Landing making sculptures and

welding. Fall—returns to New York and job at A. G. Spaulding. Makes series of welded and painted Heads. Through John Graham gets job making bases for Frank Crowninshield's collection of African sculpture, which he helps catalog.

1934 Rents studio space at a machine shop called Terminal Iron Works, at 1 Atlantic Avenue, on the ferry terminal in Brooklyn (until 1940). March 22—assigned to Technical Division of Civil Works Administration, Public Works of Art Project, New York, mural painting project 89. August—becomes assistant project supervisor, Emergency Temporary Relief Administration (until July 1935). John Graham gives him *Head*, by González. October—becomes member of Artists' Committee for Action for the Municipal Art Gallery and Center. Teaches for a few weeks at the Town School, New York City, for Lois Wright, the art teacher.

1935 Spring—signs a call for an American Artists Congress to be held February 1936. July 9—leaves the Temporary Relief Administration. October—takes first trip to Europe. Visits Brussels. Spends one month in Paris, where John Graham is buying African sculpture; makes etchings in Stanley Hayter's studio. Spends winter in Greece, where he has a studio at 26 Joseph Monferatu.

1936 Travels by boat from Piraeus to Marseilles, via Naples and Malta. Returns to Paris. May—visits London. Takes Russian steamer to Leningrad on twenty-one-day tour to Soviet Union. Visits John Graham's ex-wife and children. July 4—returns to New York. Goes to Bolton Landing. Fall—returns to New York. Lives at 57 Poplar Street, Brooklyn. Makes first modeled wax pieces for bronze castings about this time.

1937 February—assigned to Works Project Administration Federal Arts Project (until August 1939). September 28—joins American Abstract Artists. Works on Medals for Dishonor series (until 1940). Works on oxyacetylene-welded sculpture. Makes sculptures for the

131. David Smith, c. 1946
Photograph by Lester Talkington

WPA/FAP. Joins the Artists Union, Local 60, about this time.

1938 January—first solo exhibition, including both drawings and sculpture, opens at Marian Willard's East River Gallery. Summer—works at Bolton Landing; makes lost-wax bronzes. Makes balsa sculpture for the WPA/FAP.

1939 February (1938?)—joins Sculpture Division of WPA, headed by Girolamo Piccoli. Joins the Sculpture Guild about this time. Commissioned by the Museum of Modern Art to make andirons and fireplace tools for the museum's penthouse. August 4—father dies; Smith attends funeral and makes bronze plaque for his headstone. Smith's work included in exhibition at New York World's Fair.

1940 Spring—moves to Bolton Landing permanently and names his studio there Terminal Iron Works. Works as machinist in Glens Falls. Lectures at United American Artists, New York.

1941 Studies welding at a wartime government school in Warrensburg, New York.

1942 Lives in three-room attic at 1113 McClellan Street, Schenectady. Studies welding at Union College. Works at night for the American Locomotive Company, assembling tanks and locomotives (until 1944); is rated a first-class welder. Joins the United Steelworkers of America, Local 2054, about this time; is rated first-class armor-plate welder by army ordinance. Returns to Bolton Landing on weekends. Works half-days at Harrington and Mallery, marble and granite workers, Saratoga.

1943 Commissioned by the Chinese government to design a medal for "China Defense Supplies," which was never made. Travels to Washington, D.C., for various conferences.

1944 March—classified 4-F by the United States Army. Quits job at Schenectady and moves back to Bolton Landing. Works on studio and design of new house; finishes studio workshop about this time.

1945 Is injured falling off a truck. Summer—Dehner returns to New York for five months.

1946 January–April—lives in New York City. May–December—lives in Bolton Landing. Begins Spectres series.

1947 August 29—speaks at First Woodstock Conference of Artists. Meets Robert Motherwell.

1948 October—teaches art at Sarah Lawrence College, Bronxville, New York (until 1950). Finishes building new house at Bolton Landing.

1949 Designs three prize medals for the Art News National Amateur Painters Competition. Designs bronze medal for the National Foundation for Infantile Paralysis, New York. With Dorothy Dehner attends all Bolton Landing town meetings, then runs unsuccessfully for Justice of the Peace.

1950 April—receives Guggenheim Foundation Fellowship (renewed 1951). Separates from Dorothy Dehner. Meets Helen Frankenthaler; meets Kenneth Noland through Cornelia Langer (later Noland's wife), a student of his at Sarah Lawrence.

1951 Begins Agricola series. February—substitute teaches at Sarah Lawrence College. October—included in I Bienal de São Paulo, his first foreign group exhibition.

1952 December 24—he and Dorothy Dehner are divorced. Begins Tanktotem series.

1953 January—*Artnews* votes Smith's 1952 exhibition one of the ten best shows of the year. Spring—is Visiting Artist for one semester in the art department at the University of Arkansas, Fayetteville. April 6—marries Jean Freas of Washington, D.C. Continues to lecture at conferences and colleges.

1954 April 4—daughter Eve Athena Allen Katherine Rebecca is born. Makes silver sculpture for Towle Silversmiths, Newburyport, Massachusetts, for American Federation of Arts exhibition *Sculpture in Silver from Islands in Time*. June—included in *XXVII Venice Biennale*. September–June 1955—is Visiting Professor, Department of Fine Arts, at Indiana University, Bloomington. Visits Europe as delegate to UNESCO's First International Congress

of Plastic Arts, Venice; travels in France and Italy.

1955 Teaches at University of Mississippi, Oxford, for one semester. August 12—daughter Candida Kore Nicolina Rawley Hellene is born. Begins making stencil drawings on paper.

1956 Makes new series of bronze plaques (until 1957). Begins Sentinel series.

1957 Commissioned by Art Institute of Chicago to design Mr. and Mrs. Frank C. Logan Medal.

1958 June—included in *XXIX Venice Biennale*. Begins to make stainless steel sculptures.

1959 September—wins prize at *V Bienal de São Paulo*. Begins Albany series.

1961 Begins Zig series. He and Jean Freas are divorced. October—refuses to accept third prize at Carnegie Institute, Pittsburgh International.

1962 May–July—goes to Voltri, near Genoa, Italy, to make sculpture for the Fourth Festival of Two Worlds at Spoleto. Makes twenty-seven works in thirty days. October—begins Circle series. December–March 1963—makes Voltri-Bolton series of twenty-five works from machine parts shipped from Italy.

1963 Begins stainless steel Cubi series. September–October—makes small painted Menands.

1964 Receives Creative Arts Award from Brandeis University. Interview held with Frank O'Hara on WNTD-TV: *David Smith: Welding Master of Bolton Landing*. Invited by Cleve Gray to make a limited edition ceramic piece for *Art in America* with David Gil of Bennington Potters.

1965 February—appointed member of National Council on the Arts. May 23—dies following an automobile accident near Bennington, Vermont.

Exhibitions

Selected Solo Exhibitions

1938
David Smith: Steel Sculpture, East River Gallery, New York, January 19–February 5.

1940
David Smith, Saint Paul Gallery and School of Art, Saint Paul, Minnesota, and tour to University Gallery, University of Minnesota, Minneapolis.

David Smith, Neumann, Willard Gallery, New York, March 25–April 15.

Medals for Dishonor by David Smith, Willard Gallery, New York, November 5–23.

1941
Medals for Dishonor, Kalamazoo Institute of Art, Kalamazoo, Michigan, February.

Medals for Dishonor, Walker Art Center, Minneapolis, November–December.

1942
Jewelry by David Smith, Willard Gallery, New York, January.

David Smith, Skidmore College, Saratoga Springs, New York, January 8–28.

1943
David Smith, Willard Gallery, New York, April 6–May 1.

1946
The Sculpture of David Smith, Willard Gallery, Buchholz Gallery, New York, January 2–26.

1947
Sculpture and Drawings by David Smith, Skidmore College, Saratoga Springs, New York, February 4–25.

David Smith Sculpture, 1946–1947, Willard Gallery, New York, March 25–April 26.

David Smith, American Association of University Women, Biennial convention, Baker Hotel, Dallas, April 13–20, and AAUW tour to Gary Public Library, Gary, Indiana; Fort Wayne Civic Theater, Fort Wayne, Indiana; Worcester Pressed Steel Museum, Worcester, Massachusetts; Indiana State Teachers College, Terre Haute, Indiana; East Central State College and Public Library, Ada, Oklahoma; City Library, Logan, Utah; Provo Public Library, Provo, Utah; Butler Institute of Art, Youngstown, Ohio; Roosevelt College, Chicago; Michigan State College, East Lansing; Junior Gallery, Louisville, Kentucky; Grinnell College, Grinnell, Iowa; Alabama Polytechnic Institute, Auburn.

1948
David Smith: Medals for Dishonor, Allan R. Hite Art Institute, University of Louisville, Louisville, Kentucky, November 29–December 18.

1950
David Smith, Willard Gallery, New York, April 18–May 13.

1951
David Smith, Willard Gallery, New York, March 27–April 21.

David Smith, Bennington College, Bennington, Vermont, November 16–25.

1952
David Smith, Williams College Museum of Art, Williamstown, Massachusetts.

David Smith: Sculpture and Drawing, Willard Gallery, Kleemann Gallery, New York, April 1–26.

Sculpture and Drawings: David Smith, Walker Art Center, Minneapolis, April 12–May 11.

Drawings, Paintings, and Sculptures by David Smith, Catholic University, Washington, D.C., October 22–November 14.

1953
David Smith: New Sculpture, Kootz Gallery, New York, January 26–February 14.

David Smith, University of Arkansas, Fayetteville, February.

David Smith, Philbrook Art Center, Tulsa, Oklahoma, April.

David Smith Drawings, Willard Gallery, New York, December 15–30.

1954
David Smith, Willard Gallery, New York, January 5–30.

David Smith: Sculpture, Drawings, Graphics, Contemporary Arts Center, Cincinnati Art Museum, May 19–June 13.

1956
David Smith: Sculpture, Drawings, 1954–56, Willard Gallery, New York, March 6–31.

1957
David Smith, Museum of Modern Art, New York, September 11–October 20.

Sculpture by David Smith, Fine Arts Associates, New York, September 17–October 12.

David Smith, Widdifield Gallery, New York, October 15–November 2.

1959
David Smith: Paintings and Drawings, French and Company, New York, September 16–October 10.

1960
David Smith: Sculpture, French and Company, New York, February 17–March 19.

David Smith: Sculpture and Drawings, Everett Ellin Gallery, Los Angeles, November 7–December 3.

1961
David Smith: Recent Sculpture, Otto Gerson Gallery, New York, October 10–28.

David Smith, Department of Fine Arts, Carnegie Institute, Pittsburgh, October 27–January 7, 1962.

David Smith, Memorial Art Gallery of the University of Rochester, Rochester, New York, November 3–24, and Museum of Modern Art Circulating Exhibition tour to Phillips Exeter Academy, Exeter, New Hampshire; Massachusetts Institute of Technology, Cambridge; Phillips Collection, Washington, D.C.; John Herron Museum of Art, Indianapolis, Indiana; Wadsworth Atheneum, Hartford, Connecticut; Southern Illinois University, Carbondale; Witte Memorial Museum, San Antonio, Texas.

1963

David Smith: A Decade of Drawings, 1953–1963, Balin-Traube Gallery, New York, May 14–June 14.

David Smith: Drawings, State University of New York, Plattsburg, December 1–22, and tour to Bowling Green State University, Bowling Green, Ohio; University of Manitoba, Winnipeg, Canada; Northern Michigan University, Marquette, Michigan; Mankato State College, Mankato, Minnesota; State College at Oswego, Oswego, New York; J. B. Speed Art Museum, Louisville, Kentucky; Paterson State College, Wayne, New Jersey; Green Mountain College, Poultney, Vermont; Madison Art Association, Madison, Wisconsin; University of Detroit; Skidmore College, Saratoga Springs, New York; Wichita State University, Wichita, Kansas; Fresno State College, Fresno, California. Organized by the Museum of Modern Art.

1964

David Smith: Sculpture and Drawings, Institute of Contemporary Art, University of Pennsylvania, Philadelphia, February 1–March 15.

David Smith, Hyde Collection, Glens Falls, New York, June 7–July 5.

David Smith, Marlborough-Gerson Gallery, New York, October.

1965

David Smith: A Memorial Exhibition, Los Angeles County Museum of Art, November 3–January 30, 1966.

1966

David Smith, 1906–1965, Rijksmuseum Kröller-Müller, Otterlo, The Netherlands, May 15–June 17, and International Council of the Museum of Modern Art Circulating Exhibition tour to Tate Gallery, London; Kunsthalle, Basel; Kunsthalle, Nuremberg; Wilhelm-Lehmbruck-Museum, Duisburg.

David Smith, 1906–1965, Fogg Art Museum, Harvard University, Cambridge, September 28–November 15, and tour to Washington Gallery of Modern Art, Washington, D.C.

1967

David Smith: Eight Early Works, 1935–38, Marlborough-Gerson Gallery, New York, April.

1968

David Smith: Small Sculpture of the Mid-Forties, Marlborough-Gerson Gallery, New York, May–June.

1969

David Smith, Solomon R. Guggenheim Museum, New York, March–May, and tour to Dallas Museum of Fine Arts; Corcoran Gallery of Art, Washington, D.C.

1973

David Smith of Bolton Landing, New York, Hyde Collection, Glens Falls, New York, July 1–September 30.

David Smith: Drawings, Knoedler Contemporary Art, New York, October 13–November 3.

1974

David Smith (1912–1965), Knoedler Contemporary Art, New York, October 5–26.

The Terminal Iron Works: Photographs of David Smith and His Sculpture by Dan Budnik, University Art Gallery, State University of New York, Albany, October 13–November 17, and American Federation of Arts tour to University of Texas at Austin, Austin, Texas; Rockland Community College, Suffern, New York; Center for Music, Drama and Art, Lake Placid, New York; Hopkins Center, Dartmouth College, Hanover, New Hampshire; Hudson River Museum, Yonkers, New York; Charles W. Bowers Memorial Museum, Santa Ana, California.

1976

David Smith: Small Sculptures, Knoedler Contemporary Art, New York, March 16–April 7; *Paintings*, April 24–May 13.

David Smith, Storm King Art Center, Mountainville, New York, May 12–October 31.

David Smith: Zeichnungen, Staatsgalerie, Stuttgart, and tour to Staatliche Museen-Preussischer Kulturbesitz, Berlin; Wilhelm-Lehmbruck-Museum, Duisburg.

1977

David Smith, M. Knoedler and Company, New York, November 22–December 10.

1978

David Smith, M. Knoedler and Company, New York, November 21–December 14.

1979

David Smith, Galerie Wentzel, Hamburg, West Germany, April 24–June 2.

David Smith: The Hirshhorn Museum and Sculpture Garden Collection, Hirshhorn Museum and Sculpture Garden, Smithsonian Institution, Washington, D.C., July 25–October 28.

The Prospect Mountain Sculpture Show: An Homage to David Smith, Lake George Arts Project, Lake George, New York, August 1–October 15.

David Smith: The Drawings, Whitney Museum of American Art, New York, December 5–February 10, 1980, and Arts Council of Great Britain tour to Serpentine Gallery, London, with sculpture added.

1980

David Smith: Drawings with Color, M. Knoedler and Company, New York, May 14–June 13.

1981

David Smith: The Formative Years, Sculpture and Drawings from the 1930s and 1940s, Edmonton Art Gallery, Edmonton, Canada, January 16–March 1, and tour to Seattle Art Museum; Winnipeg Art Gallery, Winnipeg, Canada; Art Gallery of Hamilton, Hamilton, Canada; Art Gallery of Windsor, Windsor, Canada; M. Knoedler and Company, New York.

David Smith: Drawings for Sculpture, 1954–1964, Mekler Gallery, Los Angeles, April 26–May 30.

David Smith: Drawings, Klonaridis, Toronto, October 31–November 21.

David Smith: Spray Paintings and Works on Paper, M. Knoedler and Company, New York, November 21–December 12.

1982

David Smith: Drawings, Janie C. Lee Gallery, Houston, January 15–February 6.

David Smith: Drawings for Sculpture, 1954–1964, Storm King Art Center, Mountainville, New York, May 19–October 31.

David Smith: Painter, Sculptor, Draftsman, and *From the Life of the Artist: A Documentary View of David Smith*, Hirshhorn Museum and Sculpture Garden, Smithsonian Institution, Washington, D.C., November 4–January 2, 1983, and tour to San Antonio Museum of Art.

David Smith, National Gallery of Art, Washington, D.C., November 7–April 24, 1983.

1983

David Smith: Sculpture, Painting, Drawing, M. Knoedler and Company, New York, April 23–May 12.

David Smith: Spray Paintings, Drawings, Sculpture, Arts Club of Chicago, June 1–30.

David Smith: Paintings from 1930–1947, Washburn Gallery, New York, September 20–October 30.

1985

Sprays from Bolton Landing, Anthony d'Offay Gallery, London, July 3–August 24.

1986

David Smith, Skulpturen Zeichnungen, Kunstsammlung Nordrhein-Westfalen, Düsseldorf, Germany, March 14–April 27, and tour to Städtische Galerie im Städelschen Kunstinstitut, Frankfurt am Main, Germany; Whitechapel Art Gallery, London.

1988

David Smith: Sculpture and Drawings, Akira Ikeda Gallery, Tokyo, May 16–June 25.

1990

David Smith Nudes: Drawings and Paintings from 1927–1964, Knoedler and Company, New York, March 29–April 26, and tour to Montclair Art Museum, Montclair, New Jersey.

David Smith: Drawings and Sculpture, Heide Park and Art Gallery, Melbourne, Australia, September 16–November 4.

1991

David Smith: Medals for Dishonour, 1937–1940, Imperial War Museum, London, April 25–June 23, and tour to Museum of Modern Art, Oxford, England; Leeds City Art Gallery, Leeds, England; Arnolfini Gallery, Bristol, England. Organized by the Henry Moore Centre for the Study of Sculpture, Leeds City Art Gallery.

1994

David Smith, Sezon Museum of Art, Tokyo, April 14–May 30, 1994, and tour in Japan to Shizuoka Prefectural Museum of Art; Museum of Modern Art, Shiga; Kawamura Memorial Museum of Art, Chiba. Organized by International Sculpture Center, Washington, D.C., and Contemporary Sculpture Center, Tokyo.

1995

David Smith: To and From the Figure, Knoedler and Company, New York, April 29–May 20, and tour to Akira Ikeda Gallery, Tokyo.

David Smith in Italy, Prada Milano Arte, Milan, May 16–June 30.

1996

David Smith, 1906–1965, with Photographs by Ugo Mulas, IVAM Centro Julio González, Valencia, Spain, January 18–March 19, and tour to Museo Nacional Centro de Arte Reina Sofia, Madrid.

David Smith: Medals for Dishonor, Columbus Museum of Art, Columbus, Ohio, November 17–January 12, 1997, and tour to Springfield Art Museum, Springfield, Missouri; DePree Art Center, Hope College, Holland, Michigan; Boston University Art Gallery. Organized by Independent Curators Incorporated.

1997

The Fields of David Smith, Storm King Art Center, Mountainville, New York, May 19–November 16. First in a series of three annual exhibitions.

1998

David Smith: Photographs, 1931–1965, Matthew Marks Gallery, New York, March 7–April 18, and tour to Fraenkel Gallery, San Francisco.

Painted Steel: The Late Work of David Smith, Gagosian Gallery, New York, April 18–May 23.

The Fields of David Smith (part II), May 17–November, Storm King Art Center, Mountainville, New York.

Selected Group Exhibitions

1930

Fourth Annual Exhibition of American Block Prints, Print Club of Philadelphia, March 17–April 5.

1934

Winter Exhibition of Paintings by Four Contemporary Artists, Academy of Allied Art, New York, January 18–February 10.

1938

American Abstract Artists, Fine Arts Galleries, New York, February 14–28.

American Artists' Congress Second Annual Membership Exhibition, John Wanamaker, New York, May 5–21.

Thirty-seventh Exhibition, Municipal Art Society, Municipal Art Galleries, New York, October 26–November 13.

1939

Third Annual Exhibition of Paintings, Sculpture, and Prints by American Abstract Artists, Riverside Museum, New York, March 7–26.

American Art Today, New York World's Fair, New York, April 30–October.

1940

American Sculpture of Today, Buchholz Gallery, New York, December 30–January 18.

1941

Annual Exhibition of Sculpture, Watercolors, Drawings, and Prints, Whitney Museum of American Art, New York, January 15–February 19. Also included in 1942–43, 1947–56, 1958, 1960, 1964 exhibitions.

Third Outdoor Sculpture Exhibition, Sculptors' Guild, Village Square, New York, April 28–May. Also included in 1942, 1948 exhibitions.

1942

Artists for Victory, Metropolitan Museum of Art, New York, December 7–February 22, 1943.

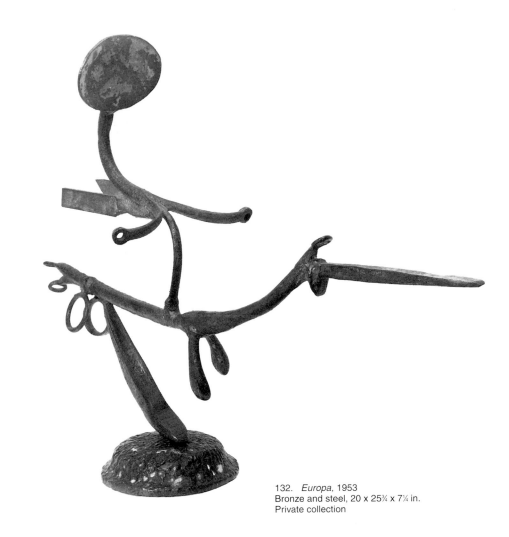

132. *Europa*, 1953
Bronze and steel, 20 x 25¾ x 7¼ in.
Private collection

1947

Abstract and Surrealist American Art, Fifty-eighth Annual Exhibition of American Painting and Sculpture, Art Institute of Chicago, November 6–January 11, 1948. Also included in 1951, 1954, 1957, 1963 exhibitions.

1948

Sculpture at the Crossroads, Worcester Art Museum, Worcester, Massachusetts, February 15–March 21.

1951

Abstract Painting and Sculpture in America, Museum of Modern Art, New York, January 23– March 4.

I Bienal de São Paulo, Museu de Arte Moderna, São Paulo, Brazil, October. Also included in 1959 exhibition.

American Sculpture 1951, Metropolitan Museum of Art, New York, December 7–February 24, 1962.

1953

Contemporary American Painting and Sculpture, University of Illinois, Urbana, March 1–April 12.

The Classic Tradition in Contemporary Art, Walker Art Center, Minneapolis, April 24–June 28.

Douze peintres et sculpteurs américains contemporains, Musée National d'Art Moderne, Paris, April 24–June 7, and tour. Organized by the International Council of the Museum of Modern Art.

1954

XXVII Venice Biennale, Venice, June–October. Also included in 1958 exhibition.

1956

The Figure in Contemporary Sculpture, Munson-Williams-Proctor Institute, Utica, New York, January 8–29, and tour.

Exposition internationale de sculpture contemporaine, Musée Rodin, Paris, Summer.

1958

Nature in Abstraction, Whitney Museum of American Art, New York, January 14–March 16, and tour.

1958 Pittsburgh International Exhibition of Contemporary Painting and Sculpture, Carnegie Institute, Pittsburgh, December 5–February 8, 1959. Also included in 1961 exhibition.

1959

The Museum and Its Friends: Eighteen Living American Artists Selected by the Friends of the Whitney Museum, Whitney Museum of American Art, New York, March 5–April 12.

Documenta II, Kassel, West Germany, July 11–October 11. Also included in 1964 exhibition.

Recent Sculpture U.S.A., Denver Art Museum, October 12–November 22, and tour. Organized by the Museum of Modern Art, New York.

1961

The Art of Assemblage, Museum of Modern Art, New York, October 2–November 12, and tour.

1962

Geometric Abstraction in America, Whitney Museum of American Art, New York, March 20–May 13.

1963

U.S. Government Art Projects: Some Distinguished Alumni, Mercer University, Macon, Georgia, March–April, and tour. Organized by the Museum of Modern Art, New York.

1964

Painting and Sculpture of a Decade: 54–64, Tate Gallery, London, April 22–June 28.

Between the Fairs: Twenty-five Years of American Art, 1939–1964, Whitney Museum of American Art, New York, June 24–September 23.

Ceramics by Twelve Artists, American Federation of Arts, New York, November 30–December 11, and tour.

1965

Sculpture of the Twentieth Century, Dallas Museum of Fine Arts, May 12–June 13.

Etats Unis: Sculptures du XXe Siècle, Musée Rodin, Paris, June 22–October 10, and tour. Organized by the International Council of the Museum of Modern Art.

1966

Twentieth-Century Sculpture, Art Museum, University of New Mexico, Albuquerque, March 25–May 1.

Fifty Years of Modern Art, Cleveland Museum of Art, June 15–July 31.

Art of the United States, 1670–1966, Whitney Museum of American Art, New York, September 28–November 27.

1967

International Exhibition of Contemporary Sculpture, Expo 67, Montreal, April–October.

American Sculpture of the Sixties, Los Angeles County Museum of Art, April 28–June 25, and tour.

Sculpture: A Generation of Innovation, Art Institute of Chicago, June 23–August 27.

Guggenheim International Exhibition 1967, Solomon R. Guggenheim Museum, New York, October 20–February 4, 1968, and tour.

1968

Dada, Surrealism and Their Heritage, Museum of Modern Art, New York, March 27–June 9, and tour.

The Art of the Real U.S.A., 1948–1968, Museum of Modern Art, New York, July 3–September 8.

1970

Noguchi and Rickey and Smith, Art Museum, University of Indiana, Bloomington, November 8–December 13.

1973

Nineteen Sculptors of the Forties, Art Galleries, University of California, Santa Barbara, April 3–May 6.

1974

Monumenta: A Biennial Exhibition of Outdoor Sculpture, Newport, Rhode Island, August 17–October 13.

Sculpture in Steel, Edmonton Art Gallery, Edmonton, Canada, September 6–October 31, and tour.

1976

Seven Plus Five: Sculptors in the 1950s, Art Galleries, University of California, Santa Barbara, January 6–February 15, and tour.

New Works in Clay by Contemporary Painters and Sculptors, Everson Museum of Art, Syracuse, New York, January 23–April 4.

1977

Graham, Gorky, Smith and Davis in the Thirties, Bell Gallery, Brown University, Providence, Rhode Island, April 30–May 22.

1978

American Art at Mid-Century: The Subjects of the Artist, National Gallery of Art, Washington, D.C., June 1–January 14, 1979.

1980

Skulpturen der Moderne, Galerie de France, Paris, February 5–March 29, and tour.

1983

Abstract Painting and Sculpture in America, 1927–1944, Museum of Art, Carnegie Institute, Pittsburgh, November 5–December 31, 1983, and tour.

1993

Picasso and the Age of Iron, Solomon R. Guggenheim Museum of Art, New York, March–May 16.

Public Collections

Ann Arbor, Michigan, University of Michigan, Museum of Art

Baltimore, Maryland, Baltimore Museum of Art

Bloomington, Indiana, Indiana University Art Museum

Boston, Massachusetts, Museum of Fine Arts

Brooklyn, New York, Brooklyn Museum

Buffalo, New York, Albright-Knox Art Gallery

Cambridge, Massachusetts, Harvard University, Fogg Art Museum

Carbondale, Illinois, Southern Illinois University at Carbondale, University Museum

Chicago, Illinois, Art Institute of Chicago

Cincinnati, Ohio, Cincinnati Art Museum

Cleveland, Ohio, Cleveland Museum of Art

Cologne, West Germany, Museum Ludwig

Dallas, Texas, Dallas Museum of Fine Arts

Dallas, Texas, Southern Methodist University

Des Moines, Iowa, Des Moines Art Center

Detroit, Michigan, Detroit Institute of Arts

Duisburg, West Germany, Wilhelm-Lehmbruck-Museum der Stadt Duisburg

Greensboro, North Carolina, University of North Carolina, Weatherspoon Art Gallery

Hartford, Connecticut, Wadsworth Atheneum

Honolulu, Hawaii, Honolulu Academy of Fine Arts

Houston, Texas, Museum of Fine Arts

Indianapolis, Indiana, Indianapolis Museum of Art

Jerusalem, Israel, Israel Museum

Lincoln, Nebraska, Sheldon Memorial Art Gallery

London, England, Tate Gallery

Los Angeles, California, Los Angeles County Museum of Art

Minneapolis, Minnesota, Walker Art Center

Minneapolis, Minnesota, University of Minnesota, University Gallery

Mountainville, New York, Storm King Art Center

New Haven, Connecticut, Yale University Art Gallery

New York City, New York, Lincoln Center for the Performing Arts

New York City, New York, Metropolitan Museum of Art

New York City, New York, Museum of Modern Art

New York City, New York, Solomon R. Guggenheim Museum

New York City, New York, Whitney Museum of American Art

Newark, New Jersey, Newark Museum

Norfolk, Virginia, Chrysler Museum

Ottawa, Canada, National Gallery of Canada

Otterlo, The Netherlands, Rijksmuseum Kröller Müller

Philadelphia, Pennsylvania, Philadelphia Museum of Art

Pittsburgh, Pennsylvania, Museum of Art, Carnegie Institute

Princeton, New Jersey, Princeton University, Art Museum

Raleigh, North Carolina, North Carolina Museum of Art

Saint Louis, Missouri, Mansion House Center

Saint Louis, Missouri, Saint Louis Art Museum

San Diego, California, San Diego Gallery of Fine Arts

San Francisco, California, San Francisco Museum of Modern Art

Seattle, Washington, Seattle Art Museum

Utica, New York, Munson-Williams-Proctor Institute

Waltham, Massachusetts, Brandeis University, Rose Art Museum

Washington, D.C., Hirshhorn Museum and Sculpture Garden, Smithsonian Institution

Washington, D.C., National Gallery of Art

Washington, D.C., National Museum of American Art, Smithsonian Institution

Williamstown, Massachusetts, Williams College, Museum of Art

133. *Primo Piano I,* 1962
Steel, painted white, 110 x 144 x 21 in.
Mr. and Mrs. David Mirvish, Toronto

Selected Bibliography

Interviews and Statements

Baro, Gene, Ed. "Some Late Words from David Smith." *Art International* 9 (October 1965): 47–51. Extracts from tape transcript of Smith's talk at Bennington College, May 12, 1965.

Gray, Cleve, ed. *David Smith by David Smith.* New York: Holt, Rinehart and Winston, 1968. Includes reprints of statements. Revised edition, Thames and Hudson, 1989.

Hess, Thomas B. "The Secret Letter: An Interview with David Smith, June 1964." In *David Smith.* New York: Marlborough-Gerson Gallery, 1964.

Kuh, Katherine. "David Smith." In *The Artist's Voice: Talks with Seventeen Artists.* New York: Harper and Row Publishers, 1962, pp. 219–34.

Lipman, Howard W. "Sculpture Today, with Statements by Alexander Calder, Richard Lippold, Louise Nevelson, David Smith." *Whitney Review 1961–1962,* n.p.

McCoy, Garnett, ed. *David Smith.* New York: Praeger, 1973. Includes reprints of statements.

The New Sculpture: A Symposium. New York: Museum of Modern Art, Junior Council, February 12, 1952. Moderator: A. C. Ritchie. Participants: Lippold, Ferber, Noguchi, Roszak, Smith. Typescript in Museum of Modern Art Library. Includes statements.

J. M. S. [Schuyler, James?]. "Is Today's Artist with or against the Past?: Part 2." *Artnews* 57 (September 1958): 38, 62. Interview.

Shirey, David L. "David Smith: Man of Iron, a Portfolio of Works and Words." *Dialogue* 3 (1970): 46–57. Includes reprints of statements.

Smith, David. "Abstract Art." *New York Artist* 1, no. 2 (April 1940): 5, 6, 15. Excerpts from a paper read at the Forum on Abstract Art held at the Labor Stage, New York, by the United American Artists, February 15, 1940.

———. "Art Forms in Architecture: Sculpture." *Architectural Record* 88 (October 1940): 77–80.

———. "Modern Sculpture and Society." Written about 1940. In Francis V. O'Connor, ed. *Art for the Millions: Essays from the 1930's by Artists and Administrators of the WPA Federal Art Project.* Greenwich, Conn.: New York Graphic Society, 1973, pp. 90–92.

———. "The Landscape. Spectres Are. Sculpture Is." In *David Smith Sculpture, 1946–1947.* New York: Willard Gallery, 1947. "I Have Never Looked at a Landscape." "Sculpture Is." Abridged and reprinted in *Possibilities* 1 (winter 1947–48): 25–26.

———. "The Golden Eagle—a Recital." In "The Ides of Art: Fourteen Sculptors Write." *Tiger's Eye* 1, no. 4 (June 15, 1948): 81–82.

———. "'H's' 'Y's' 'Birdsheads' 'The Letter.'" In *David Smith.* New York: Willard Gallery, 1951. Captions for works completed under a Guggenheim Foundation fellowship.

———. "Foreword—(Apology of a Juryman)." In "Fifth Annual Area Exhibition." *Corcoran Gallery of Art Bulletin* 4 (February 1951).

———. "Language Is Image." *Arts and Architecture* 69 (February 1952): 20–21, 33–34. Transcript of some remarks made at a seminar, fall 1951.

———. Statement in *The Museum and Its Friends: Eighteen Living American Artists Selected by the Friends of the Whitney Museum.* New York: Whitney Museum of American Art, 1959. Excerpt from a radio talk, WNYC, 1952.

———. Statement. In "Who Is the Artist? How Does He Act?" *Everyday Art Quarterly* (Minneapolis: Walker Art Center) 23 (1952): 16–21. Excerpt in Clement Greenberg, "America Takes the Lead 1945–1965," Part 6 of "The Artist Speaks," *Art in America* 53 (August–September 1965): 108–29. See p. 122.

———. Statement in "Symposium: Art and Religion." *Art Digest* 28 (December 15, 1953): 8–11, 31–32.

———. "Thoughts on Sculpture." *College Art Journal* 13 (winter 1954): 96–100. Paper read at University of Arkansas.

———. "Second Thoughts on Sculpture." *College Art Journal* 13 (spring 1954): 203–7. Transcript of a paper for Southwestern College Art Conference, University of Oklahoma.

———. "González: First Master of the Torch." *Artnews* 54 (February 1956): 34–37, 64–65.

———. "Sculpture and Architecture." *Arts Magazine* 31 (May 1957): 20.

———. "False Statements." In "Letters." *Arts Magazine* 31 (June 1957): 7.

———. "Notes on My Work." *Arts Magazine* 34 (February 1960): 44–49. Entire issue devoted to David Smith.

———. "A Protest against Vandalism." In "Letters." *Arts Magazine* 34 (June 1960): 5.

———. "Memories to Myself." *Journal of the Archives of American Art* 8 (April 1968): 11–16.

———. "Notes for David Smith Makes a Sculpture." *Artnews* 67 (January 1969): 46–48, 56.

Rodman, Selden. "David Smith." In *Conversations with Artists.* New York: Devin-Adair, 1957, pp. 126–30.

Sylvester, David. "David Smith." *Living Arts* 3 (April 1964): 5–13. Interview. Excerpt reprinted in *Art and Artists* 1 (September 1966): 46–47.

Watson, Ernest W. "David Smith." *American Artist* 4 (March 1940): 20–22, 32. Interview.

"Words by David Smith." *Artforum* 18 (December 1979): 26–27. Statements from an undated manuscript.

Monographs and Solo-Exhibition Catalogs

Blake, William, and Christina Stead. Foreword to *Medals for Dishonor*. New York: Willard Gallery, 1940. Includes statements.

Budnick, Dan. *The Terminal Iron Works: Photographs of David Smith and His Sculpture*. Albany: University Art Gallery, State University of New York, 1974.

Carandente, Giovanni. *Voltron*. Philadelphia: University of Pennsylvania, Institute of Contemporary Art, 1964.

———. *David Smith in Italy*. Milan: Charta, 1995.

Carmean, E. A., Jr. *David Smith*. Washington, D.C.: National Gallery of Art, 1982.

Clark, Trinkett. *The Drawings of David Smith*. Washington, D.C.: International Exhibitions Foundation, 1985.

Cone, Jane Harrison. *David Smith 1906–1965: A Retrospective Exhibition*. Cambridge: Fogg Art Museum, Harvard University, 1966.

Cummings, Paul. *David Smith: The Drawings*. New York: Whitney Museum of American Art, 1979.

David Smith: Medals for Dishonor, 1937–1940. Introduction by Matthew Marks and Peter Stevens; essays by Dore Ashton and Michael Brenson. New York: Independent Curators Incorporated, 1996.

David Smith in Italy: Photos by Ugo Mulas. Milan: Charta, 1995.

Day, Holliday T. *David Smith: Spray Paintings, Drawings, Sculpture*. Chicago: Arts Club of Chicago, 1983.

Dehner, Dorothy, and Kettlewell, James K. *David Smith of Bolton Landing, New York*. Glens Falls, N.Y.: The Hyde Collection, 1973.

Ellin, Everett. *David Smith: Sculpture and Drawings*. Los Angeles: Everett Ellin Gallery, 1960.

Fry, Edward F. *David Smith*. New York: Solomon R. Guggenheim Museum, 1969.

———, and McClintic, Miranda. *David Smith: Painter, Sculpture, Draftsman*. New York: George Braziller and Washington, D.C.: Hirshhorn Museum and Sculpture Garden, 1982.

Gimenez, Carmen. *David Smith, 1906–1965, with Photographs by Ugo Mulas*. Valencia, Spain: IVAM Centro Julio González, 1996.

Greenberg, Clement. Foreword to *David Smith: Sculpture and Drawings*. Philadelphia:

University of Pennsylvania, Institute of Contemporary Art, 1964.

Hazlitt, Gordon J. Introduction to *David Smith: Drawings for Sculpture: 1954–1964*. Mountainville, N.Y.: Storm King Art Center, 1982.

Hunter, Sam. *David Smith*. *Museum of Modern Art Bulletin* 25, no. 2 (1957).

———. Foreword to *David Smith: Recent Sculpture*. New York: Otto Gerson Gallery, 1961.

Johnson, Una E. *David Smith in the Storm King Art Center Collection*. Mountainville, N.Y.: Storm King Art Center, 1971.

Kramer, Hilton. Foreword to *David Smith: A Memorial Exhibition*. Los Angeles: Los Angeles County Museum of Art, 1965. Includes statements.

Krauss, Rosalind E. *David Smith: Eight Early Works, 1935–38*. New York: Marlborough-Gerson Gallery, 1967.

———. *David Smith: Small Sculpture of the Mid-Forties*. New York: Marlborough-Gerson Gallery, 1968.

———. *Terminal Iron Works: The Sculpture of David Smith*. Cambridge: MIT Press, 1971.

———. *The Sculpture of David Smith: A Catalogue Raisonné*. New York: Garland Publishing, 1977.

Lampert, Catherine. *David Smith: Sculpture and Drawings*. London: Arts Council of Great Britain, 1980.

Lewison, Jeremy. *David Smith: Medals for Dishonor, 1937–1940*. Leeds, England: Henry Moore Centre for the Study of Sculpture, 1991.

Marcus, Stanley E. *David Smith: The Sculptor and His Work*. Ithaca, N.Y.: Cornell University Press, 1983.

McClintic, Miranda. *David Smith: The Hirshhorn Museum and Sculpture Garden Collection*. Washington, D.C.: Smithsonian Institution Press, 1979.

McCoy, Garnett. *From the Life of the Artist: A Documentary View of David Smith*. Washington, D.C.: Archives of American Art and Smithsonian Institution Press, 1982.

Mekler, Adam, and Nordland, Gerald. Foreword to *David Smith: Drawings for Sculpture, 1954–1964*. Los Angeles: Mekler Gallery, 1981.

Merkert, Jörn, ed. *David Smith: Sculpture and Drawings*. Munich: Prestel-Verlag, 1986.

Motherwell, Robert. *David Smith*. New York: Willard Gallery, 1950.

Nemerov, Howard. Preface to *David Smith: Sculpture and Drawing*. New York: Willard Gallery, Kleemann Gallery, 1952.

O'Hara, Frank. Introduction to *David Smith 1906–1965*. New York: Museum of Modern Art, 1966. Reprinted in *Art Chronicles, 1954–1966*, New York: George Braziller, 1975, pp. 53–64.

Pachner, Joe, and Rosalind E. Krauss. *David Smith: Photographs, 1931–1965*. New York: Matthew Marks, 1998.

Sandler, Irving. *The Prospect Mountain Sculpture Show: An Homage to David Smith*. Lake George, N.Y.: Lake George Arts Project, 1979.

Valentiner, Wilhelm R. *The Sculpture of David Smith*. New York: Willard Gallery, Buchholz Gallery, 1946.

———. *David Smith: Sculpture and Drawing*. New York: Willard Gallery, Kleemann Gallery, 1952.

Wiese, Stephan von. *David Smith: Zeichnungen*. Stuttgart: Staatsgalerie, 1976.

Wilkin, Karen. *David Smith: The Formative Years, Sculptures and Drawings from the 1930s and 1940s*. Edmonton, Canada: Edmonton Art Gallery, 1981.

Periodicals, Books, and Group-Exhibition Catalogs

Alloway, Lawrence. "3-D: David Smith and Modern Sculpture." *Arts Magazine* 43 (February 1969): 36–40.

"Artistic Smith at Work." *Life*, September 22, 1952, pp. 75–76, 78.

Ashton, Dore. "David Smith." *Arts and Architecture* 82 (February 1965): 26–28.

Bannard, Darby. "Cubism, Abstract Expressionism, David Smith." *Artforum* 6 (April 1968): 22–32.

Baro, Gene. "David Smith (1906–65)." *Arts Yearbook: Contemporary Sculpture* 8 (1965): 99–105.

———. "David Smith: The Art of Wholeness." *Studio International* 172 (August 1966): 69–75.

Beam, Lura. "David Smith." *Journal of the American Association of University Women* 43 (spring 1950): 154–55. Includes reprints of comments by Milton Brown, Clement Greenberg, Carlyle Burrows, Elizabeth McCausland, Maude Riley, W. R. Valentiner.

Budnik, Dan. "Issues and Commentary: David Smith: A Documentation." *Art in America* 62

(September–October 1974): 30–33.

————, and Ugo Mulas. Photographs in "David Smith." *Art in America* 54 (January–February 1966): 33–48. Special section on Smith; includes statements.

Carmean, E. A., Jr. "David Smith: The Voltri Sculpture." In *American Art at Mid-Century: The Subjects of the Artist*. Washington, D.C.: National Gallery of Art, 1978, pp. 214–41.

Cherry, Herman. "David Smith." *Numero: Arte e Letteratura* (Florence, Italy) 5 (May–June 1953): 20. Reprinted in *Sculpture by David Smith*. New York: Fine Arts Associates, 1957.

Cone, Jane Harrison. "David Smith." *Artforum* 5 (June 1967): 72–78.

Dehner, Dorothy. "Medals for Dishonor: The Fifteen Medallions of David Smith." *Art Journal* 37 (winter 1977–78): 144–50.

————. "Memories of Jan Matulka." In *Jan Matulka, 1890–1972*. Washington, D.C.: National Collection of Fine Arts and Smithsonian Institution Press, 1980.

————, and Marian Willard. "First Meetings." *Art in America* 54 (January–February 1966): 22. Special section on Smith.

de Kooning, Elaine. "David Smith Makes a Sculpture." *Artnews* 50 (September 1951): 38–41, 50–51.

Donadio, Emmie. "Smith's Legacy: The View from Prospect Mountain." *Arts Magazine* 54 (December 1979): 154–57.

"Farewell to the Vulcan of American Art." *Life*, June 11, 1965, pp. 129–30.

Fourcade, Dominique. *Julio González, David Smith, Anthony Caro, Tim Scott, Michael Steiner*. Bielefeld-Kunsthalle, 1980. Includes statements.

Geist, Sidney. "A Smith as Draftsman." *Art Digest* 28 (January 1, 1954): 14.

Goossen, Eugene C. "David Smith." *Arts Magazine* 30 (March 1956): 23–27.

Gray, Cleve. "Last Visit." *Art in America* 54 (January–February 1966): 23–26. Special section on Smith.

Greenberg, Clement. "American Sculpture of Our Time: Group Show." *Nation*, January 23, 1943, pp. 140–41.

————. "Art." *Nation*, January 26, 1946, pp. 109–10.

————. "Art." (David Smith.) *Nation*, April 19, 1947, pp. 459–60.

————. "David Smith." *Art in America* 44 (winter 1956–57): 30–33, 66. Reprinted in *Art in America* 51 (August 1963): 112–17.

————. "David Smith." *Art in America* 54 (January–February 1966): 27–32. Special section on Smith.

Hughes, Robert. "Dream Sculptures in Ink and Paper." *Time*, December 24, 1979, p. 47.

————. "Iron Was His Name." *Time*, January 31, 1983, pp. 70–71.

"Iron Works Closed." *Newsweek*, June 7, 1965, pp. 78–79.

Jacobs, Jay. "David Smith Sculpts for Spoleto." *Artnews Annual* 29 (1964): 42–49, 156–58.

Kozloff, Max. "David Smith at the Tate." *Artforum* 5 (November 1966): 28–30.

Kramer, Hilton. "The Sculpture of David Smith." *Arts Magazine* 34 (February 1960): 22–43. Entire issue devoted to Smith.

————. "David Smith: Stencils for Sculpture." *Art in America* 50 (winter 1962): 32–43.

————. "David Smith's New York." *Arts Magazine* 38 (March 1964): 28–35.

————. "A Critic Calls David Smith 'Greatest of All American Artists.'" *New York Times Magazine*, February 16, 1969, pp. 1, 40, 54, 59–62.

————. "Smith Sculpture Altered after Death." *New York Times*, September 13, 1974, p. 28.

————. "Art: David Smith in Washington." *New Criterion* 1 (January 1983): 62–66.

Krasne, Belle. "A David Smith Profile." *Art Digest* 26 (April 1, 1952): 12–13, 26, 29.

Krauss, Rosalind. "Issues and Commentary: Changing the Work of David Smith." *Art in America* 62 (September–October 1974): 30–34.

————. "The Essential David Smith." *Artforum* 7 (February 1969): 43–49. "Part 2." (April 1969): 43–51.

McCoy, Garnett. "The David Smith Papers." *Journal of the Archives of American Art* 8 (April 1968): 1–11. Includes statements.

Marmer, Nancy. "A Memorial Exhibition: David Smith." *Artforum* 4 (January 1966): 42–45.

Marter, Joan, ed. *Dorothy Dehner and David Smith: Their Decades of Search and Fulfillment*. New Brunswick, N.J.: Jane Voorhees Zimmerli Art Museum, 1983.

Meltzoff, Stanley. "David Smith and Social Surrealism." *Magazine of Art* 39 (March 1946): 98–101.

Millard, Charles. "David Smith." *Hudson Review* 22 (summer 1969): 271–77.

Motherwell, Robert. "David Smith: A Major American Sculptor, a Major American Painter." *Vogue* 155 (February 1965): 134–39, 190–91.

Navaretta, E. A. "New Sculpture by David Smith." *Art in America* 47 (winter 1959): 96–99.

Nodelman, Sheldon. "David Smith." *Artnews* 67 (February 1969): 28–31, 56–58.

O'Hara, Frank. "David Smith: The Color of Steel." *Artnews* 60 (December 1961): 32–34, 69–70.

Pomeroy, Ralph. "David Smith in Depth." *Art and Artists* 4 (September 1969): 28–30.

Porter, Fairfield. "David Smith: Steel into Sculpture." *Artnews* 56 (September 1957): 40–43, 54–55.

Riley, Maude. "David Smith, Courtesy American Locomotive." *Art Digest* 17 (April 15, 1943): 13.

Rosati, James. "David Smith (1906–65)." *Artnews* 64 (September 1965): 28–29, 63.

Rubin, William. "David Smith." *Art International* 7 (December 1963): 48–49.

Russell, John. "David Smith's Art Is Best Revealed in Natural Settings." *Smithsonian* 7 (March 1977): 68–75.

————. "Sculpture: David Smith." *New York Times*, April 30, 1982, sec. C, p. 24.

Shirey, David L. "Man of Iron." *Newsweek* 69 (March 31, 1969): 78–79.

Silver, Jonathan. "The Classical Cubism of David Smith." *Artnews* 82 (February 1983): 100–103.

Tuchman, Phyllis. "In Detail: David Smith and Cubi XXVIII." *Portfolio* 5 (January–February 1983): 78–82.

Tucker, William. "Four Sculptors, Part 4: David Smith." *Studio International* 181 (January 1971): 24–29.

Valentiner, William R. "Sculpture by David Smith." *Arts and Architecture* 65 (August 1948): 22–23, 52.

Wilkin, Karen. *Sculpture in Steel*. Edmonton, Canada: Edmonton Art Gallery, 1974.

————. "David Smith." In *Abstract Painting and Sculpture in America, 1927–1944*. Edited by John R. Lane and C. Susan Larsen. Pittsburgh: Museum of Art, Carnegie Institute, 1983.

Index

Photography Credits

All photographic material was obtained directly from the collection or photographer indicated in the caption, except for the following: Courtesy Archives of American Art, Smithsonian Institution, Washington, D.C.—David Smith Papers: plates 1, 2, 10, 11, 56, 57, 73, 79, 82, 87, 90, 101, 117, 124, 126–29; Will Brown, Philadelphia: plate 115; Dan Budnik, New York (courtesy Archives of American Art): plates 114, 122; Barney Burstein, Boston: plate 83; Courtesy Christie's, New York: plates 76, 77; Geoffrey Clements, New York: plate 17; Ken Cohen (courtesy M. Knoedler and Company, New York): plates 12, 13, 25; X da Gery: plate 75; Courtesy Dorothy Dehner: plate 5; Courtesy Edmonton Art Gallery: plate 39; Michael Fredericks, Jr.: plate 3; Robert Fuhring: plate 93; Courtesy Solomon R. Guggenheim Museum, New York: plate 58; David Harris, Jerusalem: plate 97; Courtesy M. Knoedler and Company, New York: plates 34, 121; Eleanor Lazare (courtesy Edmonton Art Gallery): plate 46; Eleanor Lazare: plate 103; Leonid Lubianitsky: plate 86; Carroll Martin: plate 108; Robert E. Mates: plate 32; A. Mewbourne: plates 4, 24; Jack Meyers: plate 85; Paul Micapia, Seattle: plate 47; T. E. Moore: plate 67; Ugo Mulas (courtesy Archives of American Art): plates 8, 130; Ugo Mulas (courtesy M. Knoedler and Company): plate 92; Muldoon Studio, Massachusetts: plate 84; Courtesy Museum of Art, Carnegie Institute, Pittsburgh: plate 102; O. E. Nelson, New York: plates 33, 48; Kenneth Noland, New York: plate 18; Eric Pollitzer, New York: plate 113; George Roos, New York: plates 6, 40; Derek St. John: plate 62; Sherwin, Greenberg, McGranahan and May, Inc., Buffalo: plate 118; Courtesy Smith Estate: plates 9, 20, 21, 22, 26, 63, 70, 71, 99, 104; William Sogher, New York: plates 15, 23, 43, 112, 132; Ken Strothman and Harvey Osterhoudt: plate 41; Lester Talkington, Tappan, New York: plate 131; Grant Taylor: plate 109; John Tennant: plates 54, 60; Jerry Thompson, New York: plates 55, 72, 81; Courtesy Washburn Gallery, New York: plate 7.

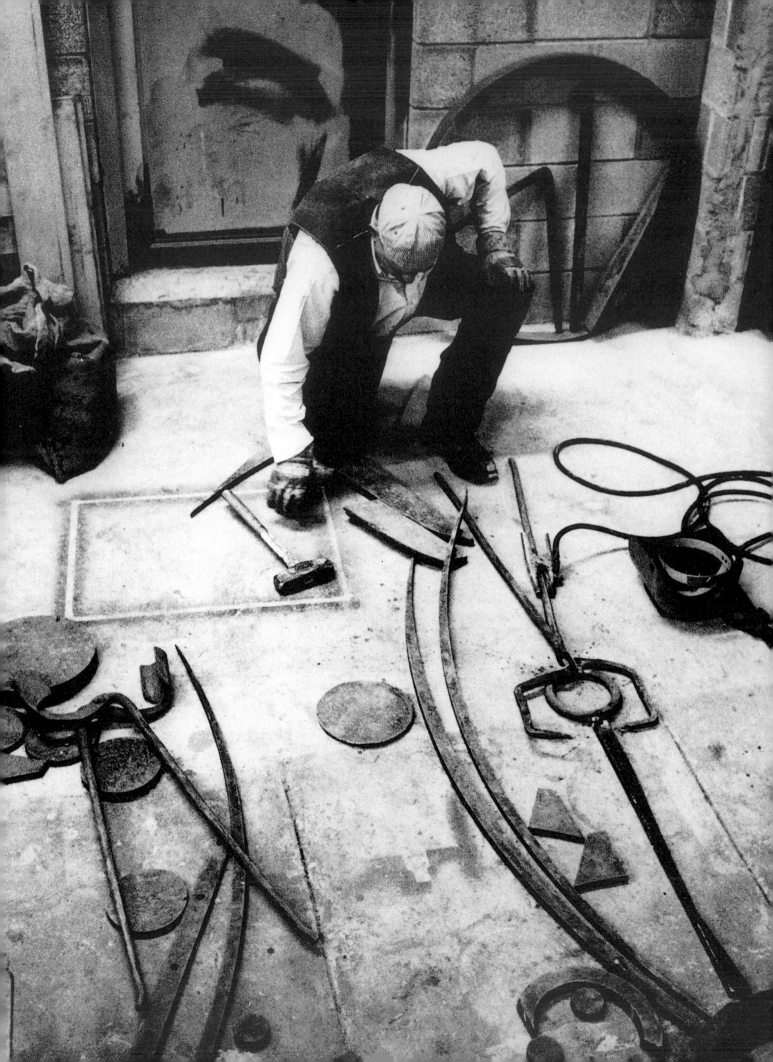